THE ART OF
BOTANICAL
PAINTING

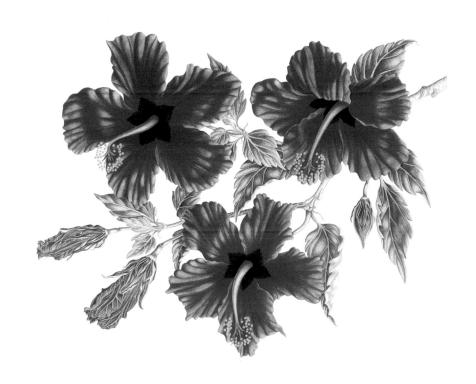

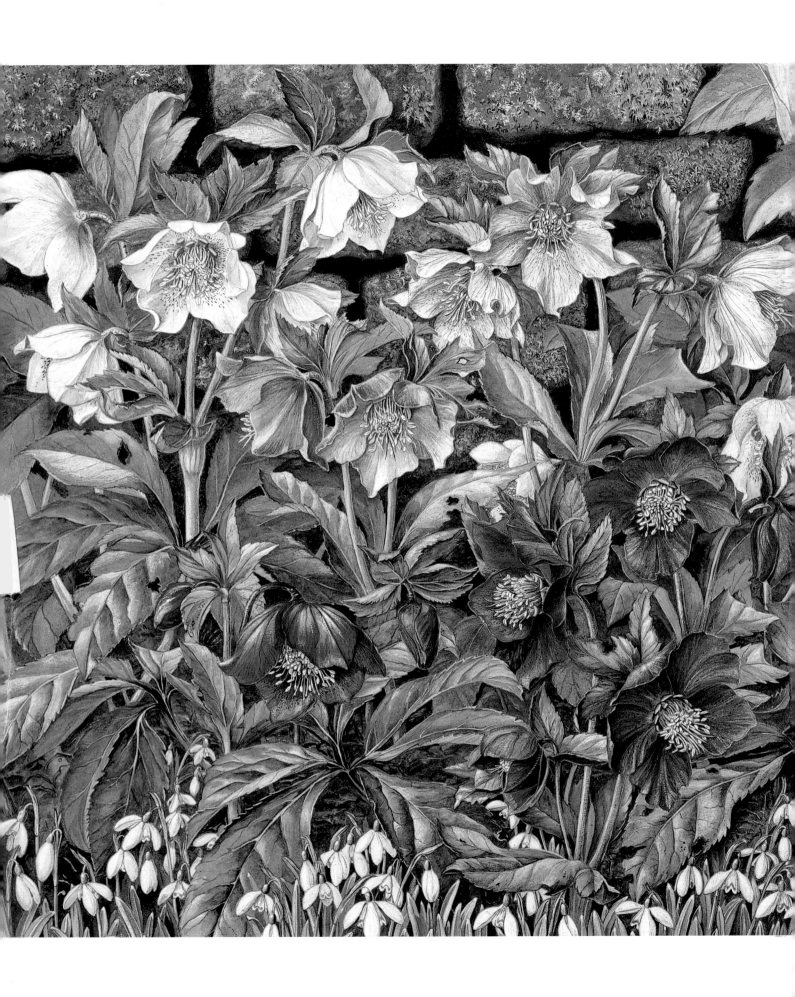

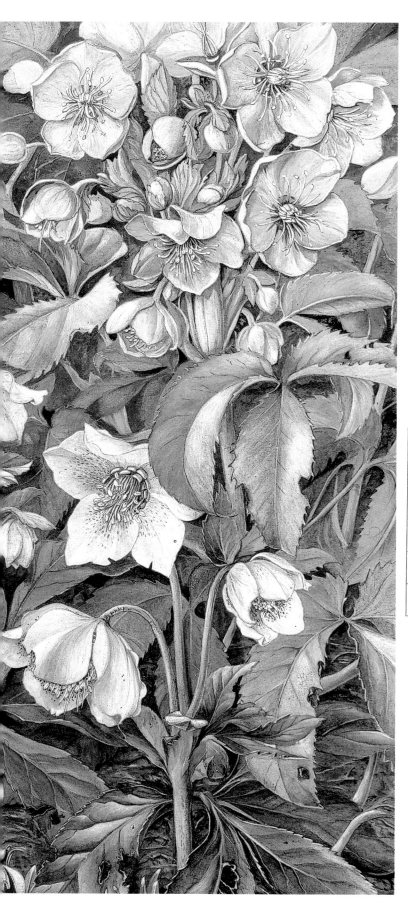

THE ART OF
BOTANICAL
PAINTING

IN ASSOCIATION WITH THE SOCIETY
OF BOTANICAL ARTISTS

MARGARET STEVENS VPSBA

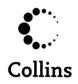

Collins

DEDICATION

For Suzanne Lucas and a Society built upon her vision

First published in 2004 by
Collins, an imprint of
HarperCollins*Publishers*
77-85 Fulham Palace Road
Hammersmith
London W6 8JB

The Collins website address is www.collins.co.uk

Collins is a registered trademark of HarperCollins
Publishers Ltd

10 09 08 07 06 05 04
10 9 8 7 6 5 4 3 2 1

**A catalogue record for this book is available from the
British Library**

ISBN 0 00 716988 4

Designer: Caroline Hill
Editor: Diana Vowles
Indexer: Ingrid Lock
Photographer: Richard Palmer

Colour reproduction by Saxon Photolitho Ltd, Norwich
Printed and bound by Printing Express Ltd, Hong Kong

Page 1 HIBISCUS
32 × 24 cm (12½ × 9½ in)
SUZANNE LUCAS FPSBA

Page 2 HELLEBORES AND SNOWDROPS
37 × 51 cm (14½ × 20 in)
MARTINE COLLINGS SBA

▷ SUNFLOWER
53 × 40 cm (21 × 15¾ in)
ANN SWAN SBA

CONTENTS

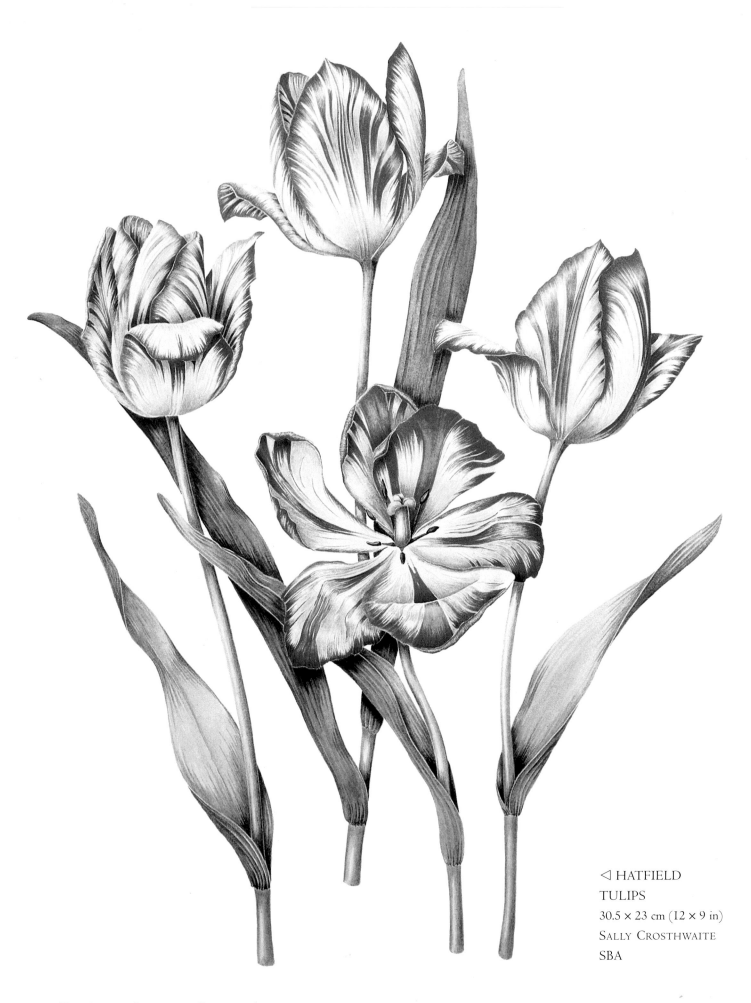

◁ HATFIELD
TULIPS
30.5 × 23 cm (12 × 9 in)
SALLY CROSTHWAITE
SBA

FOREWORD

I T IS A GREAT pleasure to be able to contribute the foreword to this magnificent new book by the Society of Botanical Artists. The history of botanical illustrations and the development of the science of botany have been intertwined for millennia, but especially since the Enlightenment the urge to document and understand the diversity of plant life has gone hand-in-hand with an escalation in the skills of generations of artists to capture the glory of the plants in a two-dimensional medium.

At the Royal Botanic Gardens, Kew, we have been fortunate to have been associated with some of the greatest names in the history of botanical art, from Francis Bauer, who lived at Kew in the late eighteenth century, to Walter Fitch and Marianne North in the mid-nineteenth century and to Mary Grierson, Margaret Mee, Margaret Stones, Stella Ross-Craig and many others in the twentieth century. The art of botanical painting continues even in the face of enhanced photographic technology and the digital revolution, for there is simply no substitute for the discerning talents of the artist in capturing the essence of plant form. For this reason the preparation of illustrations is as important today as it was a century ago.

Looking ahead to the future, what is perhaps most encouraging is the sheer popularity of botanical artistry. The urge to capture the exquisite beauty of plants – from flowers to their overall form and architecture – continues unabated. *The Art of Botanical Painting* provides further evidence, if any were needed, that botanical artistry in all its many guises continues to flourish. The Society of Botanical Artists is an important catalyst in this endeavour and all professional botanists wish it the very best of good fortune in the future.

Professor Sir Peter R. Crane FRS
Director, Royal Botanic Gardens, Kew

CHAPTER I

INTRODUCTION

T HE SOCIETY of Botanical Artists was founded in 1985 by Suzanne Lucas, a distinguished artist who was already President of the Royal Society of Miniature Painters, Sculptors and Gravers and a Fellow of the Linnean Society. This august body recognized the value of her work and portrayal of nearly four hundred species of fungi. The Royal Horticultural Society also acknowledged this marathon task (albeit a labour of love) by awarding a total of 13 Gold Medals to Suzanne for her artistry and accuracy.

We believe that at the time of its foundation it was the only society of its kind in the world, although other countries have followed our lead and societies now flourish in the United States, South Africa and Australia. Botanical artists in other European countries are less well-catered for. This is surprising when one considers the history of the art form and I hope that as we briefly explore this history it will go some way towards resolving the issue of whether it is truly art or, at best, illustration with a bent towards science.

▷ *LEPISTA NUDA*
29.5 × 48 cm
(11½ × 18¾ in)
SUZANNE LUCAS
FPSBA

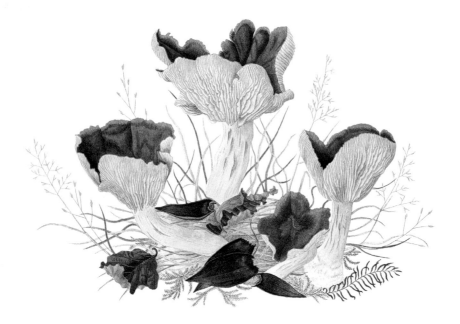

THE BEGINNINGS OF BOTANICAL ART

For the earliest decorative portrayal of flowers we should look to illuminated manuscripts and Books of Hours, the latter dating back to the mid-thirteenth century. Artists and calligraphers worked in monasteries across Europe to create jewel-like texts as devotional aids which gradually became objects of desire for the laity. Among the flowers depicted can be found roses, dianthus and chamomile as well as ivy, strawberries and even bulrushes, to name but a few.

Flowers were usually painted not just for their beauty but also for the symbolism attached to them. For example, in the fourteenth-century Wilton Diptych, which can be seen at the National Gallery in London, roses, iris and violets are scattered in a meadow, representing the purity, sorrows and humility of the Virgin, alongside daisies for innocence. The Madonna lily *(Lilium candidum)*, the flower most often used to symbolize the purity of Mary, appears as a fine growing clump in the fifteenth-century Ghent altarpiece by Hubert and Jan van Eyck.

Only the Portinari altarpiece by Hugo van der Goes is better known by botanical painters, since it depicts two of the earliest vases of flowers painted in Europe. They are filled with columbines, the dove of the Holy Spirit, *Lilium croceum*, the orange lily of the Passion, and again the iris and violets of sorrow and humility. This combining of spiritual meaning with earthly subjects would have seemed natural to the artists of the time since they had a greater sense of reverence for the whole of creation than that which is apparent in our more secular age. Perhaps botanical painters cling a little to the standards of the past by wanting to portray the true beauty of the plant without feeling the need to improve or change it for change's sake.

The earliest drawings of plants made with a scientific intent were collected together in the herbals which helped identify those plants with medicinal value. Since the drawings were copied many times by hand they were often changed

◁ CUCKOO FLOWERS AND COMMON GRASS *(Flos cuculi* and *Gramen vulgare)* 21 × 17 cm (8¼ × 6¾ in) MARIA SYBILLE MERIAN

▷ WHITE LILY *(Lilium album)* from *A Curious Herbal* 33 × 24.5 cm (13 × 9¾ in) ELIZABETH BLACKWELL

△ MAGNOLIA

50 × 35 cm (19¾ × 13¾ in)

G D Ehret

out of all recognition, so kill rather than cure could easily result. By the sixteenth century, the woodcuts and metal engravings which replaced this practice led to a more refined portrayal. Then, from the seventeenth century onwards, herbals were joined by florilegia, or collections of plant portraits, coinciding with the wealth of new plant varieties which flooded into Europe, including tulips. No doubt the portraits of that genus helped to fuel tulipmania, the frenzy that led to collectors paying enormous sums to acquire tulip bulbs.

Dutch and Flemish flower painters were kept busy producing the huge mixed bouquets which we still admire, although this form of botanical painting is rarely practised today. In fact, an idea seems to have become established which suggests that only the straightforward botanical study on a white ground is acceptable. This is not historically correct. Plants *in situ* and with landscape or other background go back at least to the early nineteenth century, at the same time as Pierre-Joseph Redouté (1759–1840) was continuing the classic style of the German botanical painter Georg Ehret (1708–70) which we tend to think of as the only form of botanical painting or plant portraiture. I suspect this way of thinking developed in reaction to the Impressionist style, where detail and accuracy was frequently sacrificed for effect. Obviously this was contrary to the whole ethos of botanical art, where the formal style arose from the need to identify plants accurately at a time when many explorers, often accompanied by an artist, were sailing around the world and returning with new seeds and dried specimens.

THE RISE OF FEMALE ARTISTS

Botanical painting was considered to be a man's job as these artists often faced great hazards, although strong-minded women had always made a name for themselves. One such was the Dutch artist Maria Sybille Merian who, in 1685, left her husband and went to live in a

commune for a number of years. In 1698 she took her younger daughter, Dorothea, to Dutch Surinam where she recorded the exotic flowers and insects of that South American country.

In the 1730s Mrs Elizabeth Blackwell produced *A Curious Herbal*, working at the Chelsea Physic Garden to record medicinal plants while her doctor husband, Alexander, languishing in a debtors' prison, helped her with the text. Upon publication it made enough money to obtain his release. Sadly, whatever happiness they might have enjoyed did not last. Dr Blackwell went from one dubious scheme to another and was eventually beheaded after being found guilty of treason.

Gradually, throughout the nineteenth and twentieth centuries, female botanical artists replaced and now far outnumber males, probably helped by the Victorian promotion of flower painting as a ladylike pursuit, while a man might believe it to be an insufficiently macho occupation. Thankfully some men know better, as illustrations in this book will prove.

THE MODERN DAY

To sum up, at the start of the twenty-first century the Society of Botanical Artists exists to carry forward a great artistic movement. At our annual exhibition in London, provided they are botanically correct, we show paintings in a variety of styles from the classic plant portrait on a white ground to those with backgrounds, *in situ* or in vases. This book draws on the combined expertise of the members of the Society, many of whose paintings are included and many more of whom responded to my initial questionnaire, giving their opinions on materials, methods and techniques. It is my hope that the aspiring botanical artist will benefit from these collective skills in a way which is impossible from just one tutor.

For those who wish to learn more of the history of botanical art and the fascinating characters who practised it, titles for further reading are listed at the end of the book.

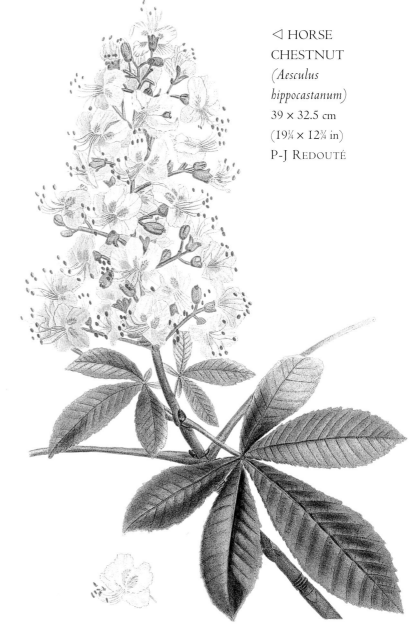

◁ HORSE CHESTNUT (*Aesculus hippocastanum*) 39 × 32.5 cm (19¼ × 12¾ in) P-J REDOUTÉ

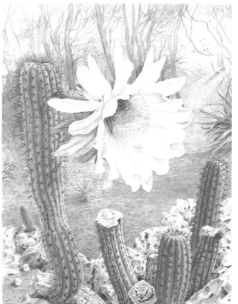

◁ TORCH THISTLE (*Cereus*) 23 × 18 cm (9 × 7 in) MARION PERKINS SBA

The torch thistle's common name comes from the torch-like appearance of the young growth. The combination of scorching midday sun, parched earth and this beautiful bloom persuaded Marion to show the background when she encountered the plant at the Botanical Gardens in Majorca.

CHAPTER 2
MATERIALS

Tᴴᴇʀᴇ ɪꜱ ᴀɴ old saying that runs, 'Bad workmen always blame their tools.' It is to be hoped that this is something that does not apply to the aspiring botanical artist. Buy the very best quality materials that you can afford and the difference in your work will soon become apparent. Artists' watercolours will contain more pigment and less 'filler' than Students' grade, allowing you to mix richer colours with easier handling. Good papers will do justice to the paint by enhancing colour rather than deadening it by absorption. Although they may seem expensive to purchase at the outset, good sable brushes will in fact repay you many times over by their handling performance and the greater longevity they possess.

Work in progress, showing my preferred working layout with water pot and kitchen paper ready to absorb excess water or paint. Plant material will be positioned to give easy viewing.

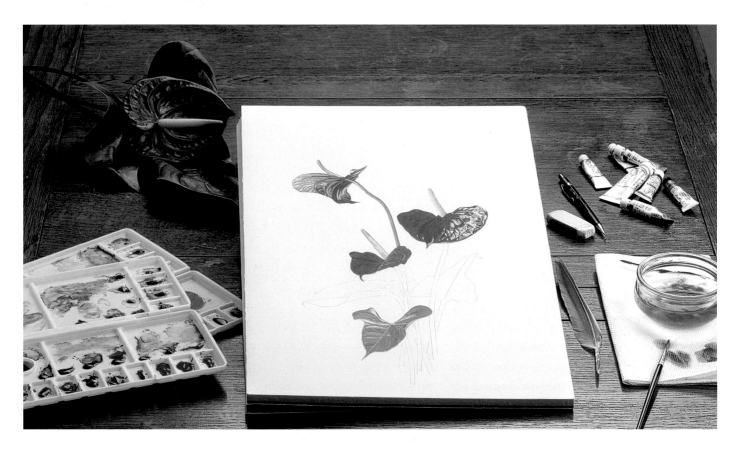

PENCILS, PENS AND ERASERS

Graphite pencils are superb for producing monochrome work. Ordinary 'lead' pencils, where the graphite has been mixed with clay, are better for the initial outline drawing before painting, as you need the line to be clear but unobtrusive and easily erased. Grades F, HB or H are ideal; softer Bs are too black and can contribute to a dirty finish. Be aware, though, of the differences between various manufacturers' grades of pencil. Mechanical pencils such as those made by Pentel are my choice, particularly with a 0.3 mm lead which gives the line I want.

Equally useful for drawings, this time in ink, is the Edding 1800 Profipen series, with 0.25 mm, 0.35 mm, 0.5 mm and 0.7 mm tips. The black ink is waterproof, light-fast and dries immediately.

Some artists are afraid to use an eraser, believing that it will damage the surface of the paper. No doubt some will do so, but not the Staedtler Rasoplast, which is a good-quality plastic eraser. Gently rubbing over a line will remove it cleanly and without harm. You can also 'blot' an over-dark line to lighten it and the eraser is easily cleaned on scrap paper or recut in order to give it a sharp edge for altering intricate areas.

You will need to keep a sharp point on your pencils at all times if your drawing is to be crisp, so a good pencil sharpener is essential. Electric models give a needle point but wear away your pencils very quickly.

PAPER AND OTHER SUPPORTS

SBA members have their favourites, mostly preferring hot pressed (HP) or satine finish papers which have been sized to give a beautifully smooth surface. Arches HP or satine finish, 100 per cent cotton conservation-quality paper with a slight ivory tone is popular. Saunders Waterford 100 per cent cotton acid-free conservation paper, Bockingford, Winsor & Newton, Lana and Schoellershammer all have their champions and it is obviously a matter of personal choice. However, you have to start somewhere and as a tutor I recommend that students use Arches. If working on a smooth surface is too much of an initial challenge, a move to Fabriano cold pressed (Not) paper soon increases confidence. The medium-grain surface of this paper will often enhance the subject, where, for example, there is texture in leaves such as those of buddleja.

No matter how talented the artist, his or her work will not look its best on cockled paper. The ways of avoiding this are simple. Buy a sufficiently heavy paper for the subject you intend to paint – 300 gsm (140 lb) is most often used – and if in doubt stretch the paper (see p. 72). Alternatively, if the work is of a fairly moderate size, paper on a block is unlikely to be troublesome unless, again, you need a heavier paper or you are using an excessive amount of water.

△ WATERLILIES
33 × 35.5 cm
(13 × 14 in)
Oil
ANTHEA MONCHER
DUNKLEY SBA

Here a difficult subject has been handled successfully in oil paint so that the lily pads really appear to float among the gleaming flowers. The 'wetness' of the water has not been overdone, with just enough highlights and droplets to create the right effect.

▷ *TILIA EUROPEA*
20 × 15 cm (7¾ × 6 in)
Oil
Iris Huckvale SBA

Iris uses oil paint with all the delicacy of the miniature artist to capture the brittle beauty of a dry leaf. Polymin is an excellent substitute for ivory and handles in a very similar fashion.

The ultra-smooth surface of Bristol Board or Schoellershammer 4G is generally too difficult for the inexperienced artist as it requires the time-consuming technique of the miniature painter, with a slow colour build-up and much stippling and hatching.

Vellum also requires a certain expertise. The ability of this natural material to project glowing colour is second to none, but it is expensive. You cannot use an eraser on it and it must not become too wet, so it is best left until you have reached a degree of proficiency. Polymin, a popular choice of miniature painters and one of several substitutes for ivory, is a cheaper alternative and a way to test yourself in the required techniques, that is, very controlled brush strokes and only a little water. It is also suitable for oils and acrylics.

WATERCOLOURS AND OTHER MEDIA

Brands favoured by botanical artists include Winsor & Newton, Schmincke, Daler-Rowney and Holbein, but virtually all makes find a place in someone's box, provided they are Artists' quality and not fugitive, meaning not likely to fade in the light. Although no watercolours should be hung in strong or direct sunlight, some pigments are more prone to fading than others so take care to check them against the manufacturer's shade card. However, the range available today is so great that this does not pose a great problem.

Whether to use tubes or pans is largely a matter of preference. Contrary to common belief, paint squeezed from the tube onto the palette does not need to be wiped off in the same way as oil paint. Of course it will harden a little but no more than paint in pans, and water will soon make it usable again, even months later.

Hinged palettes are ideal since these give some protection from dust when closed. Metal palettes are more expensive but worth the extra; in summer the paint sometimes becomes difficult to mix on plastic, which seems to react to hot weather. Empty paint boxes are also available and these can be fitted with pans of your choice or filled from tubes.

Although watercolour is the most usual medium for the botanical artist, some prefer to work in gouache. Artists' quality is preferable to Designers', being of a more lasting quality. Acrylics, particularly Daler-Rowney and Chroma, the acrylic developed for the animated film industry with a very wide range of colours, also finds favour with some members.

Pastels, although not suitable for individual flower studies, are excellent for garden or outdoor scenes, showing flowers in their natural habitat. Oils, of course, have been used to portray flowers, fruit and vegetables since the days of the great Spanish and Dutch still-life artists.

In recent years coloured pencils have become increasingly popular, following a trend set in the United States. Karisma, Derwent and Lyra are all excellent and the range of colours is vast. The technique used is similar to that of the watercolour or miniature painter but these pencils are used dry and should not be confused with wet watercolour pencils, which are not generally used by the botanical artist. Equally

◁ A BOWL OF
MIXED FLOWERS
25.5 × 30.5 cm
(10 × 12 in)
Acrylic
PAMELA DAVIES FSBA

This traditional study of
pink and white flowers,
softened with fern,
shows the delicacy that
can be achieved with
acrylics. Pamela has
mastered their use to a
fine degree and her work
is greatly sought after.

important, they should not be thought of as like the crayons from schooldays. Believe me, there is absolutely no comparison. The pigments are the same and have the same light-fast qualities as those in watercolour.

Colour can be removed using clear plastic film laid over the drawing. Pressing a sharp pencil into it will lift off the layer of colour beneath – a useful technique for showing veins. A putty eraser or a plastic eraser cut to sharp angles is also handy.

A make-up brush or large feather is useful for removing pigment dust from the surface of the paper. Do not smudge it by brushing with your hand.

BRUSHES

Brushes are the essential tool upon which so much depends. Nothing beats sable for longevity and Kolinsky sable is best, with red sable as runner-up. Look for a fine point, good paint-holding capacity and 'spring', where the brush moves with the flow of the stroke but retains its point and the hairs do not separate.

Among those recommended are Winsor & Newton Series 7, Daler-Rowney Diana (sadly, hard to find but well worth a search) and Da Vinci Maestro. Miniaturists' brushes are also much used for fine work. The most popular sizes range from 2 to 6, and I often use an 8 for larger leaves and petals. Remember that it is the point that is all important. Store brushes carefully where air can circulate and *never* allow them to stand in the water pot.

Not everyone is lucky enough to live near a good art shop but if you do, please patronize it. If not, there are excellent mail order companies and some, such as Great Art, serve the whole of Europe. Their catalogue is the size of a telephone directory and is full of information on thousands of products. Cheap Joe's Art Stuff provides a similar service in the United States and will supply goods internationally.

CHAPTER 3
PLANT ANATOMY FOR A PAINTER

WRITTEN BY ALISTER MATHEWS SBA

For most botanical artists, the plants that they will be most enthused by, at least initially, will belong to the class of plants that produce true flowers, the Angiospermeae, of which there are about 250,000 species worldwide. What a treasure trove of material for the budding artist to be tempted by; as flowering plants survive in some of the harshest habitats on earth, there should always be something intriguing to paint.

Although, theoretically, every good artist should be able to observe accurately and even with minimal botanical knowledge create an excellent drawing or painting, an insight into basic plant anatomy should make the process far more interesting and enjoyable. Having a good grasp of the plant's specific features will allow you to paint a more imaginative composition while still remaining true to its characteristics. A simple hand lens and scalpel or razor blade can be invaluable aids to close examination of the plant.

THE FLOWERING PLANTS

If you spend any time in the countryside you are bound to be impressed by the sheer number of plants and their amazing diversity in size, shape and colour. In most parts of the world, the vast majority of plants seen in the wild will be flowering plants, the angiosperms.

Flowering plants usually consist of a portion above ground – the shoot, with a stem bearing leaves, buds and flowers – and, below ground, the root system. However, there can be many modifications and adaptations so that not every structure below ground is necessarily a root; for example, a potato is a stem tuber, a bulb is a compressed shoot and a rhizome is an elongated underground stem. Even the parts that are growing above soil level may not be quite what they seem. Leaves may be modified as tendrils, spines, scales or even a means of catching insects for food.

Roots, in addition to their normal function of absorbing water and mineral salts from the soil, can be storage organs, for example in celandine, carrot and dahlia, or adapted for climbing as in ivy. Special roots can act as a buttress system such as in maize, or absorb water from the atmosphere as in epiphytic tropical plants such as some orchids. Peas and beans house nitrogen-fixing bacteria in root nodules and some plants, for example broomrape, are parasitic, absorbing all their food from others.

◁ *LILIUM NEPALENSE*
42.5 × 28 cm
(16¾ × 11 in)
Watercolour and pencil
Joanna Craig-McFeely SBA

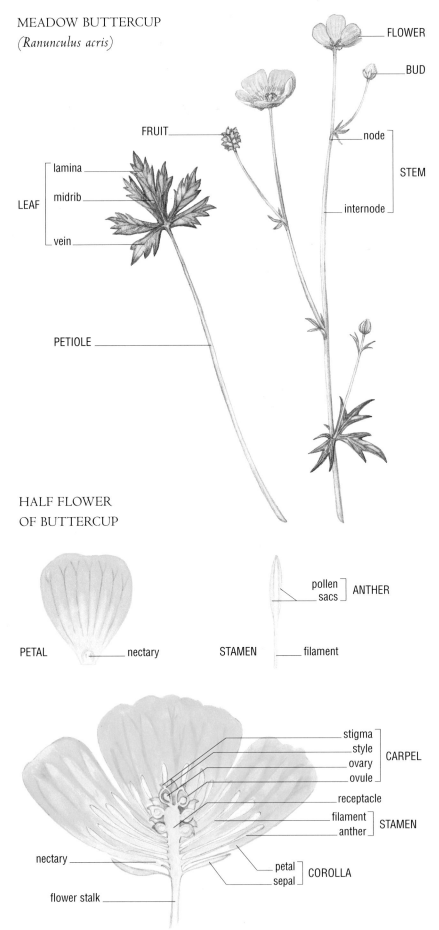

MEADOW BUTTERCUP
(*Ranunculus acris*)

FLOWER

BUD

FRUIT

node

STEM

LEAF

lamina

midrib

vein

internode

PETIOLE

HALF FLOWER
OF BUTTERCUP

pollen
sacs — ANTHER

PETAL — nectary

STAMEN — filament

stigma
style
ovary — CARPEL
ovule

receptacle

filament
anther — STAMEN

nectary

petal
sepal — COROLLA

flower stalk

FLOWER STRUCTURE

Flowers evolved from spore-bearing shoots supporting four types of structures arranged in spirals or whorls around a central flower stalk, the receptacle. Starting from the outside, these structures are:

● The sepals, a series of modified, usually green, bracts or leaves which act as protection for the inner parts of the flower and are collectively called the calyx;

● The petals, another series of modified bracts or leaves, making up the corolla. They are usually coloured in order to attract pollinators. Many petals have dark lines or dots, known as honey guides, to direct insects towards the nectaries;

● The stamens, which are the male organs. Each stamen consists of pollen sacs forming the anther and a supporting stalk, the filament. The male parts are known as the *androecium*;

● The carpels, the female organs, which are composed of an ovule or ovules encased within the ovary and a style bearing the stigma upon which pollen collects during pollination. These female parts are collectively known as the *gynoecium*. The name angiosperm derives from the fact that the ovules are contained inside an ovary as opposed to the gymnosperms, where they are not, such as in cycads and conifers, for example.

POLLINATION

The function of flowers is to produce seeds, and all the floral parts have been modified over millions of years to achieve precisely this end. Each type of flower has evolved to attract its own specific pollinators, be they insects, birds or bats, enticing them by sight or smell or both so that they can locate the nectar that is a rich food source for them and, in the process, inadvertently carry pollen to other flowers of the same type.

Wind-pollinated flowers need no showy-coloured parts, perfume or nectar to attract pollinators; in fact, the more reduced and

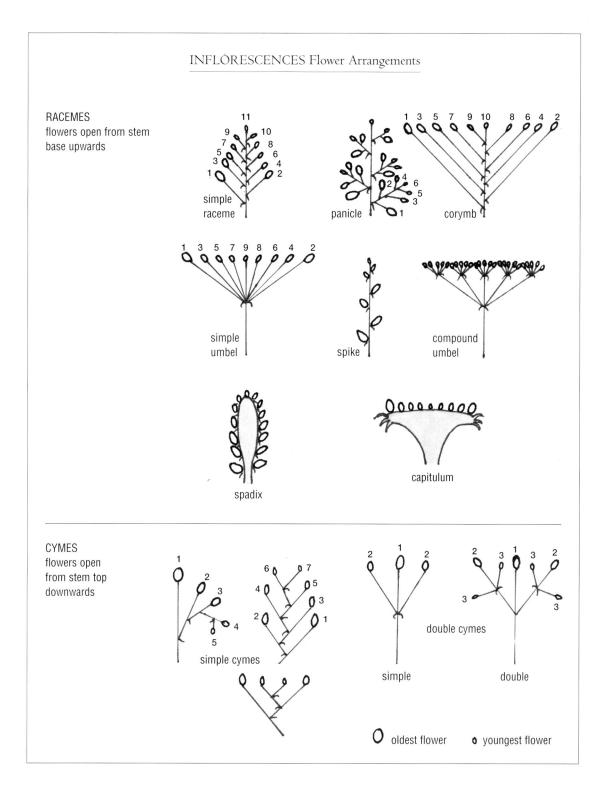

RACEMES
flowers open from stem
base upwards

simple
raceme

panicle

corymb

simple
umbel

spike

compound
umbel

spadix

capitulum

CYMES
flowers open
from stem top
downwards

simple cymes

double cymes

simple

double

⦰ oldest flower ⦰ youngest flower

minimalized their structure the more effective their pollen dispersal and collection. Usually the anthers produce vast quantities of light, dry pollen and dangle out of the flowers on long, flexible filaments, while the stigmas have a huge, often feathery-looking surface area to catch the airborne pollen grains, for example grasses and many trees.

A flower stalk can bear one single flower or many, forming an inflorescence. The parts of individual flowers can be radially or bilaterally symmetrical in their arrangement and their overall shape adapted for specific pollinators. They may be open and shallow with easy access for short-tongued insects, or semi-closed or tube-like for long-tongued insects or birds.

LEAVES

It is sometimes claimed that the ability to paint and draw leaves well, rather than flowers, is what makes the difference between a good and an excellent botanical artist. Leaves are the plants' food factory, producing carbohydrates by the process of photosynthesis. The green pigment chlorophyll absorbs energy in the form of sunlight and uses it to chemically combine carbon dioxide from the air with water absorbed by the roots to make soluble sugar which can then be converted into insoluble starch and other products and subsequently stored as a potential energy source.

In many leaves the chlorophyll is not apparent since other purple, red and orange pigments mask its colour, such as in copper beech, red maples and zonal pelargoniums. Variegated leaves simply have an absence of chlorophyll in some areas which appear white or cream.

Leaves are usually flat, with a thin blade or lamina supported by a central midrib from which large veins branch, forming a dense network of ever-smaller veins, so ensuring rapid passage of water and food to all parts. This can be seen by holding a thin leaf up to the light or finding a leaf 'skeleton'. Making an accurate drawing of this vein structure can be challenging. Pitfalls for the artist include failing to connect the veins to one another; not distinguishing sufficiently between small and large veins; and not showing the vein pattern towards the leaf margin.

The leaf stalk, or petiole, is a continuation of the midrib which by twisting and turning controls the position of the lamina so that light falls approximately at right angles for maximum efficiency. Watch out for leaves realigning themselves during the course of painting a picture if the light source is altered.

For structural strength and protection and to counteract evaporation, the upper surface of the lamina secretes a waxy cuticle, thick and tough in, for example, camellias, laurels and hollies, or thin where leaves are less prone to dehydration. Many leaves have other adaptations such as hairs, the ability to roll up or very reduced surface area to restrict water loss. It is a challenge for an artist to depict different surfaces. Generally, tackling shine, highlights, hairiness and other textures takes a great deal of practice and can pose many problems.

A simple leaf is one where there is a petiole and a single lamina, whereas a compound leaf has a series of leaflets attached to a central rachis which in turn is joined to the petiole and so to the stem. Sometimes small structures, known as stipules, form at the point where the petiole joins the stem.

An axillary bud is found only in the angle between the upper side of the petiole and stem, so when you are painting, for example, a tangle of trailing clematis shoots, you can determine which is the top and bottom of a stem, even though the petioles have rotated the laminas to face upward.

As far as leaf shapes, margins, venation and attachment is concerned, there is an almost infinite variety, each with its correct botanical term. The prospect of memorizing them all is a daunting one, and it is not strictly necessary to do so in order to paint leaves well.

▷ COMMON OAK
(*Quercus robur*)
5 × 10.5 cm (2 × 4½ in)
Watercolour
ALISTER MATHEWS SBA

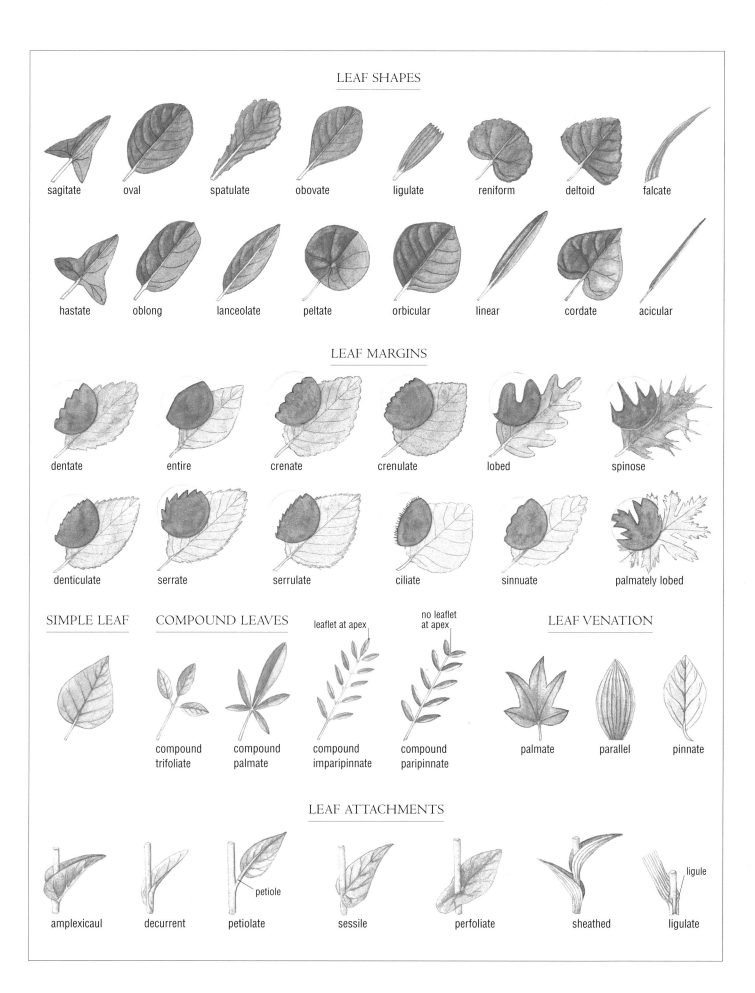

LEAF SHAPES

sagitate · oval · spatulate · obovate · ligulate · reniform · deltoid · falcate

hastate · oblong · lanceolate · peltate · orbicular · linear · cordate · acicular

LEAF MARGINS

dentate · entire · crenate · crenulate · lobed · spinose

denticulate · serrate · serrulate · ciliate · sinnuate · palmately lobed

SIMPLE LEAF

COMPOUND LEAVES

leaflet at apex

no leaflet at apex

LEAF VENATION

compound trifoliate · compound palmate · compound imparipinnate · compound paripinnate

palmate · parallel · pinnate

LEAF ATTACHMENTS

amplexicaul · decurrent · petiolate

petiole

sessile · perfoliate · sheathed · ligulate

ligule

CHAPTER 4
DRAWING TECHNIQUES

THE ART OF drawing is a discipline, considered by most botanical painters to be essential in the pursuit of the perfect flower portrait. To draw is to see, because nothing else will force you to study your specimen as carefully and from all angles. It will make you aware of the plant's structure and will help you to decide how best to place it on the paper. By sharpening your powers of observation you will notice details that are easily overlooked with just a cursory glance – but make sure that you draw only what you can see, not what you know about the plant as a whole. Observation and the three 'Ps', Patience, Practice and Perseverance, should be your guiding principles.

If you truly want to produce quality work, be prepared for many hours spent in pursuit of your goal – and that means many hours seated in front of your drawing board, often in one position because moving would alter your view of your subject. This can play havoc with your back, neck and shoulders, so apart from equipping yourself with a comfortable chair and a desk or table at the right height, make sure that you get up and move around at least once every hour.

As you work, rest your hand on another piece of paper to avoid smudging and cover completed areas with clean paper. Avoid rubbing out, especially in the later stages. Instead, dab out with small, shaped piece of putty eraser.

▷ *AMANITA MUSCARIA* WITH BIRCH LEAVES
30.5 × 23 cm (12 × 9 in)
Pencil and watercolour
VICKIE MARSH SBA

A page from Vickie's sketchbook, where a pencil drawing is enlivened by adding a watercolour wash.

BEGINNING TO DRAW

To start with a basic outline before painting, let us assume that you have a single gerbera in front of you, with a moderately long stem and daisy-like flower. It is facing you so, without a tilt, there is no need to worry about foreshortening at this stage.

First, you must decide where to place your drawing on the paper. With a pencil, lightly mark it at the halfway point and in half again. The flower will be best positioned in the lower part of the top section.

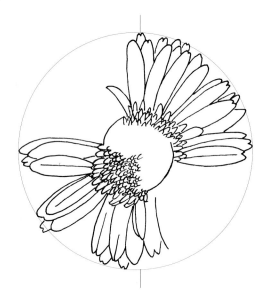

▷ Diagram I
Working around a 'clock face' will help you to deal with many-petalled *Compositae* flowers.

Measure the bloom vertically and horizontally and mark the paper accordingly. Then measure the centre of the flower in the same way. If it helps, lightly sketch in a rough circular outline and another for the centre. Now imagine your flower has a clock face and draw in the petals that you see at 12, 3, 6 and 9 o'clock. These will be your focal points and by breaking down the flower into sections you will be less confused by the multitude of petals. Now, using the pencil of your choice, be it mechanical or an F lead pencil, lightly draw in each set of petals around the clock (see diagram I). Do not use short sketching strokes but keep the heel of your hand resting on a piece of paper kitchen towel or scrap paper, so that the line becomes confident and unbroken.

Repeat this for the flower centre and any tiny petals that may surround it. It will help if you examine the structure of the centre and the way the petals are attached through a magnifying lens (see diagram 2).

◁ Diagram 2
Use a magnifying lens to gain understanding of a flower's structure even if you are not intending to draw in such a complex fashion.

Measure the width of the stem and draw it, making sure that it links to the centre of the flower even though it is not in view. Failing to check this is one of the most common mistakes; another is neglecting to draw the stem accurately.

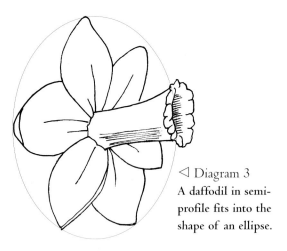

◁ Diagram 3
A daffodil in semi-profile fits into the shape of an ellipse.

Drawing a daffodil presents the largest problem for many people. Remember that unless you are looking it in the face, directly into the trumpet, the pencil outline will be an ellipse rather than a circle, and the tips of the petals should touch this (see diagram 3). Obviously, if a petal is furled this may not be the case in practice but you have to consider the unfurled petal. The stem, too, must join and be in line with the centre of the trumpet or cup (see

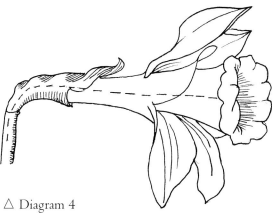

△ Diagram 4

Always ensure that the central line of a flower follows from the stem through the tube, no matter which way it is turned. This applies to all flowers, as a misdrawn stem spoils many a painting.

diagram 4). When the flower is in three-quarters profile, so that the tube is hidden, extra care needs to be taken. However good the painting, a basic error here will make it worthless, so always get it right at the drawing stage.

MULTI-PETALLED FLOWERS

Multi-petalled flowers can be very confusing. I showed my art group a *Camellia incarnata* and asked them what shape they saw, expecting them to say a circle, so I was pleased when they thought

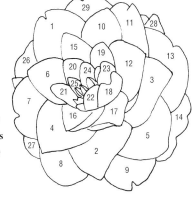

▷ Diagram 5
A camellia with numbered petals shows the order in which they were drawn.

it was a triangle. In diagram 5 I have drawn this camellia and numbered the petals in the order in which I drew them. Several triangles are obvious: numbers 1, 4 and 3; 1, 8 and 13; and, of course: 1, 2 and 3. I chose this one because the lower petal, number 2, is at six o'clock.

While the same clock face method is helpful, in the case of multi-petalled flowers such as old

roses or carnations look for petals which have an individuality, perhaps an indentation or a crease. By positioning them in the early stages you can plot the other petals more easily. Always try to relate the position of one petal to another. All this becomes second nature with practice and I cannot emphasize enough how important it is to try to draw every day, even if only for half an hour. Even doodling while speaking on the telephone can help. Try drawing repeated treble clef signs or scrolls – anything that requires smooth movement from the wrist. Also practise long, sweeping lines such as you need for stems or leaves such as those of narcissi. See how accurately you can draw two parallel lines, another area for error when depicting long-stemmed flowers. This may all sound very basic but it will help build your confidence and the fluidity of your line.

CREATING TONE

The technique for hatching or cross-hatching (see diagram 6) is of importance for both pencil and ink illustrations and when drawing with the brush, which we will come to later in Chapter 6. The spacing of the strokes determines the density of shading.

△ Diagram 6
A *Clematis montana* drawn with a 0.3 mm Edding Profipen, with hatching and cross-hatching moulding the contours of the petals.

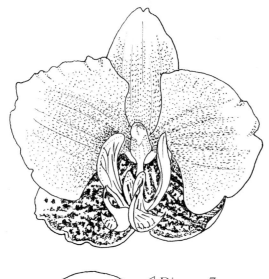

◁ Diagram 7a
This is an example of bad stippling, haphazardly done.

The same applies to stippled dots, a very popular method for illustrators. Extra rows of dots can be applied to darken a given area. Remember that dots are actually broken lines, and as such will only look good if they are applied in lines with the pencil or pen held fairly upright. If there is a conspicuous line or vein, such as is seen on some orchids, always draw this in before stippling. Drawn after, it will look quite wrong. Apply the dots to follow the growth or curve of the leaf or petal (see diagram 7). If you stipple haphazardly the result will be a mess (see diagram 7a).

FORESHORTENING

The anthurium, with its simple structure of spathe and spadix, is a good example on which to try foreshortening. I turned the plant so the flower was in profile and measured it as shown in diagram 8. Then, with the flower turned towards me, I measured it again, keeping the ruler upright, from the point where the spathe was nearest to me, that is, from its tip to the top of the spadix. In diagram 8a you can see that the 3 cm (1¼ in) spathe has reduced to 2.5 cm

(1 in). It is foreshortened by tipping to the horizontal. Likewise the spadix in profile is clearly tilted forward but has increased in length when tipped towards the vertical. Diagram 8b shows the true size of the spathe. You will see that the 3 cm (1¼ in) profile measurement is actually 5.9 cm (2⅜ in) and even the width has increased to 7.9 cm (3⅛ in).

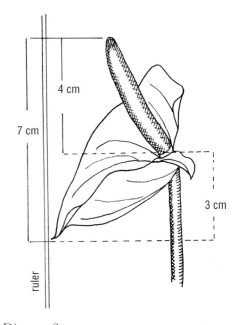

△ Diagram 8
The side view of an anthurium with measurements to demonstrate foreshortening.

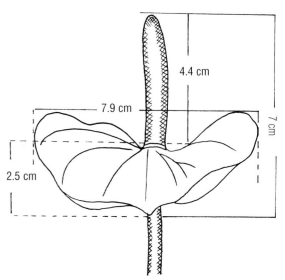

△ Diagram 8a
Front view with the anthurium in a more upright position and the corresponding change in the measurements.

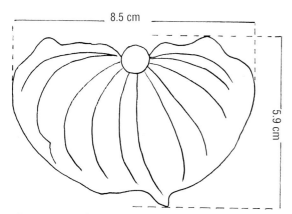

△ Diagram 8b
The true size of the spathe.

This is the basis of all foreshortening; the vertical measurement will change according to the angle of tilt. Any object will prove this. Hold a coin at eye level and it is circular; tilt it and it becomes an ellipse; tilt it again to the horizontal and you can see only the edge. It would be exactly the same, barring differences in shape, were it a leaf or petal. One very important point: always take your measurements from the point which you fixed initially, that is the part of the plant, be it leaf or petal, which is nearest to you. It will give you automatic perspective as those parts set further back are bound to measure less and appear smaller. Returning to diagram 8a, the true length of the spadix was 5.5cm, not 4.4 cm, which gives you an example of a foolproof method.

Obviously, the ruler must be held upright and not tilted, which would distort the perspective. Trust your measurements rather than your eyes.

Time spent drawing is never wasted, so keep at it and your confidence and skill will increase steadily. Do not throw away your early drawings; you will be glad to look back on these one day.

▷ *CORNUS NUTTALLII*
35.5 × 43 cm (14 × 17 in)
Graphite
MARTHA G KEMP OVSBA

A precise and accurate graphite drawing which conveys, without colour, the form and beauty of the specimen.

▽ PUMPKIN
(*Cucurbita*)
70 × 100 cm (27½ × 39½ in)
Pencil
MARTA CHIRINO OVSBA

Its textural interest made this pumpkin the subject of pencil study.

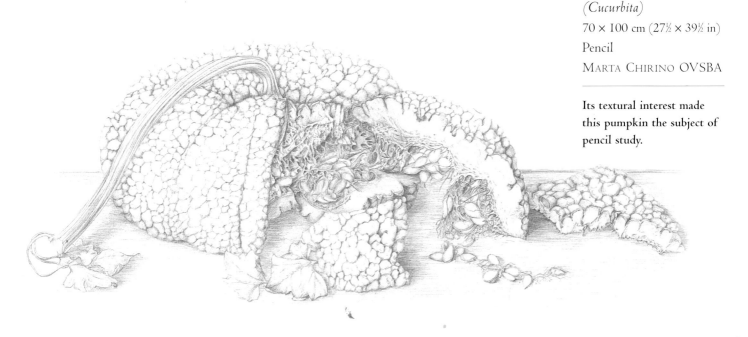

STREPTOCARPUS
Streptocarpus primulifolius

Julie Small SBA

This plant's texture and architectural structure made it ideally suited for portrayal in pencil. The composition aims to show the plant in various stages of growth and from different angles. It is important to show top and bottom leaf surfaces, particularly in a plant of this type where the large leaves have many undulations which catch the light. The intricate pattern of veining on both upper and lower leaf surfaces, coupled with the overall covering of fine hairs, added to its attraction.

PENCILS

FABER-CASTELL
9000 2H, H, HB, B and 2B

SCHWAN STABILO
Micro 8000 B, 2B and 4B

SURFACE

FABRIANO
Classico 5 HP 300 gsm (140 lb)

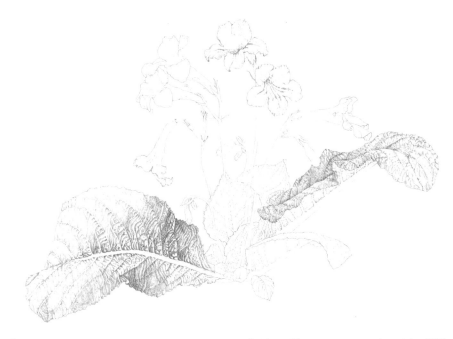

△ **Stage I**

Start by measuring the length and width of the flowers, the distances between petals, the position and number of sepals at the base of the flower and the stem width immediately below the flower.

Draw the flowers, using a sharp H pencil and a very light touch. At this stage the line must be clear but not too dark. Use an F or HB if you find H is too hard to see, but lightly. Keep a putty eraser broken into pieces on hand to remove any errors.

Use a sharp HB pencil to draw the leaves. Mark out the midrib and measure the length and width of the leaf and also the main veins,

which will act as a good guide. When you are plotting the main veins leading from the midrib, note how they bend away due to the curve of the leaf, or disappear behind a fold. It is sometimes useful when you are making a study of such a complex leaf to draw in some eye-catching detail along a vein which will act as a focus for your eye and save you becoming lost as you look up and down.

Keep your pencil work light so that correction is easy. Be aware of where the flower stems originate, either in front of or behind the leaves. This will eventually give depth to the picture and avoid an empty central space or stems criss-crossing.

Draw in the underside of the leaves in H grade, again marking the midrib and main veins, noting any curves and the distances between them.

With the outline complete, check your light source – in this case it is from the right-hand side. Using an H pencil, lightly shade in the deepest areas of shadow on the flowers and any folds on the petals. With an HB pencil, define the stripes leading from the throat of the flower, noting any undulations and width variations. Be accurate, for these act as a useful guide to the trumpet shape. Always make your pencil strokes follow the contours of the flower.

Shade in the sepals using an HB pencil, slightly darkening the side away from the light. Do not worry about the stem at this stage except for noting any shadows below the flower heads for about 2 cm (1 in).

Moving on to the leaf, plot out those areas that immediately catch the eye and use these as a focal point to work from – in this case the 'cushions' along the midrib and main veins and the fold along the leaf (screw up your eyes to help you distinguish the main shadows). Concentrate on plotting areas of deepest tone, using an HB pencil. Leave any highlights alone, as well as the midrib and main veins, focusing only on the obvious raised 'cushions' either side of the midrib, noting their individual areas of shadow and deeper shadows in the leaf folds.

Use a variety of small elliptical strokes on the raised areas. When working along the areas between a leaf vein, towards the outer edge and away from you, make small, slightly straighter pencil strokes (on a more vertical axis), as these areas are less defined and appear flatter. These will later have the appearance of hairs. Do not press down hard and be prepared to vary your strokes. You may need to use ellipses, short straight strokes or cross-hatching.

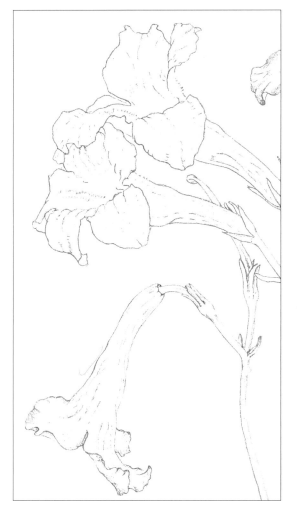

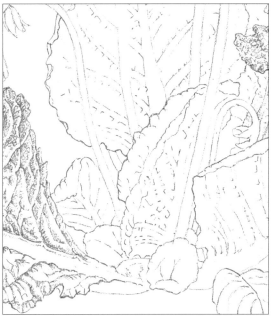

◁ Details of Stage 1

Far left: The flowers are lightly drawn, making sure stems follow the line of the tube.
Left: The origin of the stems before and behind the leaves is carefully noted.
Below: The fold in the leaf gives a focal point from which to note the changing depth of shadow on the cushions.

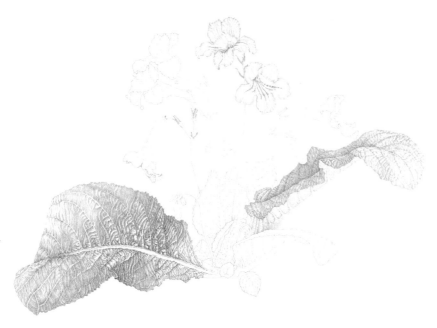

△ Stage 3

With a 2H pencil, shade in the flower petals using continuous tone and a light, delicate touch. Use an H grade for deeper tone near the edge of the petals and where they overlap. With a curved stroke, shade the bottom of the petals near the top of the throat. This helps to show up the tubular shape. Use an HB grade to emphasize stripes leading from the throat and the darker areas behind the stigma and style where visible.

Shade down the side of the stem away from the light, using an H pencil and light, slightly curved, semi-elliptical strokes. Take the shading approximately halfway across the stem.

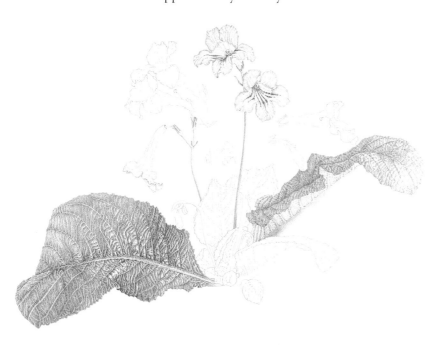

With the leaves, the aim is to emphasize the areas of deepest shadow along the main veins on either side of the midrib and where the leaf folds. Using a B pencil, shade between the main veins, away from the more pronounced areas, keeping the strokes small and fairly straight to give the impression of a downy surface, especially where the leaf bends away from you. With a 2B, build up the tone around the little 'cushions' near the midrib and emphasize the main fold. Leave highlighted areas alone. Small circular pencil marks are required to suggest leaf pores.

Use an HB to blend or shade where tones are less dark away from the midrib. Begin to mark out shading on the midrib.

Treat the upper surface of the leaf on the right in a similar way, beginning with the area furthest away from you, using a B pencil and short strokes. Move to a 2B as the tone deepens near the hidden midrib. The nearside of the leaf needs an HB to emphasize the raised 'cushions'.

On the under-surface of the leaf, where the veins are pronounced and hairy, short pencil strokes are required. Use an H pencil to pick out the pattern of hollows between the main veins. Observe and carefully shade the sides of the veins which have a deeper tone. Shade the midrib with an H, initially with short strokes, then pick out with an HB any obvious deeper tones near the base of the leaf or where it curves round.

◁ Stage 4

Continue to build up the tone on the petals, using a sharp B pencil then 2B on the flower markings. Deepen the stems using HB, B and a sharp H pencil to draw the hairs (note how they emerge from the stem).

Continue to build up the tones of the leaf. Julie used Schwan Stabilo Micro 8000 B, 2B and 4B pencils, which are soft, smooth pencils very useful in these latter stages. An H pencil was used to soften the edges of highlights and depict the hairs on the leaf margin. The under-surface was completed using Faber-Castell HB, B, 2B pencils, keeping the pencil strokes short and deepening the tone lower down the stem.

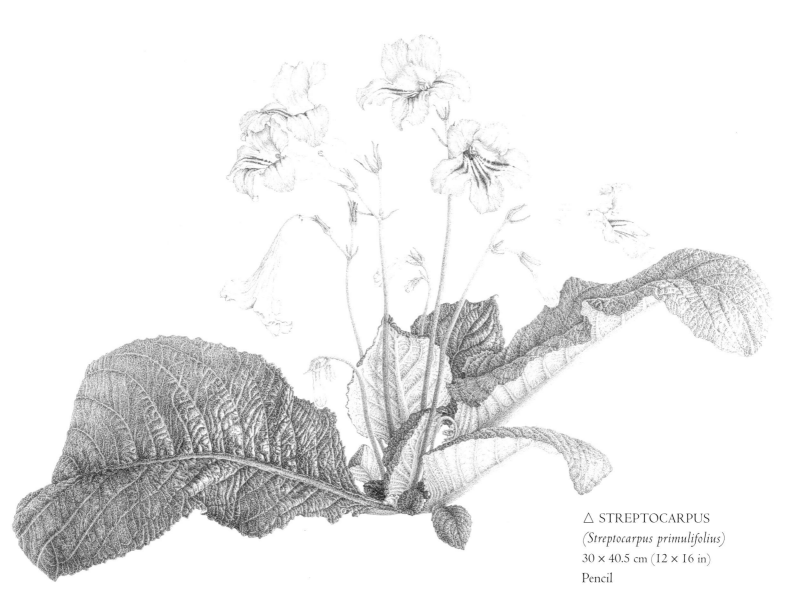

△ STREPTOCARPUS
(*Streptocarpus primulifolius*)
30 × 40.5 cm (12 × 16 in)
Pencil

△ **Final Stage**

All the deepest tones have been completed and the middle and lighter tones adjusted as necessary. A continuous process of balancing tone over the whole picture was required because the under-surface of the leaves and shadows cast from the stems could only be completed when the upper surfaces were finished, or where a leaf in the background dictated the tone of the one in front. A 2B pencil was used to deepen the lower stem.

Both the size and complexity of the streptocarpus leaves may be daunting for the aspiring botanical artist. In that case it would be best to start off with a primrose plant, where the leaves also display a cushioned effect which requires very similar treatment.

CHAPTER 5

WORKING WITH COLOURED PENCILS

ARTISTS WHO choose this medium are attracted to its versatility and its forgiving nature, since it allows for a degree of erasure. It is also clean and very controllable.

With so many brands on the market, all with a range of up to 120 colours, it is hard to know what to buy. A botanical painter certainly will not use the whole range and your best plan is to purchase a selection of pencils in the main colour areas, building up as required. For a surface you will need HP paper such as Arches or Bristol Board which will allow for fine work.

As in watercolour, work from light to dark, building up layers of pigment to create the colour you want. Whether you lay down colour by hatching or with small elliptical strokes, you will need to keep the pressure even, something that comes with practice. You can blend and smooth colours with a tortillon or paper stump. To burnish your work, apply a heavy layer of colour (white is often used) which forces the under layers into the tooth of the paper and creates a smooth finish. It will also create a sheen on some fruits.

It is advisable to apply fixative to finished work to prevent smudging and as an aid to colour fastness. It will also prevent a wax bloom appearing on the surface. Test colours first to ensure that fixative does not alter them.

▷ SOLOMON'S SEAL
(*Polygonatum multiflorum*)
50.5 × 35 cm
(19¾ × 13¾ in)
HILARY BUCKLEY SBA

This is a graceful drawing of an elegant plant whose every line is an aid to good composition. The effort put in to practising long, sweeping lines with either pencil or brush is repaid when you attempt a plant study such as this.

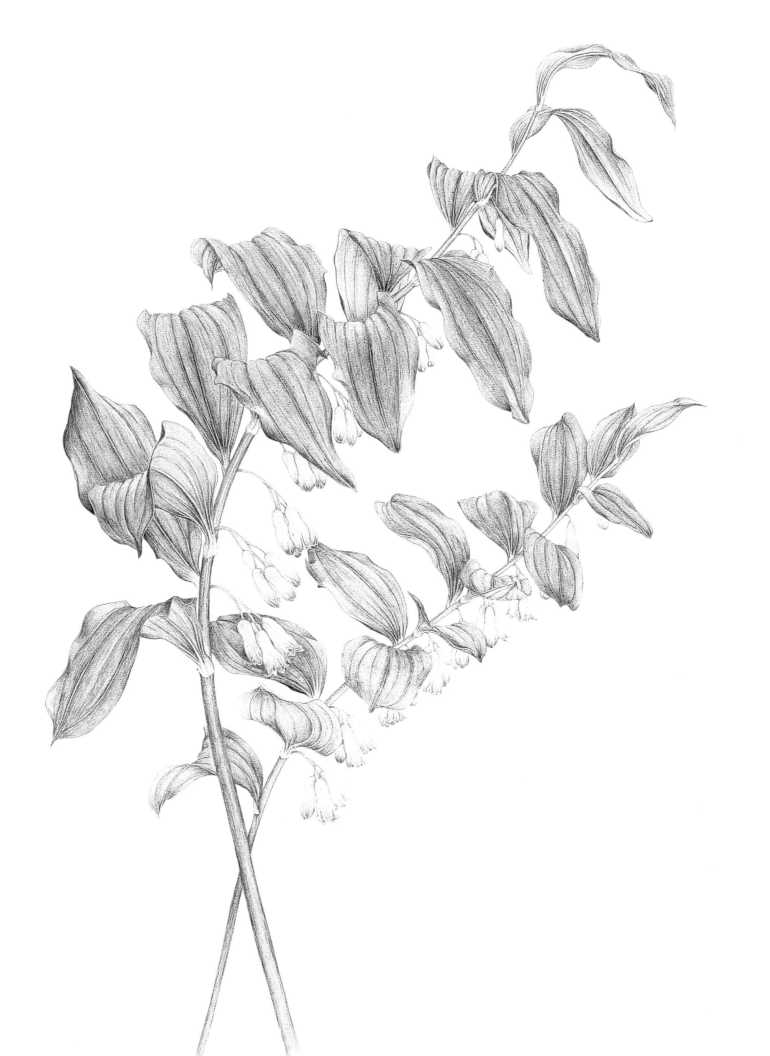

LEUCADENDRON
Leucadendron 'Safari Sunset'

Susan Christopher-Coulson SBA

Susan was attracted to this plant by the dramatic colours and the striking contrasts where dense darks meet lime yellows, particularly when caught by the light. It is a long-lasting plant in water and remains static for several days which is a boon for the artist.

PENCILS

DERWENT ARTISTS PENCILS
Cedar Green 5000, Fir Green 4120, Green Grey 5010, Juniper 4200, Moss Green 5110, Sap Green 4900, Chartreuse 5130, Light Moss 5120, Lime 0000, Gold 0300, Blue Grey 6800, Delft Blue 2800, Bright Red 1410, Mars Violet 6470, Burnt Carmine 6500, Burnt Rose 6460, Rioja 1810, Venetian Red 6300, Fell Mist 7100

BEROL VERITHIN
Terracotta 66, Tuscan Red 56

BEROL KARISMA
Dark Green 908, Olive Green 911, Scarlet Red 922, Mahogany Red 1029, Pale Peach 927

FABER-CASTELL, ALBRECHT DÜRER
Magenta 133, Red Violet 194, Indian Red 192, Light Yellow Glaze 104, Light Yellow Ochre 185, Green Grey 501, Yellow Ochre 5720, Light Rust 6440, Light Sienna 1610, Earth Green 172, Cold Grey II 231, Ivory 103, Cream 102

SURFACE

BRISTOL BOARD

△ Stage I

Before commencing, Susan studied the specimen carefully. Using a soft graphite B or 2B pencil and a sheet of Bristol Board, she drew in the initial outline using a very light touch. (Note that the outline was drawn in a much darker line than normal for the purpose of reproduction.) If, as a beginner, you find Bristol Board too smooth you may choose a paper with more surface, or tooth, such as cartridge paper, but the colour saturation will be less intense.

▷ **Stage 2**

Have to hand a sheet of smooth surface paper to act as a shield to protect the drawing from smudging and spatters of excess pigment, a clean putty eraser and a very sharp pencil sharpener, or scalpel if preferred. Work with good-quality pencils. There are many brands on the market with different qualities; for the initial stages of this example Susan chose Derwent Artists pencils as they are less waxy than some brands and therefore easier to blend on the surface.

Always erase initial pencil lines, leaving only the faintest trace as graphite cannot be removed once colour is applied. Erase only small areas at a time as you work. Don't feel that the initial drawing was a waste of time because going through that process helped you to become familiar with the subject.

Define the outline of the leaves in the appropriate colour (Burnt Carmine or Cedar Green), keeping the outline crisp but soft at this stage. Rarely, if ever, is one colour alone true to the subject, so gently layer in appropriate shades to achieve accurate reproduction (see pencil colour mixes on p. 46).

Keeping her pencils well sharpened, Susan began to fill in a base coat using gentle cross-hatching strokes that left only a light film of colour, blending the layers and softening areas where colours overlap to avoid harsh boundaries. After about three or four layers of cross-hatching she began to work with longer strokes, following the direction of veins or the contour or length of each leaf. On mid to dark colours she began with lighter shades, blending in darker ones to build up and intensify the base coat. For paler shades, for example yellow, she worked in the darker tones (such as shadows) first.

The base coat should define areas of light and shade. Areas of strong highlight may require you to leave the whiteness of paper showing through surrounded by an area which may only have a tint of colour – perhaps only one or two delicately applied layers (see the central stem bud

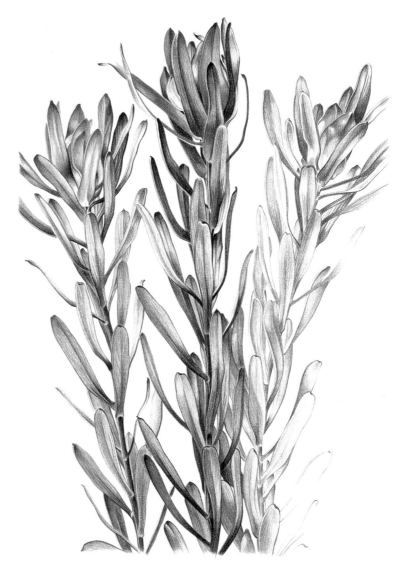

area). Strong highlights and finer details such as veins can be left for a later stage, but be aware of their presence. Avoid darkening with black which will deaden the work but instead work in darker tones that will enrich colour intensity (see pencil colour mixes on p. 46).

Experiment on a spare piece of paper. By the end of Stage 2 you should just be aware that there is white paper under most of the coloured areas but the colour is beginning to intensify (the stem on the right shows early stages).

If you are a newcomer to coloured pencil work, keep in mind that it is not a speedy process; much patience is required in order to build up rich layers of colour. However, it is this very possibility of achieving intense, glowing colour that has attracted many artists to the medium.

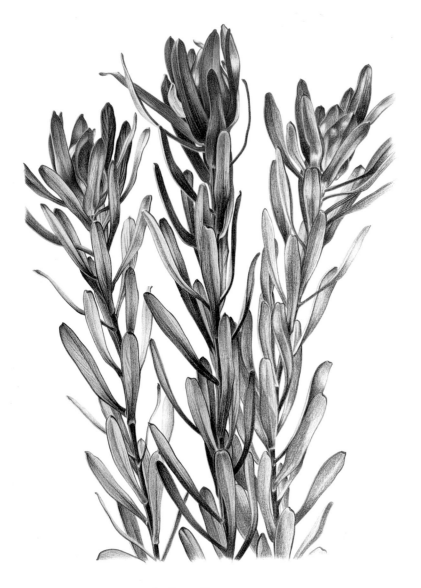

△ Stage 3

To see the stages in blending, contrast the stem on the left of the leucadendron with the one on the right: the left stem is almost completed with highlights and darker tones intensified, so defining the form of the plant with its softly 'leathery' leaves, while the right stem is at Stage 2 with some paper still visible. The central stem is nearing completion.

By Stage 3, colours and pencil direction marks should be blended except where ribs, veins and outlines are a feature. It is now time to develop the contrast between darker shadowy areas and the highlights, which may need subtle toning.

As the leucadendron is a bold plant, Susan used some more 'waxy' pencils at this stage to intensify depths of tone and emphasize the density of the leaves. A word of caution about using waxy pencils: too much pressure or too many layers of colour tends to lift the colour away from the sheet completely since the wax becomes too tacky. Leave the most waxy pencils until the final colour layer. When highlighting, try to avoid too much lighter waxy colour such as ivory or white as it may deaden that area.

It is not necessary to use all the suggested pencil shades but to select a suitable combination from the list, taking into account the conditions affecting each leaf. In some cases, seven or eight of the listed shades may need to be combined to achieve the required intensity and hue. Here are some suggestions:
- To intensify the greens: use Dark Green 908, Olive Green 911 (Karisma, Berol).
- To intensify the reds: Scarlet Red 922, Mahogany Red 1029 (Karisma, Berol), Magenta 133, Red Violet 194, Indian Red 192 (Albrecht Dürer, Faber-Castell).
- To intensify the yellows: Light Yellow Glaze 104 (Albrecht Dürer, Faber-Castell).
- To intensify the orange: Light Yellow Ochre 185 (Albrecht Dürer, Faber-Castell).
- To highlight: Green Grey 501 softens but covers the white paper; Yellow Ochre 5720, blended over some areas of rust; Light Rust 6440 and Light Sienna 1610 soften white paper and can be used over some rusts; Earth Green 172 (Albrecht Dürer, Faber-Castell), blended over green; Cold Grey II 231 (Albrecht Dürer, Faber-Castell), blended over green. Ivory 103 and Cream 102 (both Albrecht Dürer, Faber-Castell) can be blended over greens and rusts.
- To blend over rusts and light greens: Pale Peach 927 by Karisma.

▷ Final Stage

In the final stage, ensure that all outlines are crisp and check that the background was completely clean. Where necessary, use a fresh piece of putty eraser which can be shaped to fit into small nooks and crannies.

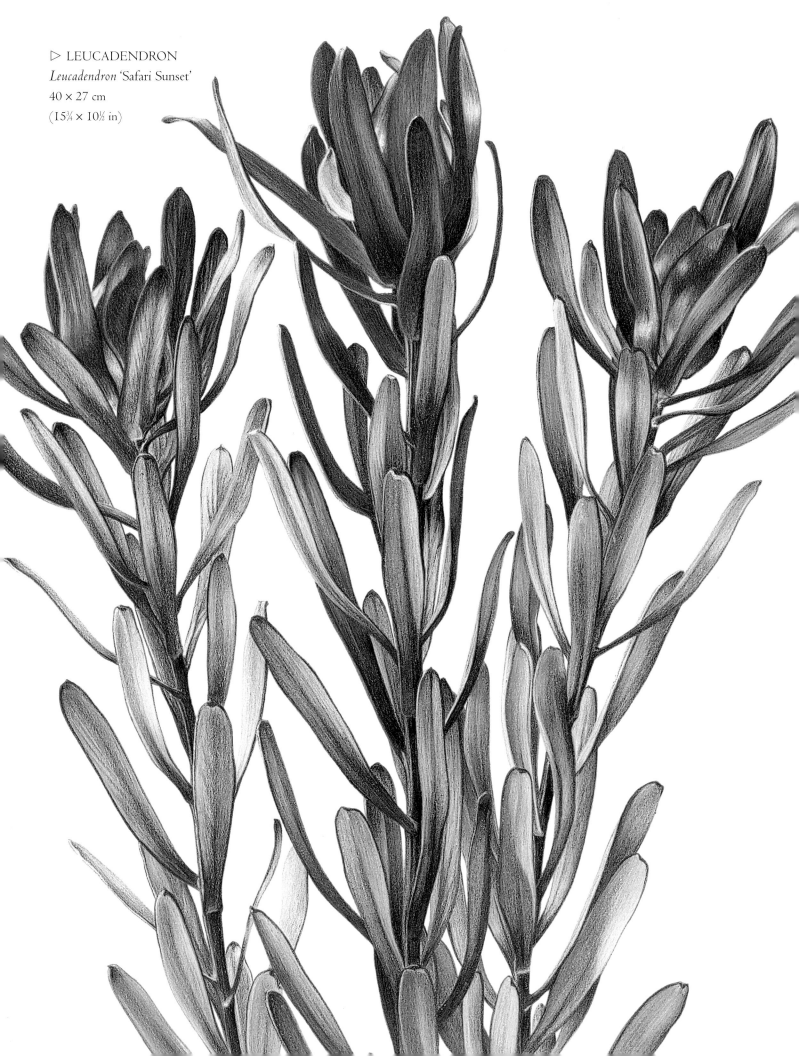

▷ LEUCADENDRON
Leucadendron 'Safari Sunset'
40 × 27 cm
(15¾ × 10½ in)

CHAPTER 6

WATERCOLOUR PAINTING TECHNIQUES

T HE OBVIOUS advantage of watercolour in comparison with other media is its transparency and the manner in which washes of paint can be laid one on top of the other to create a wonderful intensity of colour or iridescence.

As you become familiar with your paints, try to see colour as reflected light, not merely pigment with a name given by the manufacturers. Remember that without light there is no colour. The experienced painter hops around the palette taking a little of this and layering it on top of a little of that without a thought for what the pigment is called. This is what you should aim for, and practising with your colours so that you know them well is the way to achieve it. Bear in mind that however many ground rules you learn, every artist develops their own technique, finding by trial and error what is best for them. The techniques described here and the step-by-step examples in this book typify a variety of styles and your own practice pieces will lead you to discover what is right for you.

▷ BIRD OF PARADISE, CRANE FLOWER
(*Strelizia regina*)
41.5 × 29 cm
(16½ × 11½ in)
MARGARET STEVENS
VPSBA

One of the advantages of working in watercolour is very apparent in this painting, where the transparency of the medium enabled me to achieve the rainbow effect on the spathes.

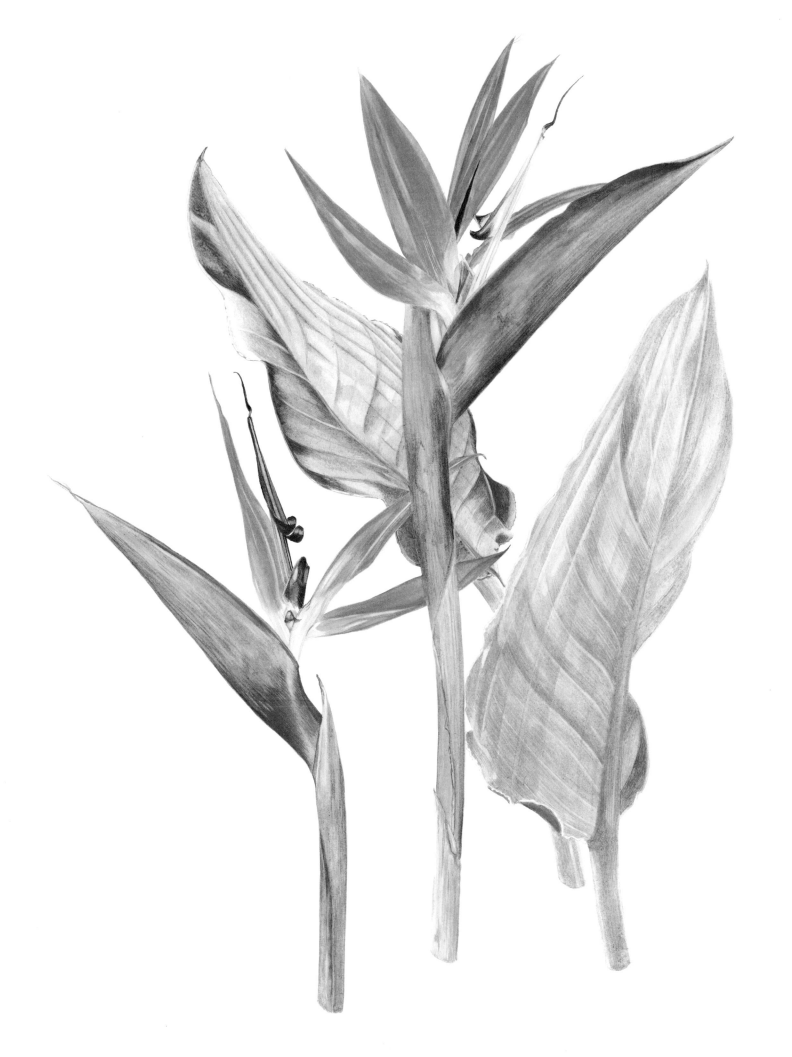

△ Fig. la
Light Red and
Ultramarine makes
'botanical grey'.

△ Fig. lb
'Botanical grey' shows
its transparency when
it is painted over
Winsor Yellow.

△ Fig. lc
'Botanical grey' over
Aurora Yellow.

▷ Fig. 2
This 'Gertrude Jekyll'
rose is shaded and given
depth by using
Schmincke Ruby Red
and Quinacridone Violet.
Grey shading is not
always desirable.

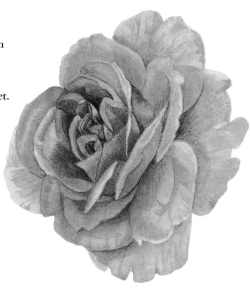

△ Fig. 3a
Naples Yellow
mixed with
Permanent Magenta.

△ Fig. 3b
Naples Yellow mixed
with Quinacridone Red.

△ Fig. 3c
Naples Yellow mixed
with Schmincke
Glowing Violet.

▷ Fig. 4
The advantage of
overlaying Naples Yellow
with other colours and
its benefits when
painting certain flowers
can be seen here with
these base colours.

Permanent Rose

Thioindigo
Violet

Quinacridone
Red

Permanent
Magenta

Glowing Violet

Ultramarine
Violet

In order to keep your paintings as clear and pure as possible, build up layers of colour rather than mixing too many pigments together. Students often wonder why their work looks muddy; usually it is a result of overmixing in an attempt to find a particular shade. As a rule of thumb I consider that a mix of two colours is ideal, three is acceptable, more than that and you are on dangerous ground. If you have not found the shade you require it is best to make a fresh start with different pigments or with different proportions of pigment and water.

A muddy look is also caused by overworking – fussing around trying to alter a shadow, a colour or even the shape of a petal. Even when something is not right it is often best left alone. You will learn from these mistakes and a notebook in which to jot down errors is as valuable as noting successful colour mixes.

CHOOSING PIGMENTS

A few specific pigments are worth comment here. You can do without black because a satisfactory very dark hue can be made using Vandyke Brown and Indigo with perhaps a touch of Dark Green, Prussian Blue or possibly one in the Holbein range. White, too, is generally unnecessary, unless you are using it as body colour (gouache), or for adding awkward hairs on overlapping leaves. Painting farina, the 'flour' on certain primula leaves is another occasion when it may be useful.

Payne's Grey is all right when employed in moderation but can be overused when the artist reaches for it every time a shadow is required. It is far better to mix Light Red and French Ultramarine – just a tiny amount that can be well diluted with water to create the most subtle grey tint. It is transparent and will allow the underlying colour to shine through, making it ideal to use on yellow flowers such as daffodils which are notoriously difficult to shade. All too easily they look brown or green, but the 'botanical grey' mix will serve you well for these and many other flowers (see figs 1a, 1b and 1c).

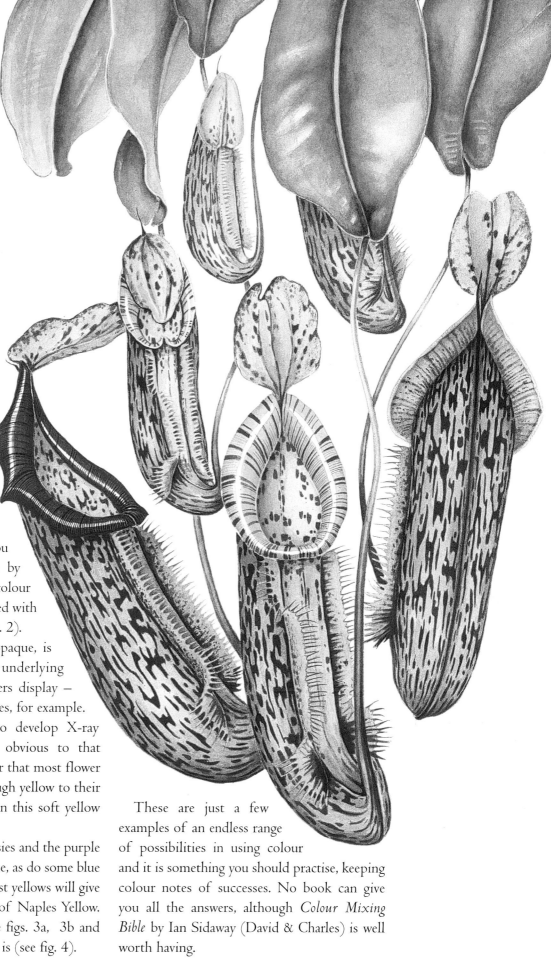

▷ PITCHER PLANT
(*Nepenthes × mixta*)
67 × 49 cm
(26¼ × 19¼ in)
LIZ McRAE SBA

These exotic pitcher plants, with their complex markings and fringes portrayed so accurately, show that the artist need not be afraid to tackle a more solid, heavy subject in what is so often considered to be a delicate medium.

All shadows have a purple content and if you remember that you will not go far wrong. Most times you will give depth to a flower by using a deeper tone of the colour and this should not be confused with the need for a shadow (see fig. 2).

Naples Yellow, although opaque, is excellent for casting the underlying golden glow that many flowers display – some pink sweet peas and roses, for example. All botanical artists need to develop X-ray vision, looking beyond the obvious to that which lies beneath. Remember that most flower buds mature from green through yellow to their ultimate colour and it is often this soft yellow that lingers.

The red-brown velvety pansies and the purple ones often require a yellow base, as do some blue sweet peas. Blue on top of most yellows will give you a green but not on top of Naples Yellow. Mixing is not the answer (see figs. 3a, 3b and 3c). Laying the colour on top is (see fig. 4).

These are just a few examples of an endless range of possibilities in using colour and it is something you should practise, keeping colour notes of successes. No book can give you all the answers, although *Colour Mixing Bible* by Ian Sidaway (David & Charles) is well worth having.

LAYING WASHES

As a botanical painter you will need a wider palette than, say, the landscape artist in order to do justice to the variety of colours within plants. However, like the landscape artist you still need to apply washes, wet-on-wet or wet-on-dry, even though they are generally on a much smaller scale.

In fig. 5 the colour has been allowed to bleed naturally, giving an appearance you might see on a rose petal. In fig. 5a the first wash was allowed to dry and the second one was blended in. To do this you can use a second brush, dipped in clean water, or, as I do, work with one brush, washing it out and blotting off excess moisture on kitchen paper. This is probably the technique most often used for flowers, leaves, fruit and most things you can think of. Add new paint with a single brush stroke so that the paint below is not disturbed. If the top layer is translucent the bottom colour will show through.

Try to achieve the correct colour with as few washes as possible by making sure you start with an appropriate depth of colour; do not use pale pink for the first wash on a crimson rose, for example, and remember that paint will dry paler than it looks when freshly laid down. When laying a second wash, always make sure that the previous one is dry in order to avoid lifting it off. It is important to hold on to clarity and in inexperienced hands too many washes can lead to 'mud'.

USING A DRY BRUSH AND WASHING OUT

When the desired depth of colour is reached it is time to start using dry brush work, adding final detail and colour with only the minimum amount of water. Keep kitchen paper under your water pot at all times – it is invaluable for absorbing surplus water and pigment. The colour obviously cannot be washed on, so apply it instead in small, light strokes, again taking care not to disturb the underlying layer. Imagine you are painting a butterfly's wing, which would tear if you were heavy-handed. These small light strokes, reminiscent of hatching with a pencil or pen, are used when working on vellum, polymer or other hard non-absorbent surfaces where wet washes are out of the question (see fig. 6).

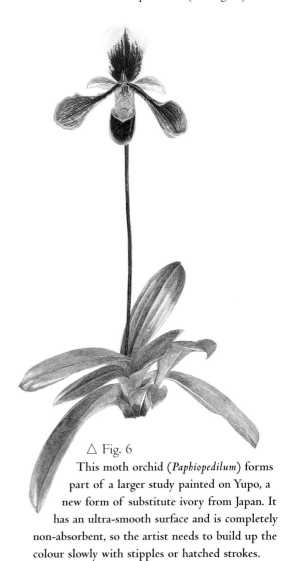

△ Fig. 5
A typical
wet-on-wet petal.

△ Fig. 5a
Here the paint has been
applied wet on dry.

△ Fig. 6
This moth orchid (*Paphiopedilum*) forms
part of a larger study painted on Yupo, a
new form of substitute ivory from Japan. It
has an ultra-smooth surface and is completely
non-absorbent, so the artist needs to build up the
colour slowly with stipples or hatched strokes.

In the case of vellum, I prefer to use a fine point size 2 or 3 Kolinsky sable from start to finish, drawing the outline very lightly in the appropriate colours. Then I apply a small amount of washed colour to one petal at a time before building up with hatched and stippled brushstrokes. Stippling in watercolour is perfect for adding texture, or for showing detail such as the stomata or pores on a shiny leaf.

Sometimes it is necessary to remove colour, as in the lower strelitzia flower on p. 39, where the flower stem shows through the spathe. On these occasions a better effect is achieved by washing out with a damp brush rather than by trying to paint it in. You can achieve highlights in the same way, provided they are not too highly glossed. The brush loaded with water rather than pigment is every bit as important in creating different effects and is another way in which the medium helps you by its transparency.

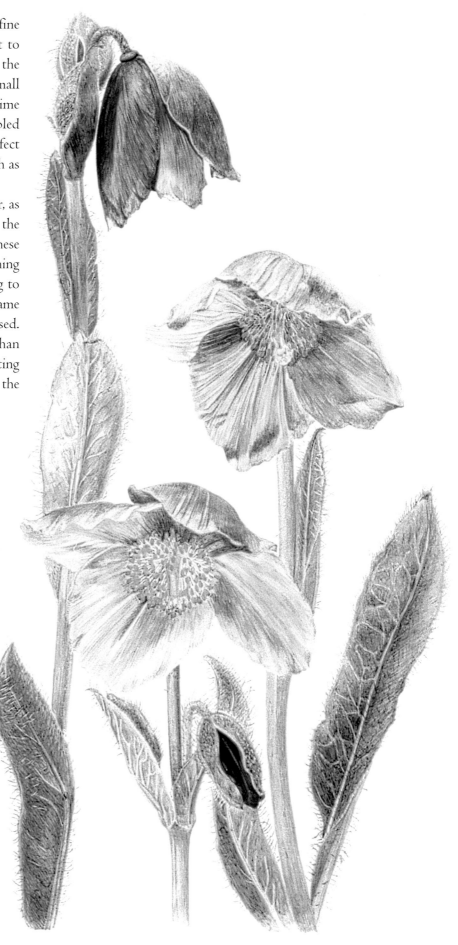

▷ HYBRID HIMALAYAN POPPY
(Meconopsis × sheldonii)
29 × 20 cm (11½ × 8 in)
MARGARET STEVENS VPSBA

This study on vellum was drawn entirely with the brush, which is by far the easiest way to work on this tricky support. It is not as smooth as Yupo or other synthetic papers, but it is nevertheless important not to let the work become too wet nor to use an eraser at the drawing stage. Talc and fine pumice or extra-fine emery paper will be required to remove pencil marks if necessary, while a faint watercolour outline can be wiped away with a damp tissue.

CHAPTER 7
FOLIAGE COLOUR

To be a successful botanical painter it is essential to come to terms with mixing and using greens. All too often, good work is spoilt by lack of care when portraying the foliage. It really must have the same attention as a beautiful flower, and indeed it is frequently far more striking than the plant's flowers, as can be seen in the hosta painting opposite. Do not think that any green will do; it will not, and it is something you cannot fudge.

Whether you use manufactured brands of paint or mix your own pigments is for you to decide, but do not expect to use paint straight from the tube. Most of the greens are too harsh and many are downright inappropriate as they would not appear in nature. You can assume that in nine out of ten cases you will need to mix with another colour. If you turn away from ready-made pigments and always mix your own, do not fall into a common trap where you discover a good mix and use it regardless of whether or not it is right. Always treat each green individually and mix to match what is in front of you.

Similarly, with coloured pencils you can expect to need to mix colours, always remembering to check the exact shade of the leaf you are depicting rather than sticking to a favourite combination.

▷ HOSTA
67.5 × 50 cm
(26½ × 19½ in)
Watercolour
Janet Wood SBA

Janet used Aureolin, Yellow Ochre and Daler-Rowney Cobalt Blue, with a little French Ultramarine where darker green was required. The bracts on the stem had a little of the flower colour, Winsor Violet, mixed in. The glaucous bloom was achieved by using a dry mix of Permanent White and Cobalt Turquoise brushed and stippled over the painted leaf.

COLOURED PENCILS

To mix a basic green with lighter or darker tones for leaves it is not necessary to combine all the the suggested pencil shades but to select a suitable combination from the list, taking into account the conditions affecting each leaf. In some cases seven or eight of the suggested shades may need to be combined to achieve the required intensity and hue. The leaves illustrated by Hilary Buckley on this page have been worked on that principle.

Building up your own shade card is a helpful exercise. The following are all Derwent Artists pencils, unless otherwise stated.

MID GREEN BASIC MIX

Cedar Green 5000, Moss Green 5110, Sap Green 4900.

To darken, add layers of Blue Grey 6800, Delft Blue 2800, Burnt Carmine 6500.

To produce blue greens, add to the mid green basic mix: Juniper 4200, Fir Green 4120, Green Grey 5010.

To produce golden greens, add to the mid green basic mix: Gold 0300, Light Moss 5120.

To produce lime green/yellows, add to the mid green basic mix: Lime 0000, Gold 0300, Chartreuse 5130.

REDDISH-SHADE LEAVES

Burnt carmine 6500, Tuscan Red 56, Terracotta 66 (the latter are both Berol Verithin), Bright Red 1410, Burnt Rose 6460, Mars Violet 6470, Fell Mist 7100, Venetian Red 6300, Rioja 1810.

To darken, add layers of Blue Grey 6800, Delft Blue 2800.

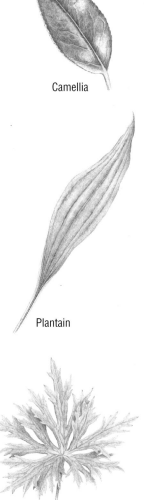

Camellia

Plantain

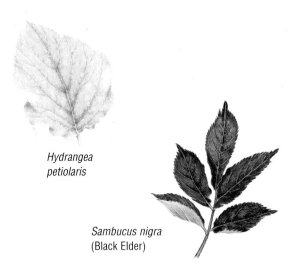

Hydrangea petiolaris

Sambucus nigra
(Black Elder)

Eleaegnus pungens

Geranium dissectum
(Cut-leaved Cranesbill)

WATERCOLOURS

When asked, SBA members came up with literally dozens of mixes. Many, although using different pigments, turned out to be very similar. I have picked out some of the most useful of these to be reproduced here.

However, as with coloured pencils, nothing beats making your own green shade card; I know from experience that if you give six people a palette each with a blob of Cadmium Yellow and Cobalt Blue you will get six different greens, since everyone will use varying proportions of paint and water. There is no substitute for experimentation and practice.

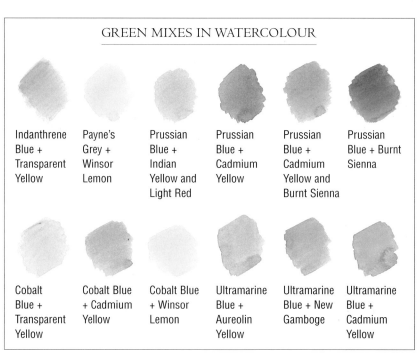

GREEN MIXES IN WATERCOLOUR

Indanthrene Blue + Transparent Yellow

Payne's Grey + Winsor Lemon

Prussian Blue + Indian Yellow and Light Red

Prussian Blue + Cadmium Yellow

Prussian Blue + Cadmium Yellow and Burnt Sienna

Prussian Blue + Burnt Sienna

Cobalt Blue + Transparent Yellow

Cobalt Blue + Cadmium Yellow

Cobalt Blue + Winsor Lemon

Ultramarine Blue + Aureolin Yellow

Ultramarine Blue + New Gamboge

Ultramarine Blue + Cadmium Yellow

A LEAF LIBRARY

In this leaf library compiled by Vickie Marsh SBA, the watercolour pigments and mixes are listed in the order in which they were applied. The '+' sign is used where colours are mixed together.

Fig 1 **Field sycamore** (*Acer pseudoplatanus*): Ultramarine + Cadmium Yellow, Indigo + Cadmium Yellow.

Fig 2 **Japanese maple** (*Acer palmatum*): Indian Yellow + Indanthrene Blue, Purple Madder + Indian Yellow. Back of leaf: Indian Yellow + Indanthrene Blue, then more Indanthrene Blue added to deepen towards the centre vein.

Fig 3 **Bramble** (*Rubus fruticosus*): Ultramarine + Cadmium Yellow, Perylene Maroon, Light Red and Brown Madder.

Fig 4 **Wych elm** (*Ulmus glabra*): Ultramarine + Winsor Lemon. Ultramarine + Aureolin.

Fig 5 **Dandelion** (*Taraxacum officinale*): Indigo + Aureolin, Ultramarine + Cadmium Yellow, Burnt Sienna.

Fig 6 **Horse chestnut** (*Aesculus hippocastanum*) (young leaf): Transparent Yellow. Cobalt + Transparent Yellow, Ultramarine + Winsor Yellow and Ultramarine + Cadmium with a touch of Light Red.

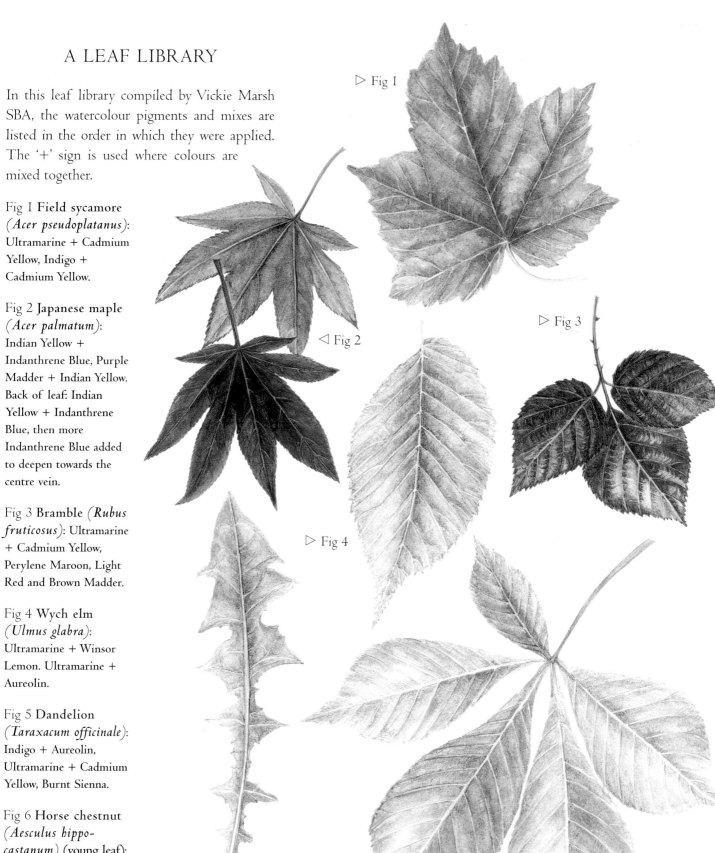

▷ Fig 1

◁ Fig 2

▷ Fig 3

▷ Fig 4

◁ Fig 5

▷ Fig 6

RUSSETED LEAVES

Brigitte E M Daniel SBA always prefers to work with a very limited palette, even when she is painting leaves that have coloured variegation. The colours that she employed for the leaves shown here are Permanent Sap Green, Hooker's Green, Cerulean Blue, Lemon Yellow and Payne's Grey, with the addition of some Bright Red on *Pelargonium* 'Mrs Pollock' and Alizarin Crimson on *Pelargonium* 'Vancouver Centennial'.

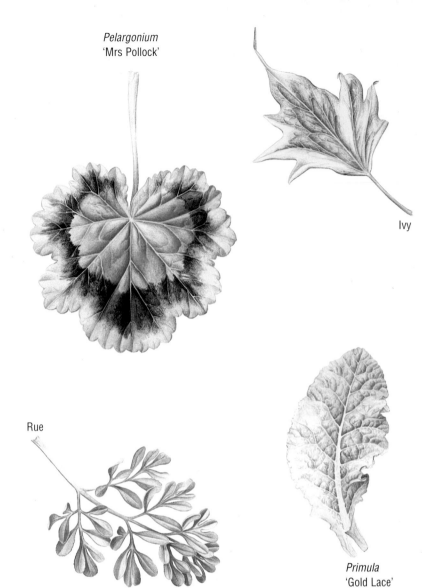

Pelargonium 'Mrs Pollock'

Ivy

Pelargonium 'Vancouver Centennial'

Rue

Primula 'Gold Lace'

Pelargonium 'Lady Plymouth'

▷ AUTUMN ARBORETUM

40 × 31 cm (15½ × 12½ in)

Watercolour

SALLY JANE PERRIN SBA

This beautiful study of leaves glowing with the richness of autumn golds is enhanced by Sally's calligraphy. This is not something to attempt unless you are very skilled indeed as a good painting can be ruined by poor handwriting. Sally used Cadmium Yellow or Winsor Yellow with Yellow Ochre for many of the leaves. Cadmium Red and Alizarin Crimson provided the red hues, while Burnt Sienna, Raw and Burnt Umber and Payne's Grey added the more subdued tones. Olive and Sap Green also contributed to the palette.

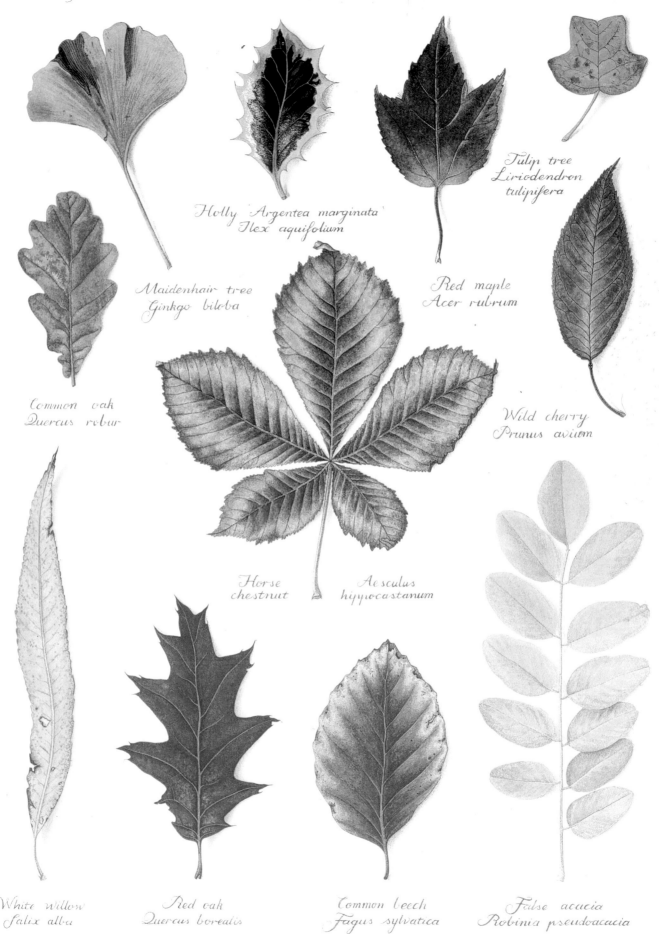

Holly 'Argentea marginata'
Ilex aquifolium

Tulip tree
Liriodendron
tulipifera

Maidenhair tree
Ginkgo biloba

Red maple
Acer rubrum

Common oak
Quercus robur

Wild cherry
Prunus avium

Horse Aesculus
chestnut hippocastanum

White willow Red oak Common beech False acacia
Salix alba Quercus borealis Fagus sylvatica Robinia pseudoacacia

IVY

Hedera helix 'Ester' and *Hedera helix* 'Obovata'

Kay Rees-Davies SBA

Kay loves leaves and chose these two ivies because although both are varieties
of *Hedera helix* they are very different in shape and colour and have a marked contrast
between the juvenile and arboreal foliage.

PAINTS

DALER-ROWNEY
Permanent Sap Green
Payne's Grey
Warm Sepia
Olive Green

SCHMINCKE
Chromium Oxide Green

WINSOR & NEWTON
Olive Green
Lemon Yellow
Prussian Blue
Indigo
Winsor Lemon
Indanthrene Blue
Transparent Yellow
Indian Yellow
Light Red
Sepia

BRUSHES

DALER-ROWNEY
Aquafine Flat Shades
size 2 AF62

WINSOR & NEWTON
Series 7 sizes 2, 3, 4

SURFACE

PRINTMAKERS
HP 300 gsm (140 lb)

△ **Stage 1**

Using a Pentel 0.3 mm HB pencil, Kay drew a fine outline. Her practice is to put in the main skeleton veins first since that enables her to get a good accurate outline of each leaf.

Kay removed all pencilled veins before applying washes with her Series 7 size 3 and 4 brushes. *Hedera helix* 'Ester' was given a first wash of Winsor & Newton Olive Green mixed with Lemon Yellow on the juvenile leaves. For the variegated leaves she used a wash of Lemon Yellow to which a touch of Daler-Rowney Permanent Sap had been added. The outlines of the variations were drawn on with very dilute Payne's Grey and the main veins were drawn with a pale green.

For *Hedera helix* 'Obovata', the first wash on the juvenile leaves consisted of a diluted mix of Prussian Blue and Winsor Lemon. The second wash was a mix of Indanthrene Blue and Transparent Yellow.

The arboreal leaves on both 'Ester' and 'Obovata' received washes of Indanthrene Blue and Transparent Yellow. All areas of shine on the leaves were left white.

Stage 2

After softening the green edges of 'Obovata', Kay worked into the white shine areas. She used the tip of a size 2 brush to stipple or apply tiny hatching strokes to create a sheen (a perfect point is essential for this). Some areas of shine in juvenile leaves may need a spot of dilute Indanthrene Blue applied with an almost dry size 4 brush; older leaves have a rougher texture and are not as shiny as the juvenile ones.

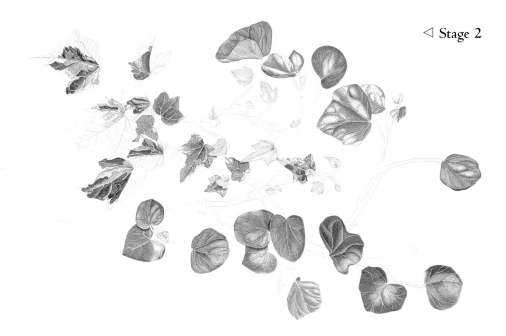

Where necessary the veins were narrowed and darker areas were painted in using a mix of Indigo and Indian Yellow, with a touch of Light Red. Kay strengthened the juvenile leaves of 'Ester' using Lemon Yellow with a little Daler-Rowney Permanent Sap Green. The touches of green where there is variation were put in using Indanthrene Blue plus some Transparent Yellow.

On the variegated leaves Kay used a diluted Payne's Grey; for the middle shade, Schmincke Chromium Oxide Green mixed with Payne's Grey; and for the darker shades Schmincke Chromium Oxide Green mixed with Payne's Grey and Indigo or Payne's Grey plus Olive and Indigo.

With a size 2 brush and the dry brush technique, Kay stippled colour from the dark areas into the shiny patches to create a smooth finish. Any streaky patches may also be evened out in this manner. A magnifying glass is a useful aid here.

▷ **Stage 3**

After completing the details on the leaves of both ivies and painting all the petioles, Kay used Daler-Rowney Permanent Sap Green to paint the juvenile stems of 'Obovata', making sure they were well rounded. For the mature stem she drew in all the texture markings and painted

them with Sepia. The stem colours were Daler-Rowney Olive Green and Warm Sepia, while Winsor & Newton Olive Green was used for the green patches.

For 'Ester', Kay painted the stems with Daler-Rowney Olive Green and French Ultramarine, touching in the nodes with Light Red. To ensure stems look rounded, Kay uses a dry brush loaded with colour to stroke in from the darker to the lighter side, using the point of the brush.

All the aerial roots were painted using Winsor & Newton Sepia to darken the side of the stem away from the light.

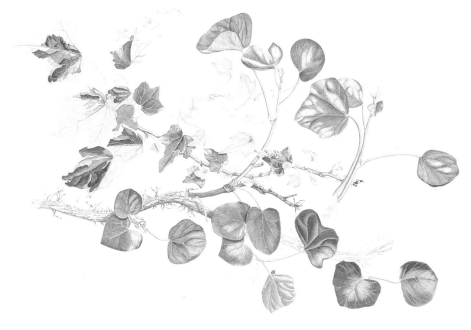

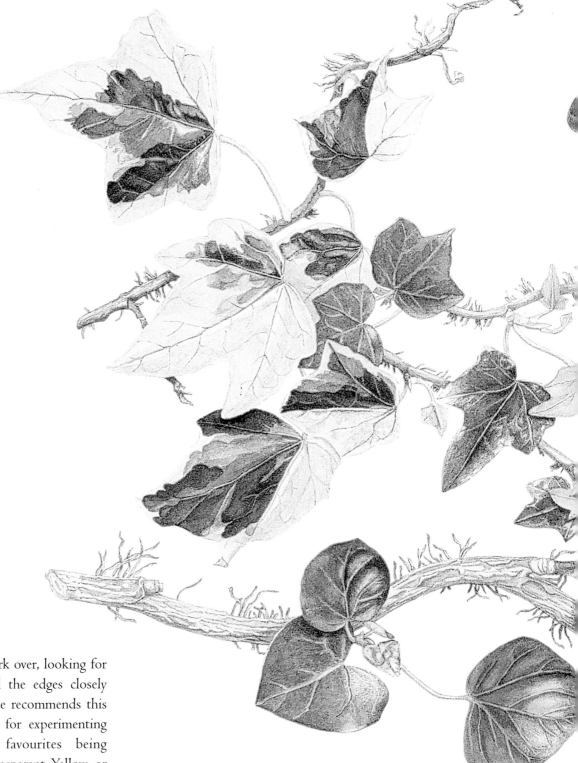

▷ IVY
Hedera helix 'Ester' and
Hedera helix 'Obovata'
38 × 25.5 cm (15 × 10 in)
Watercolour

▷ **Final Stage**
Finally, Kay checked the work over, looking for shadows and examining all the edges closely with a magnifying glass. She recommends this kind of study as excellent for experimenting with greens, her own favourites being Indanthrene Blue with Transparent Yellow or Prussian Blue with Winsor Lemon. She uses the Olive Green made by Daler-Rowney, Winsor & Newton and Schmincke because they are all different, Daler-Rowney being the darkest and very useful for shading twigs and branches. Her meticulous attention to detail results in the kind of ultra-fine study seen here.

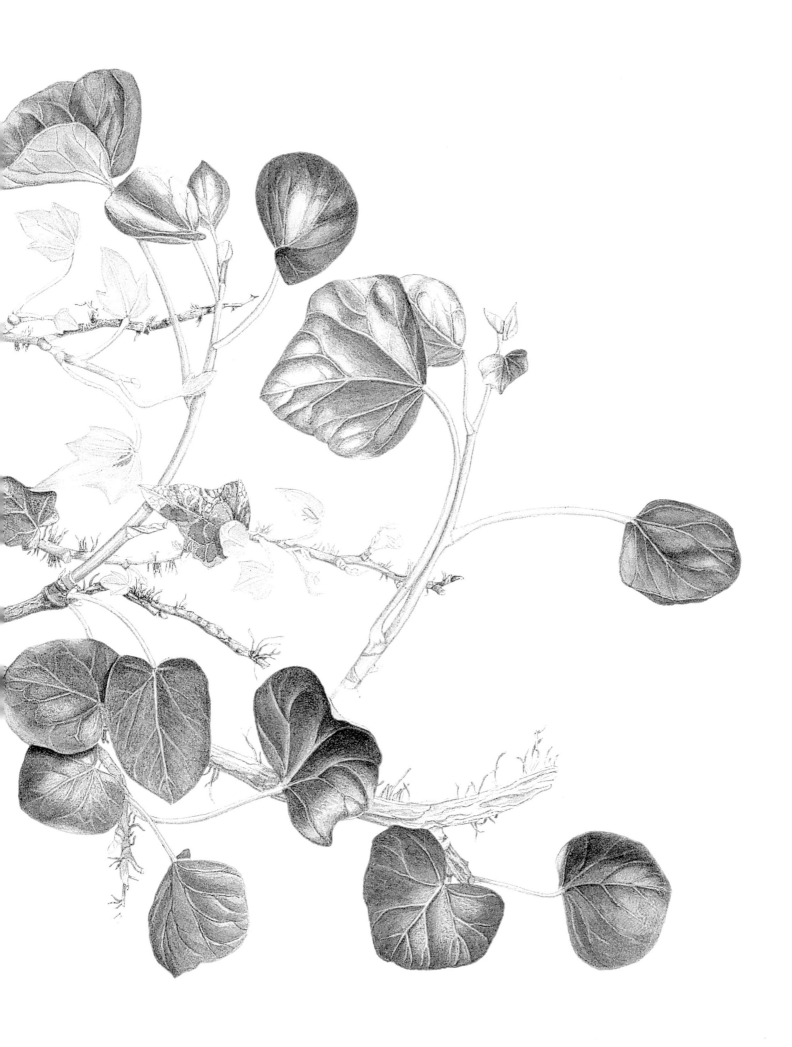

CHAPTER 8
FLOWER LIBRARY

OVER THE many years in which I have taught botanical painting to mature students, one question has predominated: 'What colour shall I use?' This question arises because only with practice and experience does the choice of colour become automatic. Initially, it can be daunting.

Although a definitive answer obviously cannot be given, I hope the following pages of flowers, divided into colour sections, will be of some help. The watercolours for each flower are listed in the order they were used, either as a wash or for added detail. Apart from copying these for practice, you may have a similar flower to paint in the future and these colour notes should help you to get started.

▷ *HELLEBORUS ORIENTALIS*
Watercolour
51 × 46 cm (20 × 18 in)
JACKIE GETHIN SBA

This modern image which enlarges the heart of a single hellebore flower shows up the colour washes in detail. Starting with the back petals, a preliminary wash of Burnt Sienna provided the underlying shade, followed with a diluted Permanent Rose over all the petals. The centre of the flower was washed in lightly with a mix of Lemon Yellow, with Cadmium Yellow used at the base of the petals and some Quinacridone Gold. Detailed parts were later picked out with Sap Green. No masking fluid was used. Washed areas of Daler-Rowney Ultramarine Violet and more intense Permanent Rose helped to mould the petals. The foliage required washes of Sap Green, Daler-Rowney Green Gold and Prussian Green.

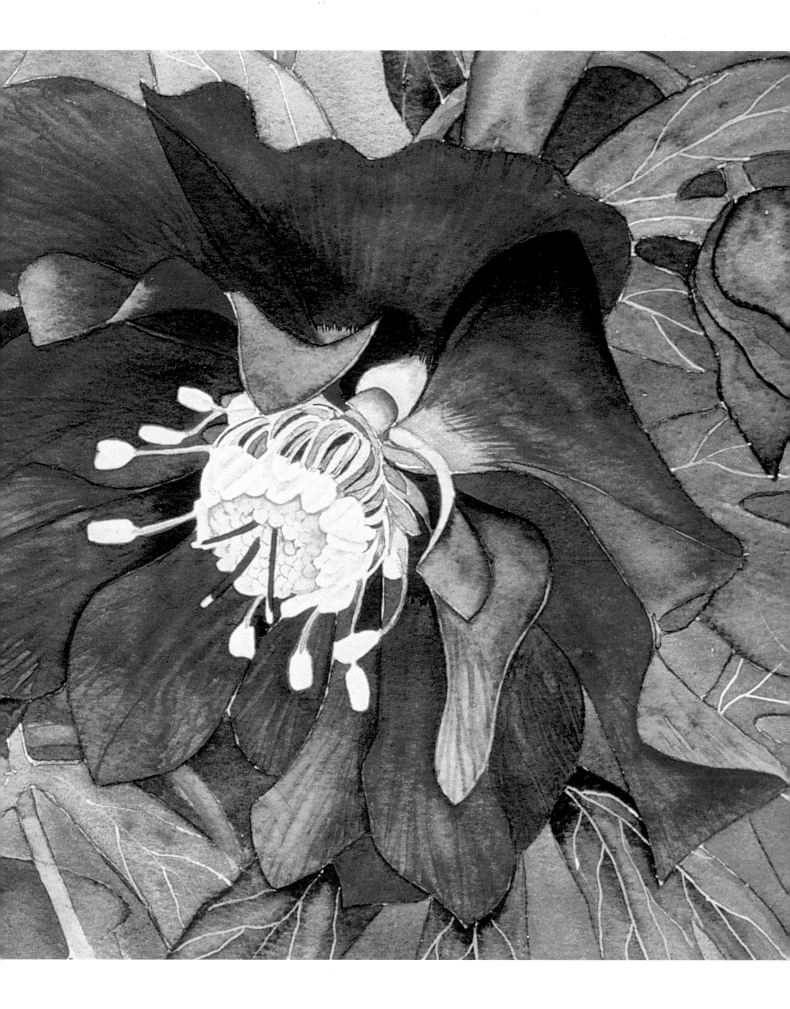

A FLOWER PALETTE

The pigments used here are all Winsor & Newton unless otherwise stated. The '+' sign is used where colours are mixed together. You may not have all the pigments, but gradually you will build up a wider palette. Half pans and small tubes are most economical as you will often use only small amounts and over the years they will dry out. A manufacturer's shade card, obtainable from your supplier or from the manufacturer, is an invaluable aid so that you can see a colour sample which will be as accurate a reproduction as possible.

'Botanical grey' refers to a mix of Light Red and French Ultramarine, which makes an excellent transparent grey (see p. 40). It should be used sparingly and well diluted. If you wish to put in a shadow which has the hint of another colour in it, add a touch of the appropriate colour to the grey mix, say, rose or green. This is often useful on a white flower which reflects colour from its surroundings.

RED FLOWERS

Fig 1 *Schlumbergera* hybrid
FLOWER TUBE: Quinacridone Magenta, Quinacridone Red.
TEPALS (PETALS/SEPALS): Quinacridone Red, Scarlet Lake, Bright Red, Permanent Carmine.
STAMENS: Naples Yellow + Aureolin.
STIGMA: Quinacridone Magenta, Permanent Carmine.

Fig 2 Japanese azalea
Schmincke Permanent Red Deep, Quinacridone Magenta, Olive Green, Sap Green, Light Red.

Fig 3 *Primula auricula* 'Dales Red'
CENTRE: Aureolin + Yellow Ochre + Olive Green. Payne's Grey to stipple and darken centre, then stippled again with original Aureolin mix, all very lightly.
STAMENS: Winsor Yellow.
PETALS: First wash of Yellow Ochre, second wash of Brown Madder + Perylene Maroon. The darkest areas are Purple Madder. Minute specks of pure Naples Yellow, without water, suggest pollen on petals.
BUD: Crimson Lake and Indanthrene Blue.
STEMS AND LEAFLET: Yellow Ochre + Indanthrene Blue.

Fig 4 *Anthurium*
SPADIX: Naples Yellow, Yellow Ochre, Permanent Alizarin, 'botanical grey'.
SPATHE: Schmincke Deep Red and Ruby Red. Cadmium Red Deep, Scarlet Lake, Winsor Red.

Fig 5 *Geum*
STAMENS: Indian Yellow + Gold Ochre.
PETALS: Winsor Orange, Cadmium Red, Cadmium Red Deep.
CENTRE: Cadmium Red + Indanthrene Blue.
BUD: Winsor Lemon, Olive Green and a touch of Permanent Alizarin Crimson.

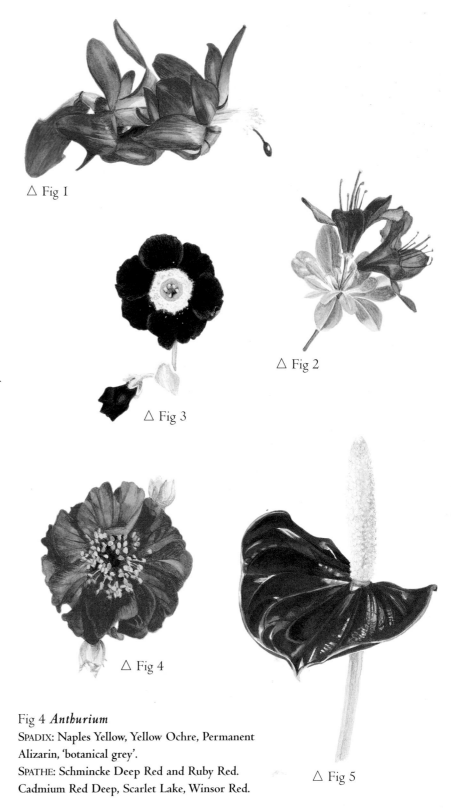

△ Fig 1

△ Fig 2

△ Fig 3

△ Fig 4

△ Fig 5

△ Fig 6

△ Fig 7

▷ Fig 8

Fig 6 **Bluebells**
PETALS: First wash of Permanent Rose then colour built up with Cobalt, Thioindigo Violet, French Ultramarine and Schmincke Glowing Violet.
Stems: Olive Green with colour transference of blue/violet.

Fig 7 **Cornflower**
PETALS: French Ultramarine, Cobalt, Schmincke Magenta, Thioindigo Violet + Ultramarine Violet. Note that no white paint is used for the stamens.

Fig 8 **Iris**
PETALS: First wash of Winsor Lemon. This must go on first in order to retain its clarity. Ultramarine Violet, Thioindigo Violet, French Ultramarine, Schmincke Glowing Violet, Quinacridone Violet.

Fig 9 **Aquilegia**
STAMENS: Winsor Lemon, then mixed with French Ultramarine to add green touches and at tips of sepals.
PETALS: Purple Magenta + Schmincke Phthalo Blue, Quinacridone Violet + Ultramarine Violet. Same colour mixes used for sepals with a top wash of Purple Magenta.

Fig 10 **Love-in-a-mist**
Cobalt, Ultramarine Violet, Purple Madder, Winsor Lemon + Olive Green.

Fig 11 *Gentiana sabra*
PETALS: Naples Yellow, Schmincke Ultramarine Violet, French Ultramarine, Cobalt, Schmincke Magenta, Winsor Lemon, Schmincke Olive, Yellow Ochre and Terre Vert. The Naples Yellow is applied in the centre and the Schmincke Ultramarine Violet is washed on the petals and merged with it before any darker washes are applied. As no white paint is used, try to work around the speckles and take your time.

△ Fig 9

△ Fig 10

◁ Fig 11

YELLOW FLOWERS

Fig 1 Tulip
FIRST WASH: Naples Yellow, Aureolin, Aurora Yellow, Cadmium Yellow, Quinacridone Gold, Quinacridone Red. 'Feathering' with Thioindigo Violet.

Fig 2 Rock rose
PETALS: Winsor Yellow, Cadmium Yellow, Gold Ochre, shaded with Terre Vert and Ultramarine Violet. Dark blotches of Perylene Maroon and Purple Madder.
LEAVES AND BUD: Terre Vert and Olive Green.

Fig 3 Pansy
PETALS: Cadmium Yellow, Lemon Yellow, Purple Madder and Windsor Violet. Touch of Olive Green at centre.

Fig 4 *Rosa* 'Simba'
PETALS: Aurora Yellow, Yellow Ochre, Cadmium Yellow.
SHADING: 'Botanical grey.'

Fig 5 *Rudbeckia*
PETALS: First wash of Cadmium Yellow to petals and centre. Perylene Maroon and Purple Madder. Pale wash of Purple Madder at centre, then stippled and hatched with Sepia cutting around the yellow stamens. Payne's Grey and Burnt Sienna for darkest moulding of centre.

PINK FLOWERS

Fig 6 Carnation
PETALS: First wash of Naples Yellow, then very dilute Cadmium Red. Thioindigo Violet and Ultramarine Violet for shading. The more intense colour on the petals is Scarlet Lake and Permanent Carmine.

Fig 7 *Rosa* 'China Pink'
PETALS: First wash of Naples Yellow, then very dilute Schmincke Madder Lake. Shaded with Schmincke Glowing Violet.
STAMENS: Gold Ochre, shaded with Sepia.

Fig 8 Pink petunia
CENTRE: Aureolin and Naples Yellow with a touch of Sap Green and Schmincke Glowing Violet. First wash of diluted Permanent Rose then, with less water, Glowing Violet, Quinacridone Red and Purple Madder. These colours mould the shape of the petals. When dry, the veins were added using strong Quinacridone Red and Purple Madder.

Fig 9 *Pelargonium* 'Pink Splash'
PETALS: First wash of Permanent Rose, shaded with

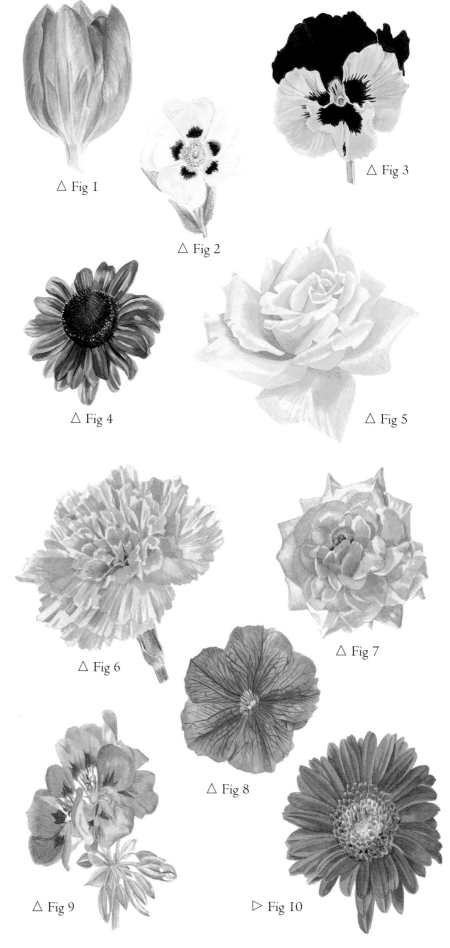

△ Fig 1

△ Fig 2

△ Fig 3

△ Fig 4

△ Fig 5

△ Fig 6

△ Fig 7

△ Fig 8

△ Fig 9

▷ Fig 10

Quinacridone Magenta and Schmincke Glowing
Violet. Centre details in Purple Madder.
BUDS: Olive Green, Prussian Green + Aurora Yellow.

Fig 10 *Gerbera*

CENTRE: Olive Green + Aureolin, with an outer ring of
Indian Yellow. All-over wash of Quinacridone Red, then
Permanent Rose and finally Purple Madder, all helping
to define the inner petals and the outer ray florets.

GREEN AND WHITE
FLOWERS

Fig 11 *Clematis montana*

PETALS: Washes irregular and pale, using Raw Sienna
and Olive Green and shading with 'botanical grey'.
CENTRE: Naples Yellow, Winsor Lemon darkened with
Payne's Grey.
LEAF: Schmincke Permanent Green + Olive and
Yellow Ochre.

Fig 12 Ivory Rose

PETALS: Naples Yellow with a touch of Olive Green
for the first wash but be careful to leave some white
paper as appropriate. Yellow Ochre, Winsor Yellow
and Winsor Lemon pick out the glowing areas.
Schmincke Glowing Violet shading. Cadmium Yellow
for final highlight colour.

Fig 13 Ivory azalea

PETALS: 'Botanical grey', Naples Yellow, Olive Green +
Terra Vert, Aurora Yellow, Cadmium Yellow.
STAMENS: Gold Ochre shaded with Burnt Umber.
FLOWER IN PROFILE: As before with a little Permanent
Carmine shading.

Fig 14 *Euphorbia*

PETALS: Aurora Yellow + Schmincke May Green.
Then the same mix with a little added Yellow Ochre.
A touch of Prussian Green and Gold Ochre.
LEAVES: Different proportions of the same pigments.

Fig 15 *Phalaenopsis* hybrid

PETALS: A tiny wash of Schmincke Glowing Violet is
painted in the centre, leaving the column white. The
sepals and petals are washed with Winsor Lemon, then
Gold Ochre and finally May Green, gradually moulding
with each colour. Blotches and speckles are added
when dry using variations of Schmincke Glowing
Violet, Quinacridone Violet and Purple Magenta. The
central lobe is washed with Cadmium Yellow and the
details added in the same range of magenta and violet.

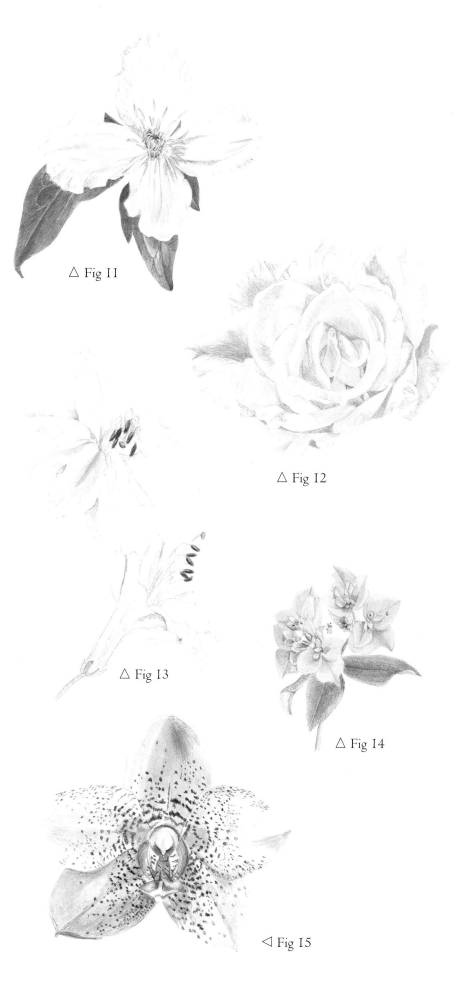

△ Fig 11

△ Fig 12

△ Fig 13

△ Fig 14

◁ Fig 15

CHAPTER 9
COMPOSITION

HOWEVER beautifully executed the painting, nothing will compensate for a poorly composed picture. Technique and colour may be perfect but the eye will not be deceived. All too often the novice painter will dive straight in without sparing time to consider the layout, which should be pleasing and harmonious. This means paying attention to the spaces between the component parts of the picture as well as the shapes created by the flowers themselves.

Remember to adapt your composition to your subject matter. Flowers with classic lines such as arums, tulips and lilies lend themselves to formal architectural layout, whereas cottage flowers do not. They need a looser, more informal spread which often mimics their growth. Think of these things while walking round a garden: often certain combinations of plants will catch the eye for later paintings.

▷ POPPIES, FOXGLOVES AND DIANTHUS
(*Papaver somniferum, Digitalis purpurea*
and *Dianthus*)
52.5 × 38 cm (20¾ × 15 in)
Watercolour
SARA ANNE SCHOFIELD FSBA

This painting demonstrates the use of an odd number of flowers to assist in the creation of a harmonious composition – in this case five poppies plus two foxgloves, with a triangle of three red poppies which exude a warm heart at the centre of the painting. All the poppy flowers are held at different angles, giving a spiral effect. Three buds take the eye across in a gentle curve while the little dianthus provide a colour link to the main flowers. A broad triangle of poppy leaves is interlinked with three foxglove leaves which anchor the arrangement. All the stems intertwine naturally with no feeling of artifice.

BASIC RULES

The few basic rules that should be followed are often just a matter of common sense. The first of these, so obvious yet often overlooked, is to make sure that you have allowed sufficient room on the paper for the flower which you intend to portray. If, for example, you have a tall stem of delphinium before you, do not just go in unthinkingly and start to draw the flowers at eye level because you will run out of paper for sure, probably about 15 cm (6 in) below the top of the spire.

▷ PHYSALIS
(*CHINESE LANTERNS*)
and GRASSES
78 × 58 cm
(30¾ × 23 in)
Watercolour
BILLY SHOWELL
SBA

In this study Billy has softened the upright lines of the physalis by backing them with the arching grasses. By dividing the painting vertically in this way she has again given a modern slant to the composition. Note the drawn line which 'signs off' at the bottom of the painting.

△ CALLA LILIES
68 × 48 cm
(26¾ × 18¾ in)
Watercolour
BILLY SHOWELL SBA

This painting shows the classic beauty of calla blooms to perfection. This is a contemporary, almost architectural image, where nothing is allowed to detract from the austere simplicity of the flowers and where even the line drawn at the bottom of the stems is an integral part of the design.

Measure and plot the position of the florets down the stem in order to avoid a great deal of wasted time and effort. This applies to many long-stemmed flowers. In the case of lilies, allow for the buds which often stand proud of the top bloom and do not let yourself to be beguiled by the perfect bloom which demands to be painted in prime position on your paper. That prime position will probably be in the lower third, not half-way up, if the rest of the stem is to get a look-in.

When you are painting a mixture of flowers, consider the size of each in relation to the other. This is easily done by visualizing them as they would appear in a bouquet or vase. Composition is really flower arranging on paper, and I doubt if you would display a vase of daffodils with the trumpets of the 'outside' flowers turned in towards the centre of the arrangement, yet occasionally students place the flowers at the extreme right or left of the paper in just such a way. Flowers need to look out at the viewer, not inwards.

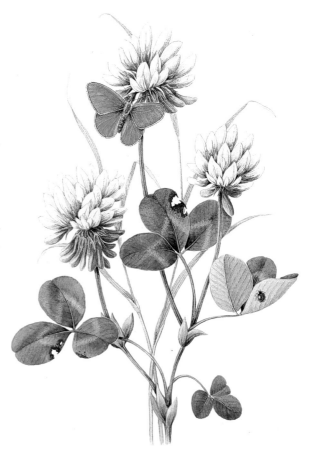

△ WILD FLOWERS FROM TRESCO
28 × 21.5 cm (11 × 8½ in)
Watercolour
Elizabeth Smail FSBA

This apparently artless grouping takes the tall foxglove as its focal point and is given solidity by the bulk of the iris leaves next to it. The three touches of yellow create an eye-catching diagonal from the trefoil at the bottom, while the combined yellow and pink of the honeysuckle holds the composition together at its centre. Notice the triangle of three campion flowers and the way in which the intense blue of the speedwell gives a lift to the painting out of all proportion to its size. Cover it with the end of a pencil and see the difference.

▷ COMMON CLOVER
(*Trifolium repens*) and
COMMON BLUE BUTTERFLY
20.5 × 15 cm (8 × 6 in)
Watercolour
Bridgitte James SBA

Here a simple sprig of clover painted in a classical botanical style is given added grace by the presence of the background grasses. This is one of those occasions when the interstices contribute to the design and soften the rather formal triangle of flowers and leaves. The blue butterfly perched upon the uppermost flower gives an immense fillip to what would otherwise be a fairly low-key painting.

△ NUTS and SEEDS
25.5 × 35.5 cm (10 × 14 in)
Watercolour
BRENDA WATTS SBA

This collection of found objects is a popular form of botanical study and is a refined version of the library page or worksheet. Unlike the worksheet, much thought needs to go into the placing of the objects, both in form and colour. Note how the green tones on the left-hand side are echoed by the fig on the right, which is again balanced by the shape of the hip. The lightest green of the hazelnuts lifts the tone of the whole study, while the skeletal leaf adds delicacy without which the shapes would be all rather similar.

◁ PASSION FLOWER
(*Passiflora alata*)
48 × 41 cm (18¾ × 16 in)
Watercolour
LIZZIE SANDERS
SBA

As a botanical study, two very salient points are made by the way in which it is composed. In the first place the habit of growth is established so that one feels the weight of the fruit pulling it down, yet the presence of tendrils establish it as a self-supporting climber. The way the foliage is cut off at the top of the painting indicates the bulk of the plant from which it has emerged. Great attention to detail has resulted in an exquisite portrayal of the flower.

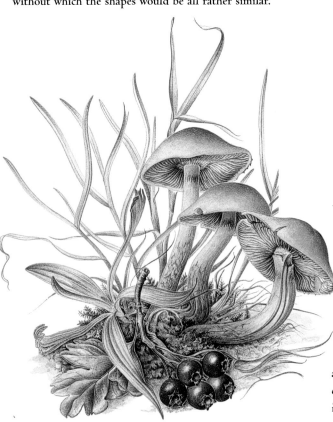

◁ SULPHUR TUFT
(*Hypholoma fasciculare*)
23 × 16 cm (9 × 6¼ in)
BRIGITTE E M DANIEL SBA

This small study has been very well considered, with the contortions of the fungi balanced by the foliage and grasses. The inclusion of five crimson haws has introduced just the right amount of contrast, adding warmth to the colour composition. Cover the berries and see how much is lost when they are no longer visible.

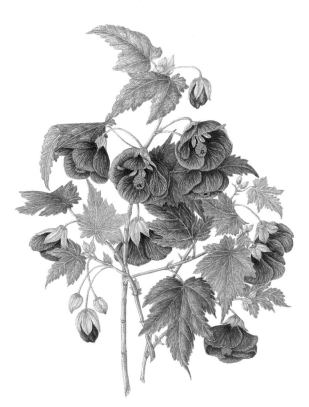

△ *ABUTILON* HYBRID
30.5 × 20 cm (12 × 7¾ in)
Watercolour
AINO JACEVICIUS SBA

Students often find it difficult to paint a piece of shrub in a way that avoids a 'lollipop on a stick' effect. The main branch is positioned and its flowers and leaves painted before they fade. The stem is best left pencilled in at this stage so the second piece can be added on the left, its stem crossing in front of the main stem. A third sprig is added on the right, its stem positioned at the back, behind the other two, which gives a feeling of depth. The flowers of this piece are partly obscured by leaves, taking the colour right across the picture and with its fullness giving a good impression of the plant's habit of growth.

▷ *LILIUM* 'PINK PERFECTION' and
ERYNGIUM GIGANTEUM
63.5 × 38 cm (21 × 15 in)
Watercolour
ALISTER MATHEWS SBA

Another example of a composition which emphasizes the vertical, with this time the soft tone of the eryngium creating a traditional effect rather than the more contemporary lines in Billy Showell's physalis. This highlights the way in which the choice of colour rather than format sets the mood of the painting.

Odd numbers of blooms will always create greater harmony and will be simpler to place to advantage, particularly in triangular shapes. Remember that it is easy to give a three-dimensional effect to your composition by showing some flowers in three-quarters profile as if they are turning towards the back and, indeed, showing the backs of one or two well-placed blooms will increase the sense that there is more to see if we could only turn the arrangement around.

Just as there are artists to whom technique comes naturally, so there are the ones blessed with an inborn sense of colour harmony and form. Most of us, however, have to struggle and learn by trial and error. One of the best ways to illustrate composition is by example, and I hope the comments on the paintings in this chapter will be beneficial.

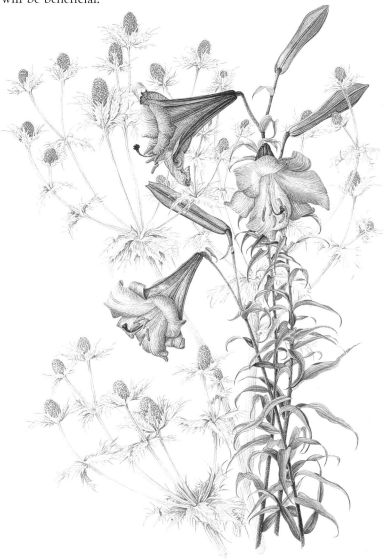

CHAPTER 10

FLOWER PORTRAITS IN WATERCOLOUR

I OFTEN THINK that watercolours were invented for the sheer enjoyment of the botanical painter. After the beautiful but opaque medium of tempera there must have been such excitement when this new transparent medium became available. In the following pages you will be able to follow step-by-step examples of watercolour studies which should help you to understand the practical application of techniques described in Chapter 6.

Be prepared to work in a cool room, particularly with flowering bulbs such as crocus or tulips. Avoid holding your specimen. With the use of florists' oasis you can usually position a stem long enough to draw it and apply the first washes. A model maker's 'third hand' is also invaluable for keeping a bloom at the required angle.

Flowers kept overnight need to be as cool as possible and most are fine placed in the refrigerator. Put specimens such as mosses on damp kitchen paper in a polythene box first. Allowing flowers to have a good long drink by standing them in a bucket of water before selecting your specimens will ensure that they have 'settled'. Singeing the stems of poppies will give you a chance to finish your painting before they wilt, while dipping rose stems in boiling water for 20 seconds prolongs their life and prevents soft necks and droopy heads.

▷ TURNING
AUTUMN
71 × 48 cm
(28 × 18¾ in)
JENNY JOWETT FSBA

Not only is this an extremely well-balanced composition but the colours are equally well co-ordinated. The soft pink carries through all the elements of the painting from the leaves of *Vitis vinifera* 'Purpurea', *Amaryllis belladonna* and hydrangea to the very bloom on the grapes. Such colour transference creates a unity in the composition.

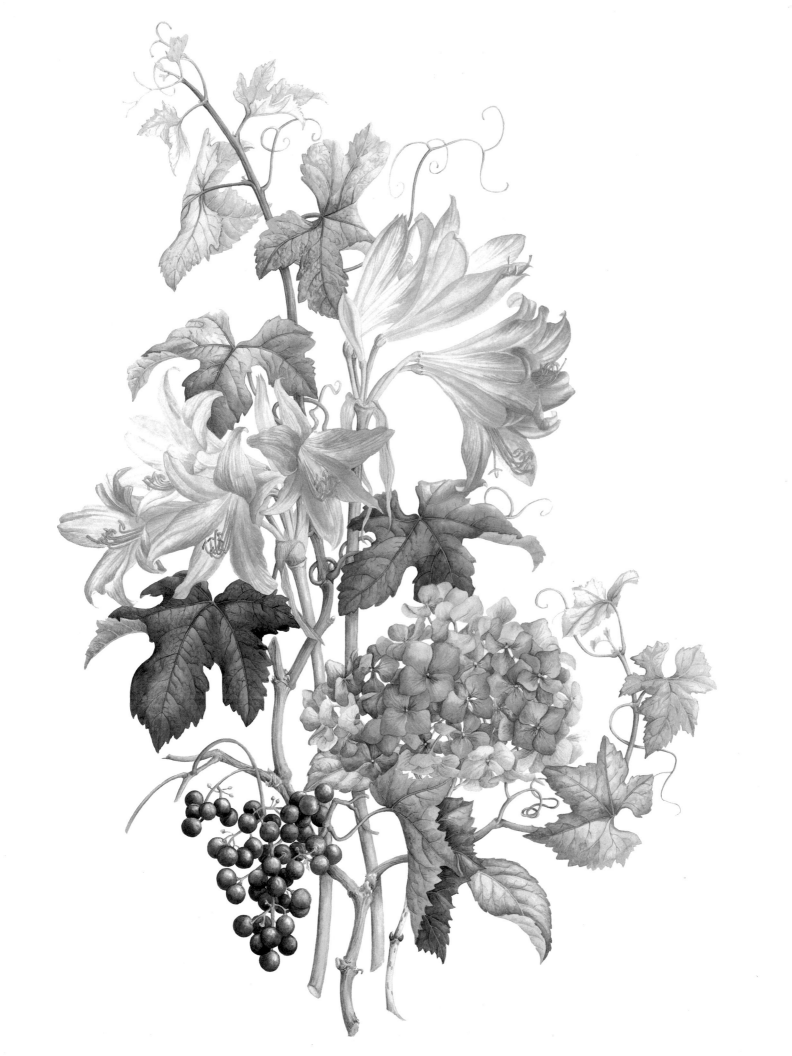

PELARGONIUM
Pelargonium 'Maverick Pink'

Brigitte E M Daniel SBA

This stunning pelargonium made a great impression on Brigitte
when she first saw it in bloom. The vibrant pink flowers coupled with the very attractive
mid-green foliage demanded to be painted and, as you can see, the result justified the time
and devotion to detail which she lavished upon it.

PAINTS

WINSOR & NEWTON
Rose Madder Genuine
Rose Madder
Permanent Sap Green
Hooker's Green
Cerulean Blue
Lemon Yellow
Payne's Grey
Permanent White gouache

SENNELIER
Alizarin Crimson

DALER-ROWNEY
Permanent Rose

BRUSHES

WINSOR & NEWTON
Series 7 Nos. 1 and 2

SURFACE

FABRIANO
*Classico 5 HP 300 gsm
(140 lb) paper*

△ **Stage 1**
Like so many botanical painters, Brigitte appreciates the whiteness of Fabriano Classico 5 HP paper and she drew the initial outline on this using an HB pencil. Composition when working with plants such as pelargoniums can be tricky because of their growth habit. They tend to produce long, thick stems before developing flower buds, also borne on long stalks. To avoid a 'blob on a stick' appearance

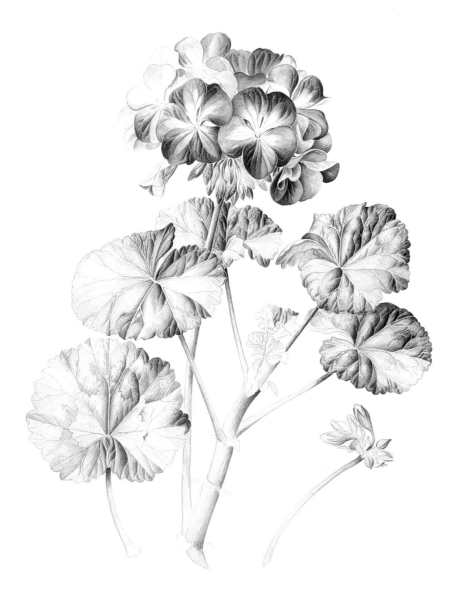

Brigitte added a detailed leaf and flower bud. This would help to pull the pink colour across the painting without devaluing the focal point, that is, the central flowers.

△ **Detail of Stage 1**

△ **Stage 2**

Brigitte advises the student to start on the two flowers which are the main focal point and will, of course, fade before the leaves. Use minimal pencil work and very little erasure to avoid paper damage. As you begin to use the pigments keep the washes bright and clean, making sure the water is changed regularly. It is also important to keep the washes under control; the bright white eyes of the flowers, which appear as the flowers develop, are at the heart of the painting and make a vital contribution to the character of the plant.

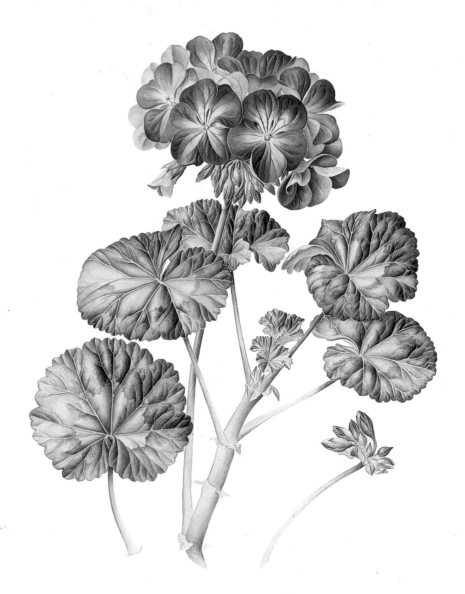

△ Stage 3

The aim at this stage is to start modelling the painting. First of all, find the depth by adding cooler, darker colours behind the stem, some leaves and the flower head. Then use warmer, brighter colours in the foreground which helps to build up the three-dimensional effect. Next, work on the middle parts of the plant, taking great care with the washes. It is important not to lose the shine on the leaf and the flower surface.

△ Detail of Stage 3

▷ Final Stage

Once the middle tones of the plant are completed, deepen the shadows as required and continue to 'model' the image. With a smaller brush, sharpen the edges of the leaves and flowers. Finally, use Permanent White gouache to pick out the hairs that overlap the stems and buds. Remember that this is not a photograph and your painting is an attempt to capture the essence of the plant. When you feel you have done this, stop. Concentrate on typical features and the characteristics of the species and you will have created a true plant portrait.

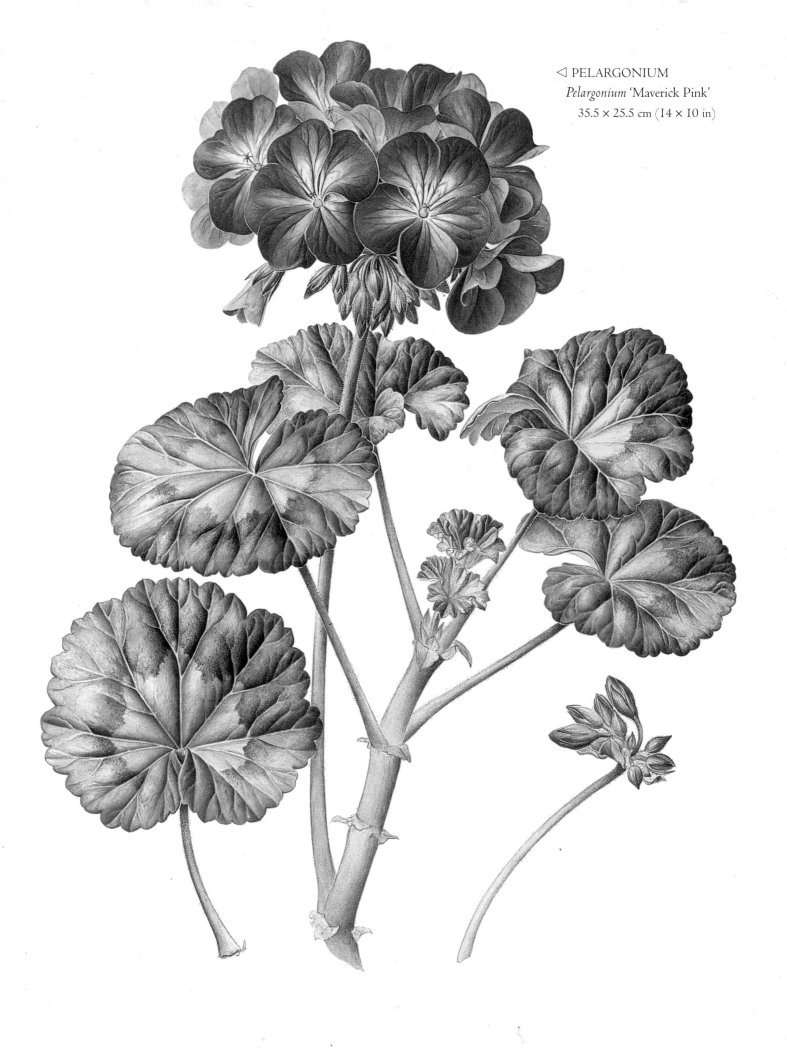

◁ PELARGONIUM
Pelargonium 'Maverick Pink'
35.5 × 25.5 cm (14 × 10 in)

ORANGE PARROT TULIPS

Tulipa 'Orange Parrot'

Paul Fennell SBA

Paul says that the 'swagger' and petal texture of these flamboyant tulips
appeals to him, as does their historical connection with the seventeenth-century Dutch
paintings. Initially he does a number of thumbnail sketches, then a very rough
compositional drawing, using a B pencil, which can be rubbed out and refined. Most of
the drawing is done with the first washes of colour.

PAINTS

WINSOR & NEWTON
Transparent Yellow
Cadmium Red Light
Cadmium Red Deep
Cobalt Blue
Permanent Sap Green

BRUSHES

DALER-ROWNEY
*S40 Kolinsky sable sizes
8, 4 and 2*

SURFACE

WINSOR & NEWTON
*Lana 300 gsm (1401b)
HP paper*

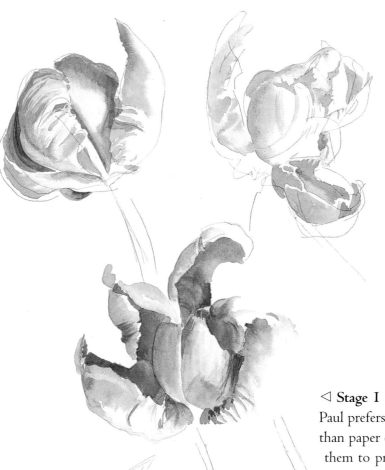

◁ **Stage I**
Paul prefers to use stretched paper rather
than paper on blocks or pads. Stretching
them to prevent cockling means he can
use larger sheets of lighter-weight
paper, which have to be put onto rigid
board such as hardboard or MDF. To
stretch paper, soak it in clean, cold
water (the bath is ideal), then lift it out
and drain off the excess water. Making
sure that you have the correct surface
uppermost, lay the paper on the board.
Use lengths of dampened gummed tape

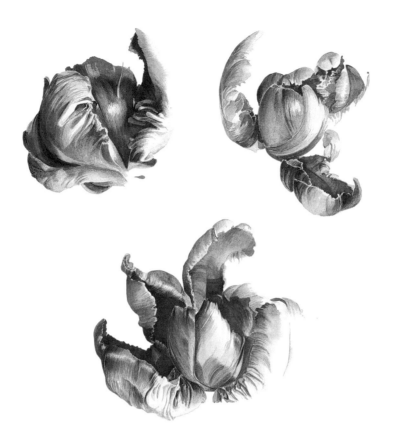

4–5 cm (1.5–2 in) wide to fix the four edges down evenly, making sure half of the tape width is over the paper and the other half on the board. Leave this flat to dry for several hours and you should have a perfectly taut, flat surface on which to work.

For this painting Paul used a limited palette of Transparent Yellow, Cadmium Red Light, Cadmium Red Deep and Cobalt Blue. He applied first washes with very diluted colour, painted loosely in order to get a pale 'feel' to the flower. The leaves were not included since tulips have such a short and changeable life that it was important to paint the flowers first. Paul erases his pencil marks at this point, although he may sometimes add others later on if he feels they will be helpful.

△ Stage 2

The aim at this stage was to create a feeling of plasticity and volume and a three-dimensional effect, using the same colours but in more concentrated form. Noting negative shapes of light and dark within the subject is important. This is the most challenging stage of the

painting and if it goes wrong now it is best to start again from scratch.

Some of the stage 1 washes were modified by strengthening the shadows and midtones. This was done in the larger areas by applying clean water and floating colour into them, which avoids the appearance of brush strokes. Where texture was required, paint was applied onto the dry surface, taking care to paint with the direction of the movement or growth of the petal – you should never paint across the growth. The paint used was slightly thicker, therefore darker.

Paul modified the tones by adding another wash, taking care not to disturb the previous ones. Colour should not be lifted or washed out at this stage as this creates a grainy look which is inappropriate for these petals. Do not feel that you have to over-paint all of the previous stage, as you should find that some of the washes were right first time. Plenty of white areas of paper are left for the highlights and it is often a good idea to leave more than you think you might need. Using a mirror to check balance and distribution of lights and darks is very helpful at this stage.

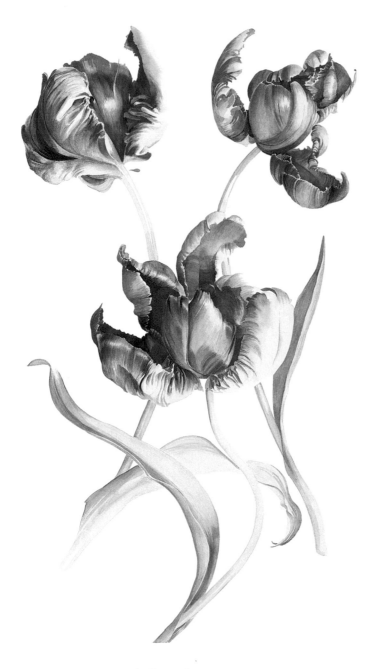

with some orange mixed from red and yellow was used for the warmer shadowy areas.

By introducing some of the flower colours into the leaves harmony is created throughout the painting. Sometimes a plant displays a very visible exchange of colour between flowers and foliage, which is known as colour transference.

▷ Final Stage

The previous stages should provide the skeleton but the final stage supplies the detail. Essentially it is about shadows, which create that detail. Remember that you cannot add highlights. Light and midtones are barely touched. Here, Cadmium Red was mixed with Transparent Yellow and a little Cobalt Blue for the shadow tones: the less water used, the darker the tone. Proceed carefully and do not get carried away by these darker tones.

The very light areas on the right-hand side of the flowers, where the light hits them, were modified by a thin delicate wash of yellow with a little red and plenty of water, sometimes layer upon layer, to achieve subtle tonal graduation. Do not feel you have to paint over everything; be content to leave some areas untouched from earlier stages. Detailed small areas may need dozens of little washes whereas larger areas will be relatively untouched, such as on the right-hand petal of the central flower. A cross-section of the painting would show that some areas have just one wash while others have many.

Now use a mirror to look at your painting, which will help you assess the composition and tonal balance. Paul felt there was too much space between the central flower and the one at top right, so he extended a petal downwards to lessen the gap. Some leaves were also modified. Check for consistency of tones throughout, making sure that one flower is not too dark or light against others. Ensure that the parts of the painting look unified, which in this case was achieved by colour transference. The underside of the central flower reflects green from the adjacent leaf; conversely some red or orange is mixed with the green.

△ Stage 3

Paul now started to think about the leaves, making the most of any twists, turns or wavy edges in order to avoid the monotonous look that many tulip leaves display. Much thought goes into the composition at this stage as leaves are a great way of suggesting depth, framing the flowers and leading the eye into the composition. Some artists undervalue leaves and do not pay them nearly enough attention in regards to both form and accuracy of colour.

The colour used is Permanent Sap Green heavily diluted and mixed with Cobalt Blue for the cooler highlighted areas. A richer colour

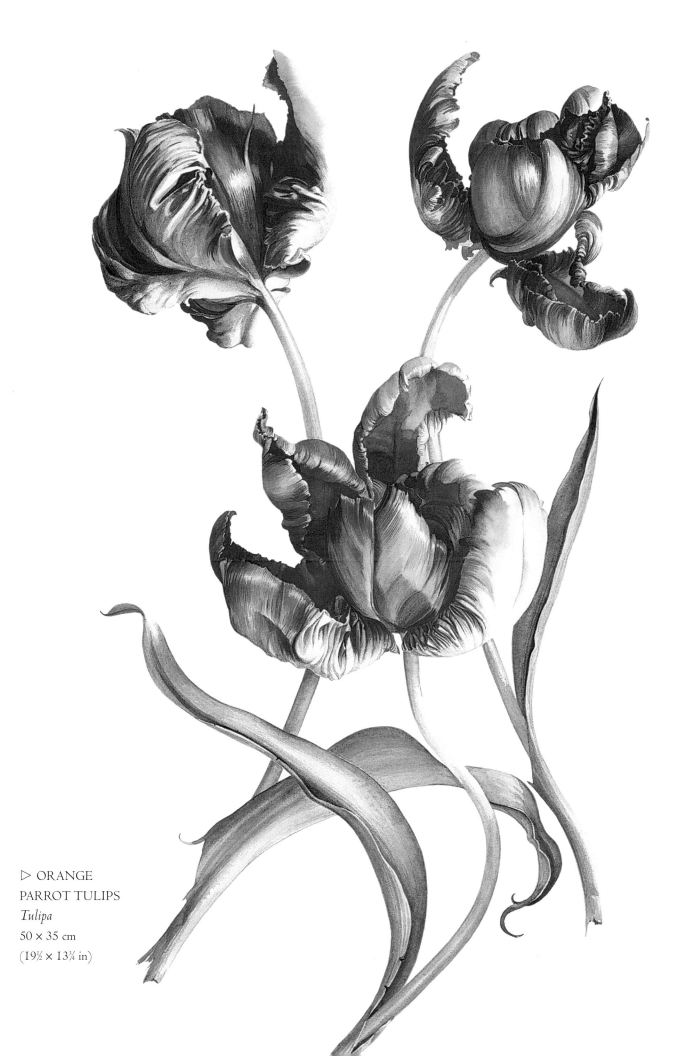

▷ ORANGE
PARROT TULIPS
Tulipa
50 × 35 cm
(19½ × 13¾ in)

AGAPANTHUS

Agapanthus praecox subsp. *orientalis*

Sally Crosthwaite SBA

Sally likes a challenge but even she found this large agapanthus flower head rather daunting. In order to aid her understanding of the plant she decided to do a comprehensive drawing before picking up her paint brush. Luckily it flowers for quite a long period so she could afford the time spent on an observational drawing.

PAINTS

SCHMINCKE
Ultramarine Violet
Raw Sienna
French Ultramarine
Aureolin Yellow

BRUSHES

DA VINCI
Maestro Nos. 1, 2 and 5

WINSOR & NEWTON
Series 7 No. 000

SURFACE

FABRIANO
*Artistico HP 300 gsm
(140 lb) paper*

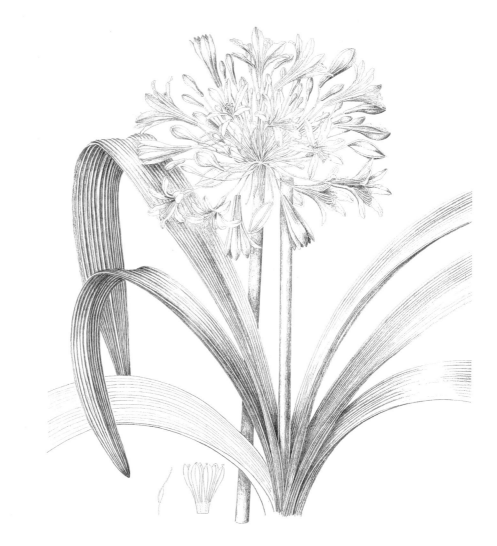

△ **Stage I**
The careful drawing exercise is a method Sally often uses when tackling a new and complicated plant. As well as learning from it, by noting colours and tonal values she is prepared if the specimen dies before the painting is completed. She also dissects a flower head to study what goes on inside the tubular structure and to do an individual drawing of anthers and other details. Sally's observational notes were:

● Leaves: arching leaves up to 70 cm (27½ in) long and 5.5 cm (2¼ in) wide. Peduncle (main stem): rather stout.

- Inflorescence: many flowers. Pedicle (stalks leading to individual flowers): 9–12 cm (3½–4¾ in) long.
- Flowers: violet blue with wavy petals, 4–5cm (1½–2 in) long.
- Stamens as long as or slightly longer than the flower.

It is important to spend time working out the composition in order to give a true representation of the plant, bending a leaf or two if it makes it more visually pleasing. By allowing the long, strap-like leaves to go off the paper it helps to indicate that this is a large, strong plant. Note the position of the cut flower stem in relation to the plant, thereby indicating its height. Sally's preliminary drawing was done on cartridge paper using a mechanical 0.5 mm HB pencil for shading and a 0.3 mm HB for outline, filaments, anthers and any detail.

▷ Stage 2

Once Sally is satisfied with the shading and composition she transfers the image, with the aid of a light box, onto Fabriano Artistico HP 300 gsm (140 lb) paper. She uses a 0.3 mm HB pencil for the outline which will eventually be erased.

Next she works to establish the correct colours by trying out washes of varying strengths on strips of paper. When these are dry they are held against the plant to check for a true match. At this stage the palette consists of just four colours: Schmincke Ultramarine Violet, Raw Sienna, French Ultramarine and Aureolin Yellow, the latter two making the green.

Using the No. 1 brush, Sally started to work on the flowers using a dilute wash of Ultramarine Violet. A fine 000 brush was used to outline filaments, anthers and stigma and the area around these was darkened in order to establish their position.

Inside the tubular part of the flower she used a stronger wash on the inside top and less paint on the bottom petals to give a feeling of depth.

The main rib or vein was allowed to show on the outside of the petals. Sally then outlined the pedicles or flower stalks with the same fine brush, using a green mix of French Ultramarine and Aureolin.

For the leaves, she used the larger brush, wetting one leaf at a time and applying a thin wash of French Ultramarine and Aureolin. When this was dry she added the leaf veins with a pencil, using the lower part of the arm as a pivot to keep the lines steady. The bracts received a delicate wash of Raw Sienna. The main stem was only outlined with the same green mix at this stage.

The pencil arrows served to remind Sally of the direction of the light source and the crosses reminded her that these areas were to remain white. By the end of this stage there was a very pale version of the plant in front of her.

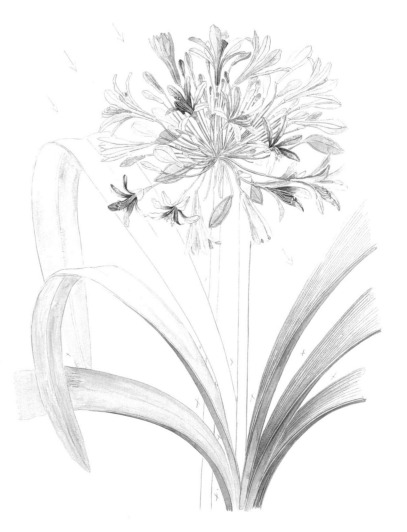

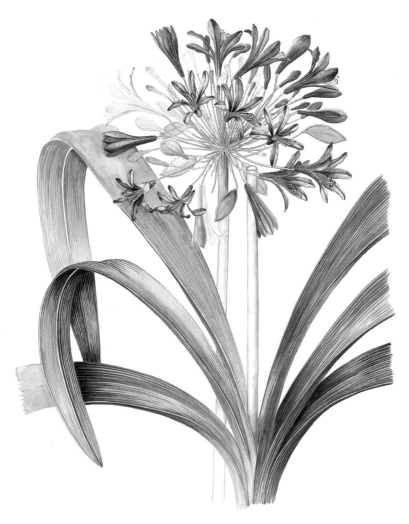

Stage 3

Now Sally clarified with her paintbrush all the information gained from the detailed drawing, giving each flower a three-dimensional look. The veins were indicated in the leaves, quite prominently on the underside but more understated on the top. She painted the anthers first with Neutral Tint and then a small amount of Lamp Black to add form.

▷ Final Stage

At this stage Sally crisped up all the edges. She added a darker tone behind overlapping pedicles, thereby pushing the front ones forward. This is particularly important at the base of the pedicles in order to show that they are all growing from the small area at the top of the stem. She darkened the right-hand side of the main stem to give a three-dimensional look. A strong mix of the Aureolin and French Ultramarine was painted over the leaves, covering most of the veins but at the same time indicating that they are there.

The curving parts on the petals were crisped up to add interest. Time spent on attention to detail such as the shadows cast on the flower stem by the leaves all go to make the finished portrait.

Sally says that if she were to paint this again she would keep the left-hand side of the whole flower area pale and make the right-hand side darker to give a greater three-dimensional effect. Botanical artists, it seems, are never satisfied.

▷ **Detail of Stage 3**

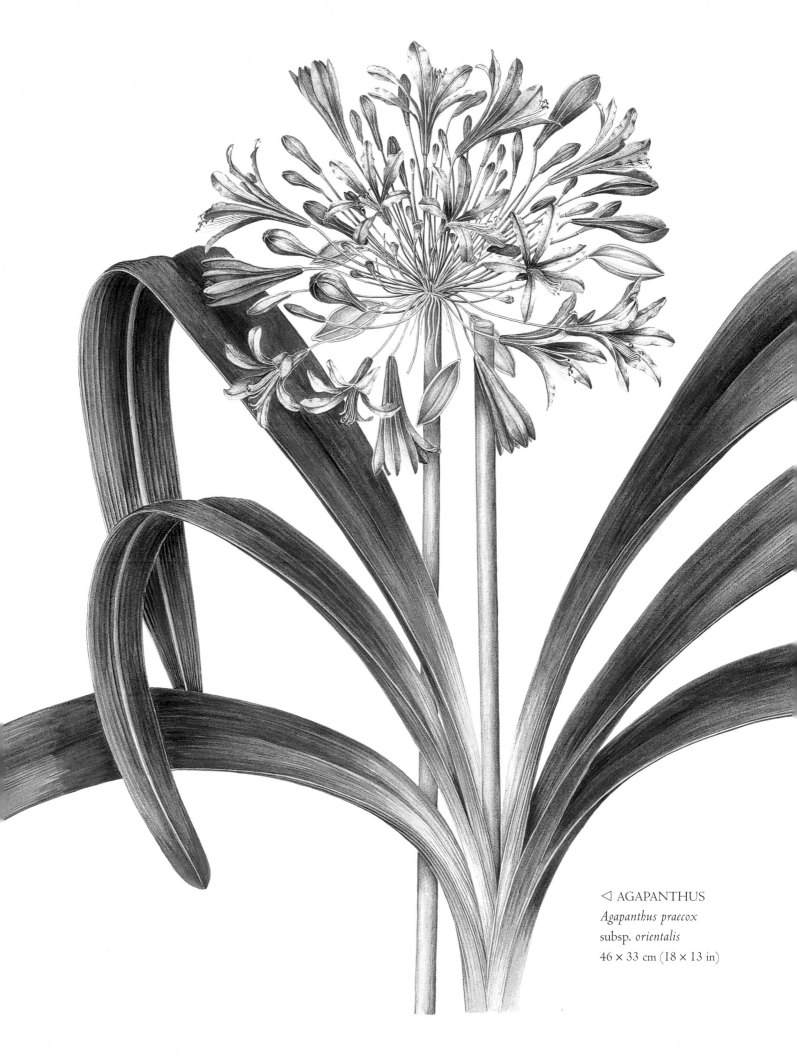

◁ AGAPANTHUS
Agapanthus praecox
subsp. *orientalis*
46 × 33 cm (18 × 13 in)

CAMELLIA 'WHITE SWAN'
Camellia japonica 'White Swan'

Jenny Jowett FSBA

Many students are afraid to tackle a 'white on white' flower study, believing it is necessary to put in a coloured background. Jenny's painting of a semi-double camellia shows that this is truly not the case and following her method will prove it to you.

PAINTS

WINSOR & NEWTON
French Ultramarine
Aureolin
Raw Sienna
Light Red

BRUSHES

DA VINCI
Maestro sizes 3 and 5

SURFACE

ARCHES
HP 300 gsm (140 lb) paper

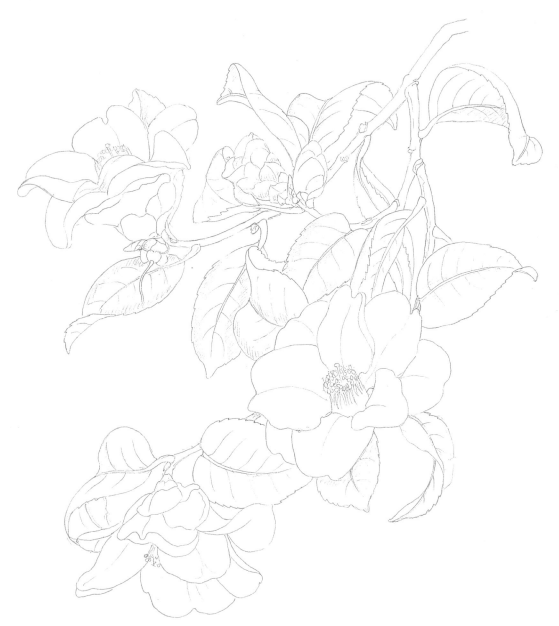

△ **Stage I**
Jenny put the specimen in a bowl filled with florists' oasis which she then placed on top of a tin. This enabled the branch to hang down in a manner which replicated the loose habit of the growing shrub. She began her work by doing a line drawing, using a clutch pencil with an F lead.

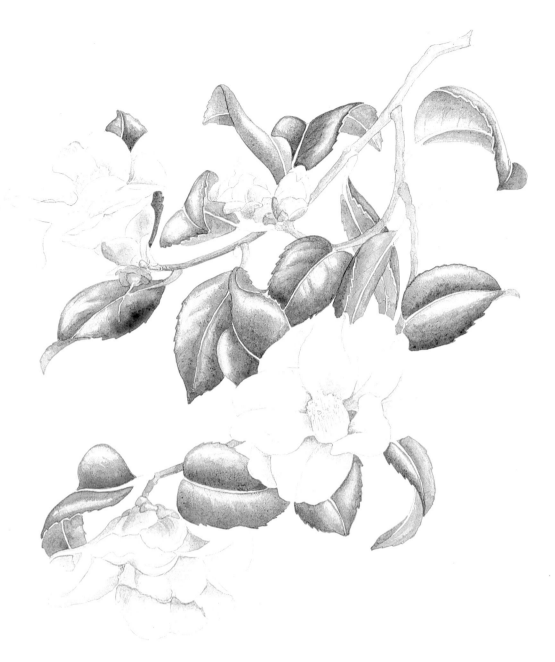

△ Stage 2

The only colours used in this study are French Ultramarine, Aureolin, Raw Sienna and Light Red. Using them in different combinations and proportions gave Jenny all the greys she needed for the flowers and stems, with a little Aureolin added for the stamens. The leaves were painted with a combination of French Ultramarine, Aureolin and a very little Light Red to keep the green natural.

The whole of this stage was done in wet washes, with an extra brush filled with clean water to keep the highlight areas open. Size 3 and 5 brushes were kept fully loaded with paint.

△ **Detail of Stage 2**

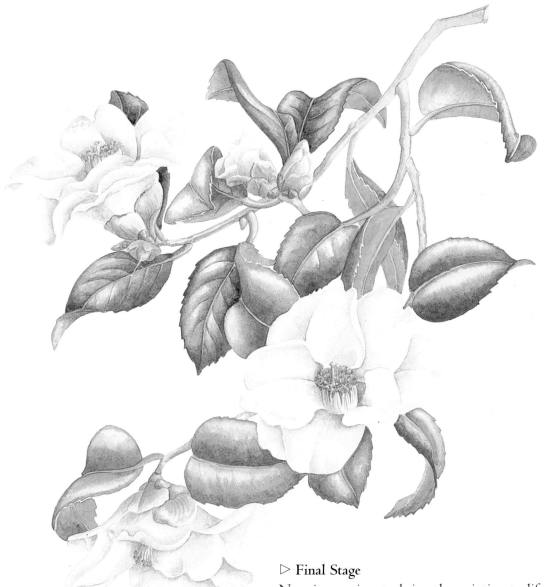

△ Stage 3

No further colours were needed as Jenny always chooses to work with a limited palette and never uses manufactured colours that she can mix, such as green or purple. She began to work up the flowers, starting with the filaments. Leaving the original pale wash, darker areas were added for definition, as well as the yellow stamens. Some of the shadows were strengthened. All the buds' calyces were painted at this stage while the specimens were still fresh.

Jenny put a first wash on the veins and started a few leaves. This was all executed in wet washes but, in order not to disturb the earlier wash, she avoided touching the under-painting.

▷ Final Stage

Now it was time to bring the painting to life. The tonal values needed to be heightened and all the leaves needed a second wash on the shadowed sides. When using such dark colours make sure that the last application of paint is totally dry. Otherwise you will lift the under-paint and make the work look very muddy. Stems and stalks were also darkened.

Jenny used a dry brush to put in the centres of the flowers to make them more three-dimensional. She points out that it is necessary to be careful not to overdo the greys in white flowers and to make sure that some white paper is left unpainted. By virtue of the contrasting tones the viewer's eye is led to believe in the whiteness of the flower even though the paper is actually a natural or ivory shade.

▷ CAMELLIA 'WHITE SWAN'
Camellia japonica 'White Swan'
30.5 × 25.5 cm (12 × 10 in)

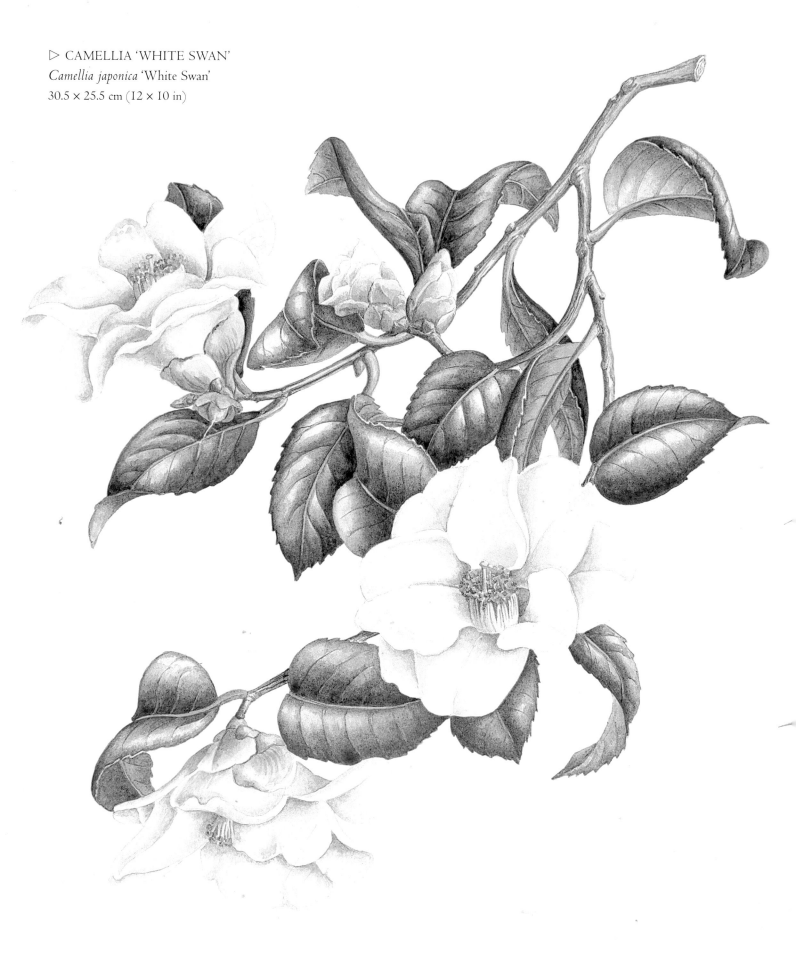

CHAPTER 11
PAINTING IN GOUACHE

T HIS CHAPTER features the work of just two artists, Sally Keir and Simon Williams, both of whom choose to work in gouache. You can compare their respective methods, starting with Sally's stunning paintings, all of which succeed in capturing light and translucence with an opaque medium. As she herself says, 'I feel sure I don't work in a traditional way – I've worked out what I want to do and how to achieve it, but I've never had any lessons or read any books about gouache technique.'

Gouache was a favoured medium on mainland Europe, particularly France, long after the transparency and luminosity of pure watercolour captured the attention of English artists. The technique dates back to ancient Egypt and was popular throughout the Middle Ages for illuminating manuscripts. It was sometimes used alongside egg tempera, that other opaque medium beloved by fresco painters and the Old Masters. Now, many centuries later, botanical painting is enriched by its use.

▷ *LILIUM*
'AFRICAN QUEEN'
38 × 30.5 cm
(15 × 12 in)
SALLY KEIR SBA

This dramatic study with its strong shadows is typical of the effect Sally strives for, full of light and radiance. The shadows cast upon the lower petals give added impact. As this picture shows, Sally has no fear of using yellow. Budding artists often shy away from it, believing it to be a difficult colour, but like most things, with practice it becomes possible.

TECHNIQUE

Sally possesses a large selection of pigments and always does a sample of dilute and strong tones on card before beginning work to aid her selection of the six or more colours that are needed for a particular painting. She puts a small amount of each colour around a circular palette, with a generous blob of white placed centrally. White is added to all her colours except when she puts a unifying layer of translucent colour over an entire leaf or petal. A colour may be deepened or intensified by adding either a deeper colour, dark brown or a touch of black.

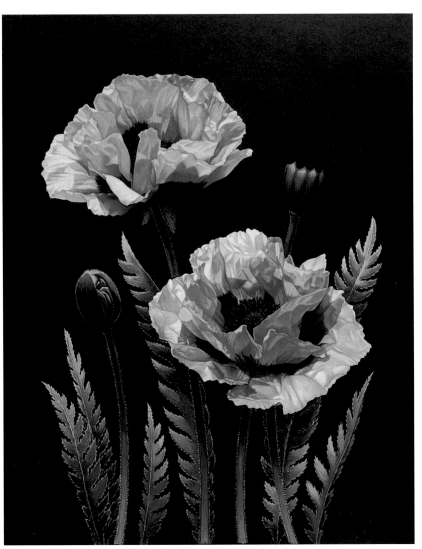

△ PINK POPPY
(*Papaver orientale*)
38 × 30.5 cm (15 × 12 in)
SALLY KEIR SBA

These poppies prove that the use of gouache is no bar to achieving delicate effects, such as these crumpled tissue paper-like petals. Note, too, the glowing heart of the lower flower and the light edges of the leaves, the latter intensifying the suggestion of backlighting. Remember that the light source need not necessarily come from the side or front and it is worth experimenting to see how your subject looks when lit from behind. Redouté used this technique on occasions with breathtaking results, but not for the paintings for which he is best known, such as those of the roses.

△ DAFFODILS
38 × 30.5 cm (15 × 12 in)
SALLY KEIR SBA

Sally likes to show the backs of some flowers as these are generally ignored and yet are often a very attractive part of the plant. *Meconopsis × sheldonii* is another plant she recommends as worthy of a rear view as this is where the iridescent shades of blue are often strongest.

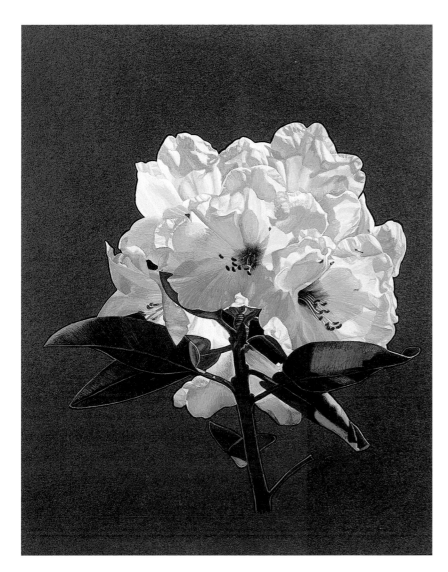

◁ *RHODODENDRON* 'IDEALIST'

38 × 30.5 cm (15 × 12 in)

SALLY KEIR SBA

In this painting Sally gives the impression of capturing light itself and not just the beauty of the soft yellow flowers. She has done this by keeping her colours pure, with no sign of unnecessary shading other than that which assists the overall effect. All those who tend to overwork, take note.

▽ *CAMPANULA*

38 × 30.5 cm (15 × 12 in)

SALLY KEIR SBA

Once again, backlighting has helped to create a fantasy of shapes and shadows from what is intrinsically a straight-forward flower. Note the way the narrow edging to stems and calyces helps to give the feeling of a plant tipped with light.

Sally works on dark green card and usually chooses white drawing ink as a base. The gouache is built up in layers. Red can be tricky as it differs greatly when dry and requires a lot of overpainting to get it right. Sally's paintings take up to a week and the white paint on the palette has to be changed daily as it becomes chalky and granular. Other colours last longer.

The finished painting is sprayed with matt spray-on varnish which protects it, intensifies the colours and darkens the card to a very dark green. Sally's brushes range from sizes 00000 to 2 which wear out quite quickly and are downgraded to other uses. Synthetic brushes are suitable for use with gouache.

Sally likes to work close to her painting, about 20.5 cm (8 in) away. She uses an almost upright easel with a kneeling chair.

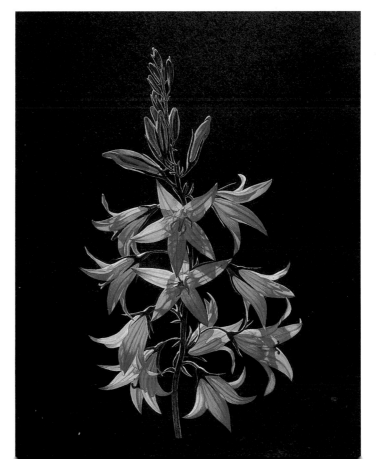

TROPICAL PITCHER PLANT
Nepenthes

Simon Williams SBA

Simon was attracted to this unusual and fascinating plant by its colour and patterns which made it an interesting subject to paint. He advises against using white in the early stages as the paint will go quite chalky and be hard to work with.

PAINTS

WINSOR & NEWTON
DESIGNERS GOUACHE
Permanent Green Middle
Vandyke Brown
Indigo Blue
Havannah Lake
Orange Lake Light
Light Green
Naples Yellow
Flesh Tint
Spectrum Yellow
Permanent White

BRUSHES

WINSOR & NEWTON
Series 7 sable,
sizes 2 and 4

SURFACE

FABRIANO
Pittura 400 gsm
(140 lb) paper

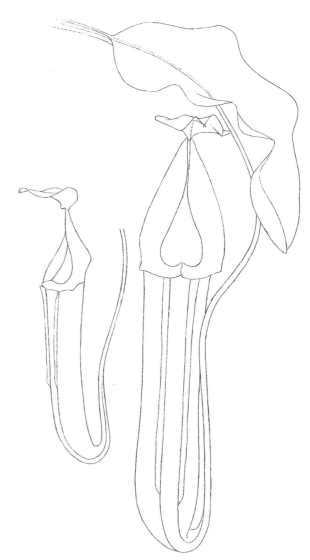

△ **Stage 1**
Simon's initial drawing was done on the Fabriano paper, which did not require stretching, using a 3H pencil which gave a clear, crisp outline. Pencil shading and detail was not required. The simple outline works well as a 'cut to white' (with no background) illustration.

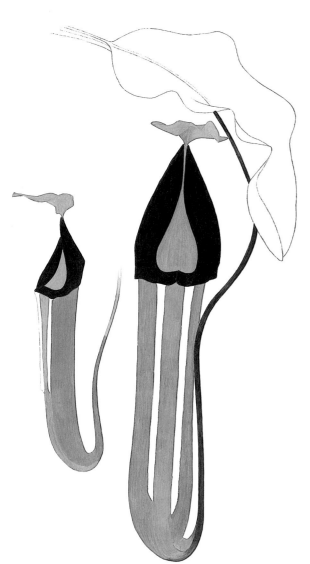

▽ **Stage 3**

The colour was built up carefully by applying layers of lighter green on top of the dark layer, using slightly less water and smaller, more controlled brush strokes. Light Green and Naples Yellow were added to the existing colours used for the dark wash. The proportion of Light Green was greater than that of the Naples Yellow.

Simon used Havannah Lake with an added touch of Flesh Tint around the lip of the flower and also to roughly paint in some of the markings so that he had an idea of the pattern and grooves. He aimed to start building up a thickness to the gouache so that the colours blend together nicely. While this process is carried out it is best to work on small sections of the painting at a time.

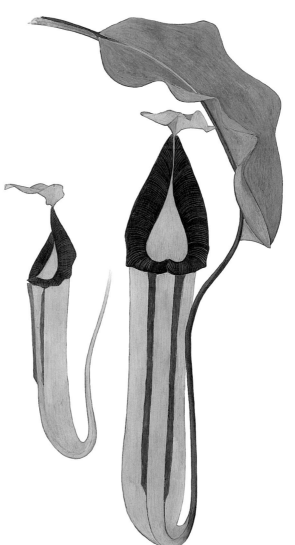

△ **Stage 2**

The first washes were applied dark, since gouache is worked from dark to light (the reverse of watercolour). A light layer must be consistent and evenly applied so that no lighter patches of paper show through. The brush strokes need to be quick in order to give a good covering of paint, which should not be too watered down.

For the green wash, Simon used Permanent Green Middle, Vandyke Brown and Indigo Blue. For the stem and peristome or lip he used Havannah Lake and Orange Lake Light.

The 'wings' down the front of the pitcher were left white to avoid confusion. This is Simon's usual method so that he knows where they are. This is, of course, a tip which can be applied when using gouache to paint many plants with distinguishing features.

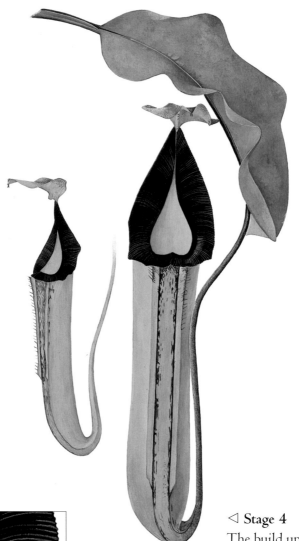

Stage 4

◁ **Stage 4**

The build up of lighter layers continues. At this stage Simon is using only Light Green, Naples Yellow and a touch of Spectrum Yellow. From now on, the technique requires an almost dry brush so that none of the earlier work is lifted off. Simon used small lines over the top of each other or stippling, and a combination of both for the leaf and small strokes for the pitcher. Work on the shadows and highlights using this method started to give the subject shape rather than the flat appearance of the previous stage.

▷ **Final Stage**

Eventually, when all the green was completed, Simon painted red markings over the top, using Havannah Lake and Indigo Blue for the dark maroon and Havannah Lake, Orange Lake Light and Flesh Tint for the lighter markings. Permanent White used towards the end gave nice light colours and pure highlights.

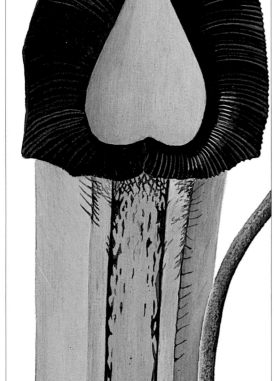

△ **Detail of Stage 4**

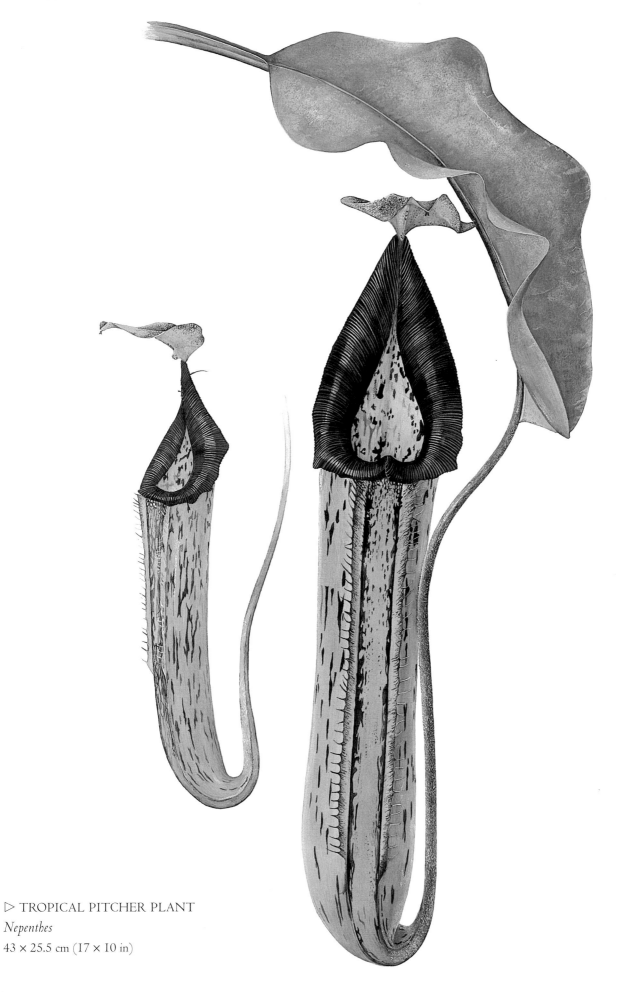

▷ TROPICAL PITCHER PLANT
Nepenthes
43 × 25.5 cm (17 × 10 in)

CHAPTER 12

WORKING IN THE FIELD

Very few botanical artists are fortunate enough to have the opportunity to take part in a scientific expedition, but just occasionally such an offer is made and in 1993 Christina Hart-Davies set off for the rainforest of Sumatra. Her help in writing this chapter has been invaluable.

Such a trip is far removed from the comfort of working in the studio because climate, insect bites (or worse), changing light and inaccessible plants all conspire to create difficulties. On the plus side you get to see the plant in its natural habitat, not wilting indoors.

If it is a scientific expedition, all parts of the plant need to be recorded and accurate identification is essential. Usually a bud, the open flower from front, side and back, fruit and a leaf, making sure that any variation in the leaves are shown, will be necessary. Sometimes roots or bulbs are also required. Make many drawings and take lots of measurements. Show how flowers and leaves join the stem: even stick drawings will suffice for this.

If possible paint part of a plant, even if just one floret, checking with other plants to see if there is a standard colour or if variation occurs. The more blobs of colour on your sketches the better and these should be circled and labelled with helpful notes, such as 'older petals' or 'stems bluer towards the base'. Remember that some plants change in colour if not shape and often a bud will open with a variation of colour.

▷ DESERT ROSE
(*Adenium obesum*)
42 × 30 cm
(16½ × 11¾ in)
Watercolour
Reinhild Raistrick
SBA

Reinhild found this interesting succulent on the plains of Tanzania. She made a detailed drawing on site and then drew the flower stem from a neighbouring tree. These were transferred to watercolour paper using a light box and painted quickly from a cut stem, as the flowers soon fade. Detailed colour notes were taken as the flowers vary from pink to deep rose.

▷ *ETLINGERA*
PUNICEA
33 × 25.5 cm
(13 × 10 in)
Watercolour
CHRISTINA HART-
DAVIES FSBA

This is one of many plants collected in the rainforest of Bengkulu, Sumatra. Christina measured the whole flower head and made a life-size drawing of it. With only time to paint part of it, she dissected one floret to show the inner structures, possibly needed for identification, and noted the colours of other relevant parts for future reference. The leaf was left as a pencil drawing showing its relative size to the flower head.

Etlingera punicea (Roxb.) RM Smith

DB8 Ginger family nr Pagar Gunung

Flo direct from ground, from creeping rhizome

trilocular ovary

calyx-tube pale. more p. rose towards base 3-toothed

Lvs sheathe stems. Stems sturdy, to 8ft. in clumps.

GROUND LEVEL

← 3 petals encl. lip

← 3-toothed calyx-tube

↓ paler, to wh

papery edges. shiny

↓ paler

bracts

p.rose Stigma

style pierces tw anthers & rises fr. base of tube

ovary 3-chambered wh.

X2

PRACTICALITIES

If you are painting in a tropical climate your paint will behave quite differently from the way it does at home. Pans are easier to manage than tubes, but you will find that although the paint dries quickly in the heat, humidity prevents it from drying thoroughly, making it difficult to lay washes. Sweat dripping from your nose onto your work is an added hazard!

Harder pencils are more suitable in a hot climate; nothing less than a 3H will do. Arches HP paper also stands up to tropical conditions. Completed work is best packed in plastic bags with packets of silica gel to keep it safe until more temperate areas are reached.

◁ *CETRARIA PINASTRI, C. JUNIPERINA,*
C. TILESII (from the top)
25.5 × 20 cm (10 × 7¾ in)
Watercolour
CHRISTINA HART-DAVIES FSBA

These are three species of related lichens from Sweden, two of which grow on specific trees, the other on soil. The composition was roughed out by laying the specimens on the page. Christina then studied them under a microscope in order to understand their structure before working on them individually. A fine pencil drawing was followed by painting with a No. 00 brush, aided by a magnifying glass. The background of *Cetraria tilesii* was built up from the appropriate reference photographs. Lichens make excellent subjects for the botanic artist as they are easily dried for transportation and storage, even for years, then come alive again when sprayed with water.

Collecting should be done carefully, as you must obey local laws and some plants will be banned from importation. Never bring in soil on the roots in case it carries disease and never collect a lone specimen.

Keep plants as cool as possible and add to the humidity in the collecting box by adding extra vegetation. Hotel mini-bar fridges, or a place outside on the windowsill overnight, will help to preserve your plants. You may need to press them if you cannot paint them immediately. Improvise if you have to, using toilet paper, thick books and the front pocket of a full suitcase. Note what you have collected and where you found it.

Although no substitute for field sketches, photographs are valuable. Take them from all angles as back-up, but record everything on paper too. Do not trust your memory, nor the capacity of the film to render colours accurately.

◁ *USNEA*
RUBIGINEA
13 × 10 cm (5 × 4 in)
Watercolour
CHRISTINA HART-DAVIES FSBA

This lichen was studied under a microscope before drawing and painting with a fairly dry No. 1 brush. Note the darker branches which give depth, the shadow side of the nearer branches and where they cross, all carefully detailed. The branches behind have less detail, which indicates distance. A No. 00 brush was used for the final 'tickling up'.

FIELD POPPIES

Papaver rhoeas

Eileen Maddison SBA

An abundance of poppies in the Lot Valley, France, inspired Eileen
to devote part of her holiday to capturing their vibrant yet fragile beauty. Poppies, with
their powerful associations of war and remembrance, are a very popular
subject for artist and public alike.

PAINTS

WINSOR & NEWTON
Alizarin Crimson
Vermilion Hue
Winsor Red
Quinacridone Magenta
Winsor Violet
Ultramarine Blue
Raw Umber
Sap Green

BRUSHES

WINSOR & NEWTON
Series 7 miniature
Kolinsky sable brushes
sizes 2 and 4

SURFACE

WINSOR & NEWTON
Lana Aquarelle HP
300 gsm (140 1b) paper

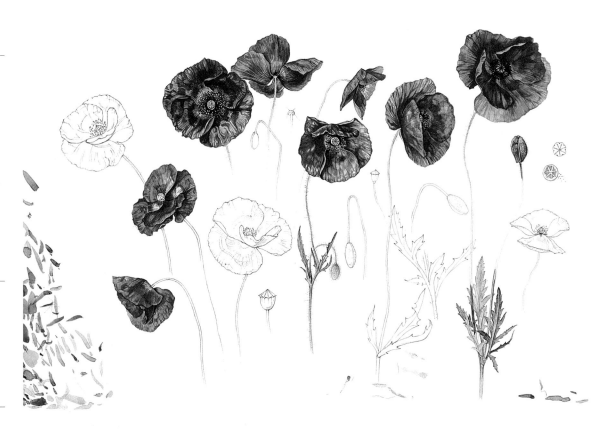

△ **Detail of Stage I**

△ **Stage I**

As the flowers are so quick to fade, lasting only
half a day when picked, it was essential for
Eileen to begin by producing a sheet of accurate
drawings with colour notes, some of which
could be incorporated into the finished
painting. Such worksheets will always be useful
for future reference and are well worth the time
spent on their preparation. Worksheets and
sketchbooks are increasingly displayed alongside
the paintings in artists' solo exhibitions as there
is a public interest in seeing what goes into the
creation of a finished picture.

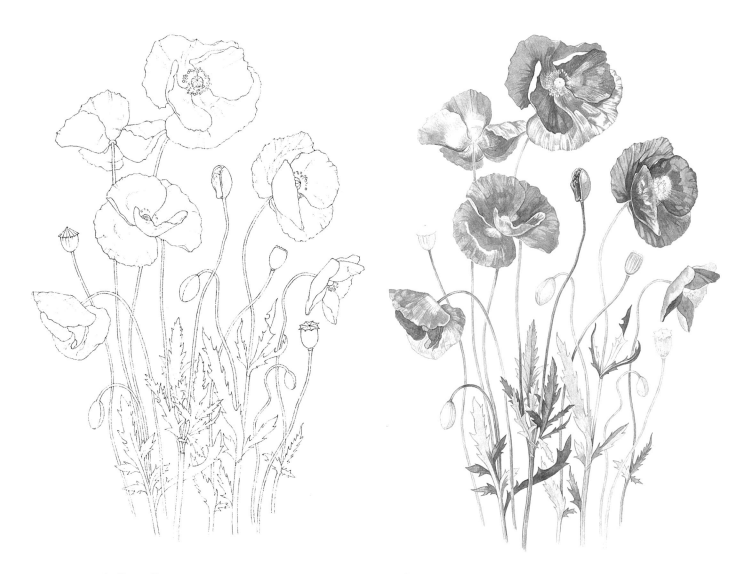

△ Stage 2

Eileen used Winsor & Newton Lana Aquarelle hot-pressed 300 gsm (140 lb) paper and an HB pencil. Concentrating on one flower at a time, she paid particular attention to the movement of the stems, themselves a great aid to composition. This is a fine example of the point made on p. 60 regarding certain flowers being ideally suited to a composition style. These poppies, with a lax growth and natural grace so typical of wild flowers, almost compose themselves. Crane's-bill, red and white campion and bluebells are equally obliging.

△ Stage 3

Eileen first washed in the highlights, using Quinacridone Magenta followed by broad washes of pale Vermilion Hue. Essential details were added with a stronger mix plus a little Winsor Red. The poppy petals show very distinct facets of light and shade.

For the leaves and stems Eileen mixed Sap Green with Ultramarine Blue and a touch of Alizarin Crimson. This made a neutral greyish mix with which to outline the leaves and so prevent the drawings from getting 'lost'. She also likes to establish the lightest and darkest greens at an early stage.

Eileen prefers to mix plenty of colour at the outset, keeping it covered when it is not in use in order to protect it from dust.

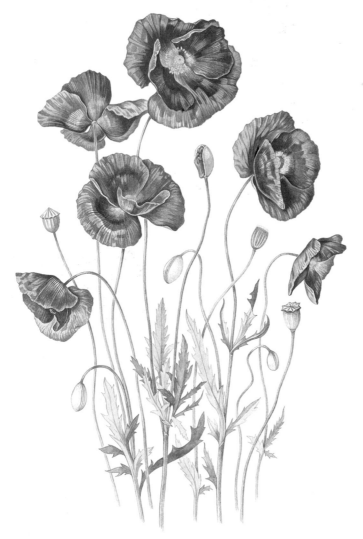

△ Stage 4

With Vermilion Hue and a size 4 brush, Eileen put in the main areas of colour on the poppies and defined the folds and crinkles of the petals. These described the movement and form and Eileen kept in mind how a cross-section would look as she drew them in. Keeping the brush angled at 90 degrees to the paper gave her more control over fine lines.

Darker areas were painted with Winsor Red. The colour appears stronger in the bowl of the flowers because it is reflected back from each of the petals. The glowing effect was created by grading the Vermilion into the Winsor Red.

Using the same green mix as before, but this time less diluted, Eileen darkened the edge of the stems, suggested some veining in the leaves and put in the darker areas of the seed heads.

She used Raw Umber for the dried seed heads and added some Ultramarine Blue for the darkest areas.

▷ Final Stage

At this point, more detail was added and small areas on the flower were picked out where more depth was needed. For the flower centres, a very strong leaf mix of red, yellow and blue gives a velvety black with which to paint the stamens. The filaments are visible on the far side and these were painted using the tip of the brush, with a very fine point, to radiate slightly curved lines from the centre. The number of stigma rays varies and these were also curved.

Eileen added Alizarin Crimson with a touch of Vermilion Hue to the darkest areas on the petals. She defined the edges where necessary with Vermilion Hue, and some areas needed a stronger Vermilion Hue wash. Dark markings in the centres of the petals were put in using Winsor Violet with a touch of green.

With a light green mix and a finely pointed brush Eileen painted the hairs on the stems, starting in the centre of the stem and flicking sharply outwards. (Practise this first to gain confidence.) The buds were built up with dots and hairs, while the darker green veining was added to the leaves in the foreground. The backs of the leaves show a very distinct midrib. To show the stem hairs against a dark ground, Eileen removed the paint with a sharp knife point. Be careful not to overdo this technique.

The sharp points on leaves are a significant feature, so these were defined where necessary. Small dots on the seed heads were added using Burnt Umber and Ultramarine Blue.

Finally, Eileen puts her painting away, at least overnight. This enables her to view it objectively later and she can judge it with a keener eye as she checks it for oversights. A large mount, cut into two so it can be moved around, is invaluable as it helps you to see the details of your painting more easily when they are isolated from the whole. Do not forget to sign your painting and keep all your worksheets.

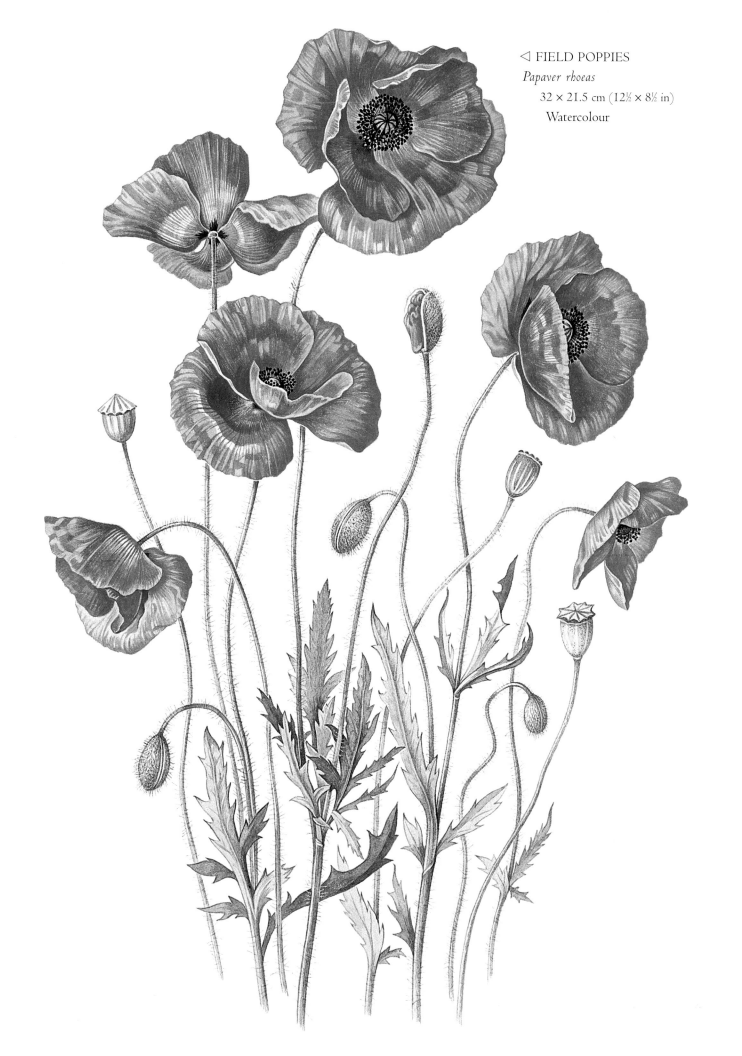

◁ FIELD POPPIES
Papaver rhoeas
32 × 21.5 cm (12½ × 8½ in)
Watercolour

CHAPTER 13
PAINTING FRUIT

FRUIT HAS long been a favourite subject for the artist, with several centuries of examples to be found in specialist collections such as the Lindley Library of the Royal Horticultural Society in London. Some of the most splendid examples were painted by William Hooker early in the nineteenth century and if you wish to specialize in studies of fruit you would be well advised to study his work. You will find no better depiction of the ruddy-streaked peel or delicately veined leaves of his 'Nonsuch Apple' nor the juiciness and texture of the cut portion of the 'Red Roman Nectarine'. The varieties may sadly no longer be commonplace, but the same standard of painting should be aimed for.

Look also at the gooseberries painted by Mrs Augustus Withers, flower painter to Queen Adelaide and later to Queen Victoria. Their translucence is unsurpassed and again the leaves are exquisite.

▷ ALMONDS
36 × 36 cm
(14¼ × 14¼ in)
Watercolour
ELISABETH DOWLE
SBA

In this classic study Elisabeth has depicted the life cycle of the almond from flower to shelled nut. Notice the furry, delicately stippled husks with a disappearing edge where they hang in front of leaves.

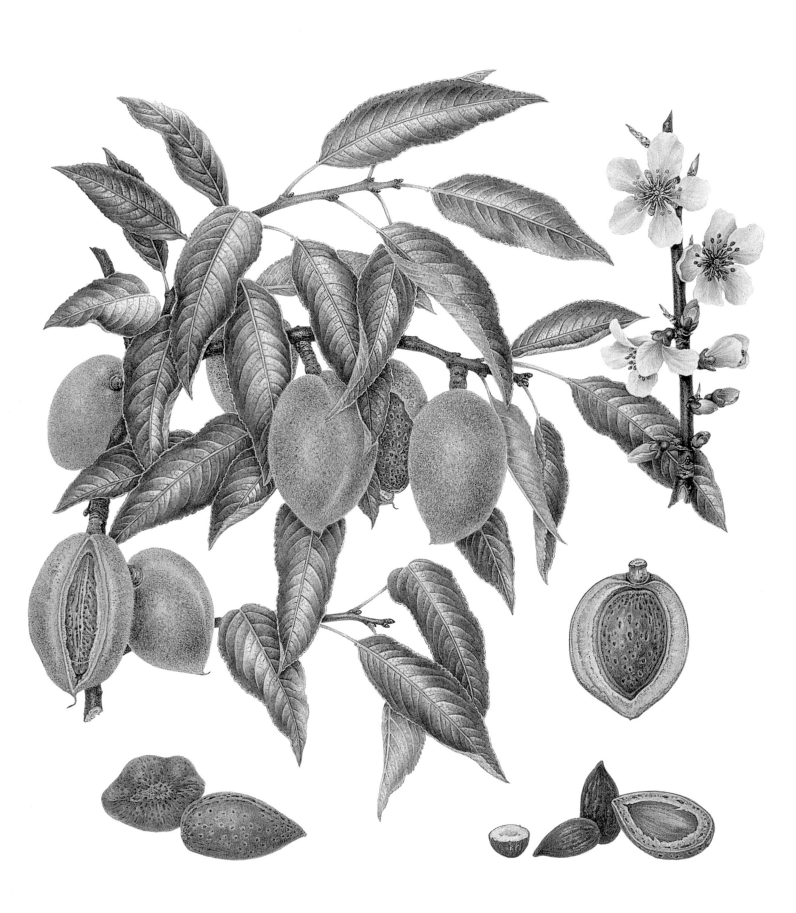

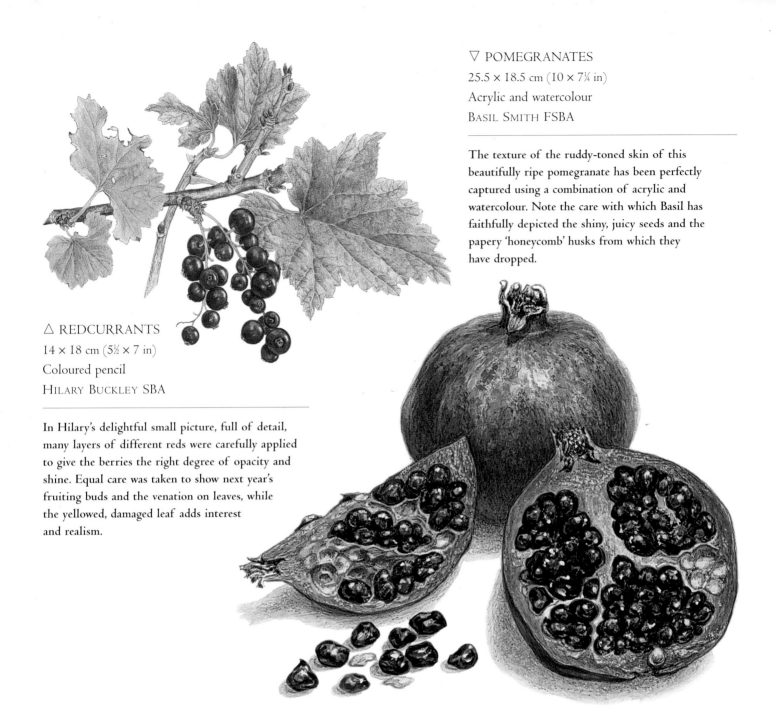

△ REDCURRANTS
14 × 18 cm (5½ × 7 in)
Coloured pencil
HILARY BUCKLEY SBA

In Hilary's delightful small picture, full of detail,
many layers of different reds were carefully applied
to give the berries the right degree of opacity and
shine. Equal care was taken to show next year's
fruiting buds and the venation on leaves, while
the yellowed, damaged leaf adds interest
and realism.

▽ POMEGRANATES
25.5 × 18.5 cm (10 × 7¼ in)
Acrylic and watercolour
BASIL SMITH FSBA

The texture of the ruddy-toned skin of this
beautifully ripe pomegranate has been perfectly
captured using a combination of acrylic and
watercolour. Note the care with which Basil has
faithfully depicted the shiny, juicy seeds and the
papery 'honeycomb' husks from which they
have dropped.

SURFACE AND FORM

Whether you choose to paint a few ripe figs
from a market stall or a perfect bunch of 'Black
Hamburg' grapes grown under hot-house
conditions, it will surely be the soft, velvety
bloom that caught your eye. In my experience,
students never tire of seeing the technique for
creating bloom demonstrated, even although it
is a very simple exercise and one where that
dangerous colour Viridian comes into its own. I
say dangerous because it is such an intense
staining green which, if used for foliage, needs
careful mixing with other hues to tone it down.
However, it is the basis for bloom so if you are
faced with, say, something easy like a fig, apply
a wash of medium-tone Viridian over the fruit.
Leave it to dry and then apply washes of other
appropriate colours which you see on your ripe
fig. Sometimes there is a patch of ochre and
always variations of purple, perhaps with a
touch of rose. As you apply these washes ignore
the bloom and just concentrate on creating a
nice, plump fig.

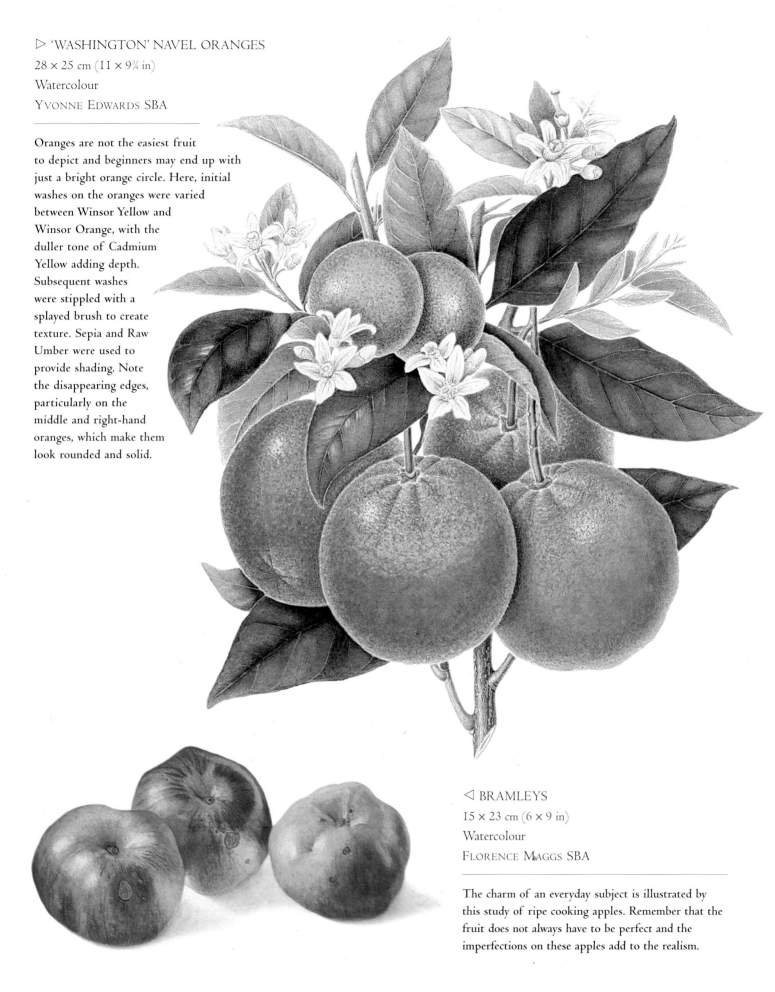

▷ 'WASHINGTON' NAVEL ORANGES
28 × 25 cm (11 × 9¾ in)
Watercolour
YVONNE EDWARDS SBA

Oranges are not the easiest fruit
to depict and beginners may end up with
just a bright orange circle. Here, initial
washes on the oranges were varied
between Winsor Yellow and
Winsor Orange, with the
duller tone of Cadmium
Yellow adding depth.
Subsequent washes
were stippled with a
splayed brush to create
texture. Sepia and Raw
Umber were used to
provide shading. Note
the disappearing edges,
particularly on the
middle and right-hand
oranges, which make them
look rounded and solid.

◁ BRAMLEYS
15 × 23 cm (6 × 9 in)
Watercolour
FLORENCE MAGGS SBA

The charm of an everyday subject is illustrated by
this study of ripe cooking apples. Remember that the
fruit does not always have to be perfect and the
imperfections on these apples add to the realism.

◁ MULBERRIES
30.5 × 48 cm (12 × 18¾ in)
Watercolour
ANNIE MORRIS SBA

Annie was fortunate to find this specimen to
paint since mulberries are relatively
uncommon these days. The shades of green
and yellow are expertly applied on the leaves
and the serrated edges are accurately drawn.
Too often, students overlook irregularities
and show a very even set of serrations.

When you are satisfied that it looks as good
as you can get it, dip your brush in clean water
and lift off the pigment where bloom occurs.
These darker shades will have merged with the
Viridian to leave a soft stain and this will be the
bloom. Blend edges with a dry brush to give a
perfect finish.

Another quick tip, this time for painting a
pineapple, always a tempting subject. Observe
the way in which the segments curve up
from the base in spiral form. Hold on to that
spiral in your drawing at all costs. Students
often start off drawing it well but lose it in the
top right-hand quadrant so that the segments
begin to form a square. This will spoil the
whole drawing, no matter how good the
subsequent painting, so beware of this error.

◁ LEMONS
23.5 × 21.5 cm (9¼ × 8½ in)
Watercolour
VIVIEN BURGESS SBA

This study has the added interest of new growth
picking up the colour of the flower buds. Vivien has
been careful to show the imperfections on a few leaves
and also to depict the texture of the lemon peel.

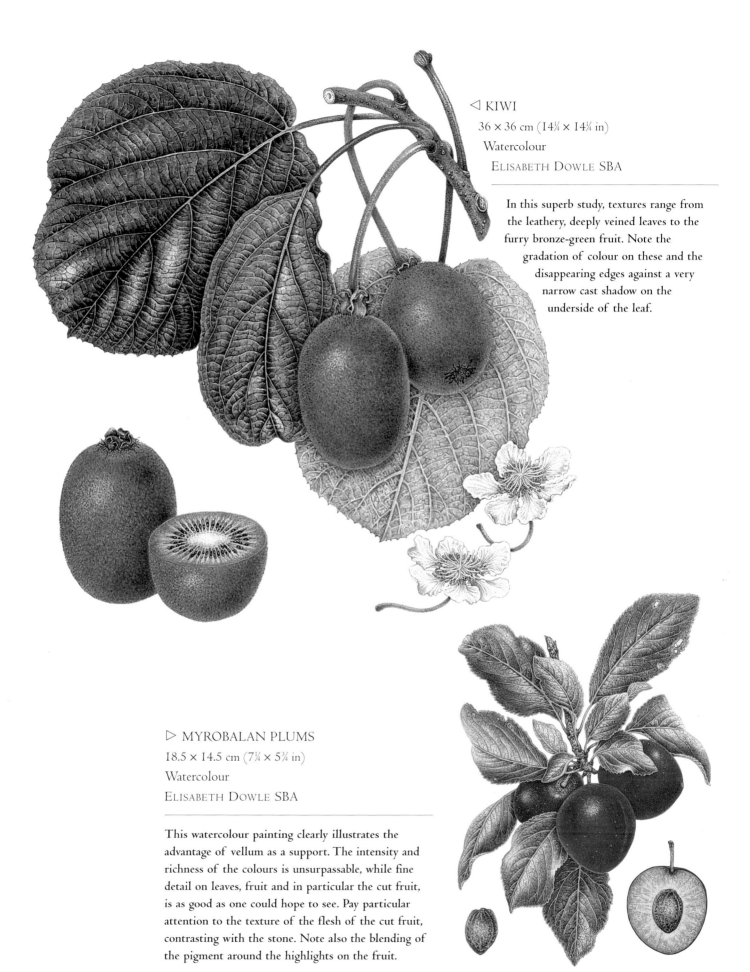

◁ KIWI
36 × 36 cm (14¼ × 14¼ in)
Watercolour
ELISABETH DOWLE SBA

In this superb study, textures range from
the leathery, deeply veined leaves to the
furry bronze-green fruit. Note the
gradation of colour on these and the
disappearing edges against a very
narrow cast shadow on the
underside of the leaf.

▷ MYROBALAN PLUMS
18.5 × 14.5 cm (7¼ × 5¾ in)
Watercolour
ELISABETH DOWLE SBA

This watercolour painting clearly illustrates the
advantage of vellum as a support. The intensity and
richness of the colours is unsurpassable, while fine
detail on leaves, fruit and in particular the cut fruit,
is as good as one could hope to see. Pay particular
attention to the texture of the flesh of the cut fruit,
contrasting with the stone. Note also the blending of
the pigment around the highlights on the fruit.

'PINK LADY' APPLE

Linda Dearden SBA

This 'Pink Lady' apple appealed to Linda because of its variety of colours and the interest created by an irregular shape and slight blemishing on the skin. Apples are an excellent choice of fruit for a beginner, with a longish studio life, giving valuable time for the artist to study and paint the layers needed to build up colour.

PAINTS

WINSOR & NEWTON
Raw Sienna
Permanent Sap Green
Terre Vert
Winsor Red
Winsor Yellow
Payne's Grey
Burnt Umber
Light Red
Olive Green
Raw Sienna
New Gamboge
Scarlet Lake
Neutral Tint
Naples Yellow
Lemon Yellow

BRUSHES

WINSOR & NEWTON
Series 7 Kolinsky sable,
sizes 0, 1 and 3

SURFACE

HEATON COOPER
Hot Pressed
watercolour paper

△ Stage 1

Linda started by measuring the dimensions of the apple and drawing the outline with a Pentel 0.3 mm pencil. Her first wash, of Winsor Yellow, left the highlights untouched. She waited for it to dry before applying a second wash of Winsor Yellow, following the rounded contours of the fruit, which strengthened the colour where required. Again she waited for it to dry. Then, using a fairly dry brush, she added some very diluted Winsor Red to create pink areas, again following the contour of the fruit with radiating brushstrokes.

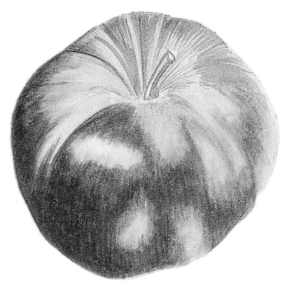

△ Stage 2

Linda added another wash of Winsor Red and used a very dry brush to blur the lines with a circular motion. She employed Winsor Yellow and Permanent Sap Green to paint in the green patches, which are most definite around the stalk and right 'shoulder' of the apple. Areas of highlights were softened with a clean, damp brush. The apple stalk was put in with Raw Sienna.

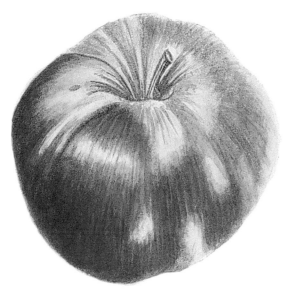

△ **Stage 3**

After denoting the brown areas around the stalk with Raw Sienna, Linda added more Winsor Red to strengthen the colour with radiating lines from the bottom of the fruit. For this the paper was turned.

With a very dry brush, Linda continued to build up the red patches. More green was added to intensify the colour around the stalk and shoulder, and all hard edges were again blurred with a clean damp brush. Another wash of Winsor Red was applied to make the surface look smooth and shiny. A mix of Terre Vert and Raw Sienna was used to further delineate the brown areas around the stalk, again with a very dry brush. This colour was also used for the dark shadows on the fruit.

▽ 'PINK LADY' APPLE
10 × 10 cm (4 × 4 in)
Watercolour

△ **Final Stage**

Using Permanent Sap Green and Winsor Yellow, Linda deepened the shadows around the stalk, which was defined with Payne's Grey and Burnt Umber. Light Red was used to deepen the shadows on the left and top edge. All edges were crisply defined, as were the brown blemishes on the skin.

Linda layered a final wash of Winsor Red and Winsor Yellow over the appropriate colours and allowed them to dry. 'White' specks were picked out using a clean, wet brush and blotted with kitchen paper. Where necessary, edges of highlights were hardened. The final touches were to apply Olive Green spots to lighter areas and Raw Sienna spots on other areas.

'FORELLE' PEAR

Linda Dearden SBA

Pears generally have a shorter studio life than apples, tending to discolour and bruise more quickly. Perhaps it is wisest to leave specimens such as this beautiful Forelle pear until you feel more confident, as there is much detail to be covered.

PAINTS

WINSOR & NEWTON
Raw Sienna
Permanent Sap Green
Terre Vert
Winsor Red
Winsor Yellow
Payne's Grey
Burnt Umber
Light Red
Olive Green
Raw Sienna
New Gamboge
Scarlet Lake
Neutral Tint
Naples Yellow
Lemon Yellow

BRUSHES

WINSOR & NEWTON
Series 7 Kolinsky sable,
sizes 0, 1 and 3

SURFACE

HEATON COOPER
Hot Pressed
watercolour paper

△ **Stage 1**
The painting was started with measuring and an outline drawing, followed by a wash of Winsor Yellow which left highlights unpainted. A wash of New Gamboge was applied on the left-hand side and a wash of Olive Green/Winsor Yellow on the right-hand side and beneath. A further wash of Scarlet Lake covered the red area.

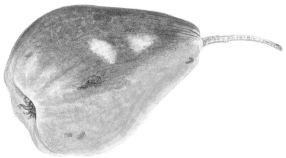

△ **Stage 2**
Linda stippled on a mix of Olive Green and Winsor Yellow. Next she applied a further wash of Scarlet Lake and stippled it. Scarlet Lake and Raw Sienna were used for the stalk, and the 'eye' was Neutral Tint and Burnt Umber. Radiating lines of Olive Green were painted from the bottom and the bruised areas were Raw Sienna.

△ 'FORELLE' PEAR
9 × 15 cm (3½ × 6 in)
Watercolour

◁ **Final Stage**
Red and highlighted areas were stippled with Scarlet Lake, which was also used to paint in the dots over red areas, with Raw Sienna and Olive Green dots for yellow areas. The 'eye' was finished with Neutral Tint. A few more dots of Light Red were put in with a dry brush before a final all-over wash of Winsor Yellow was applied, avoiding the highlights. Finally, Linda tightened and defined the edges and put in little black scars using Neutral Tint.

Half Pear

▷ **Stage 1**

Linda cut neatly the fruit neatly and measured it, then drew a faint outline. She painted the inside edge of the pear with Naples Yellow, using this also as a weak wash over the rest of the surface in a dappled fashion, rather than as a complete covering of colour. The darker areas and the stalk were also painted with Naples Yellow.

Next, Linda applied very dilute Light Red on areas that had started to redden, dappling it on and blotting it with kitchen paper. She added more Light Red to the left-hand outline. Lemon Yellow was applied to the right-hand outline, around the pips in the inside and on the outside skin where it showed.

The core area of the pear was outlined in a very dilute mixture of Naples Yellow and Light Red. The more yellow areas at top and bottom of the pear required some New Gamboge.

Naples Yellow was again dappled on and blotted, and numerous little half-moon shapes of this colour were added to convey texture to the flesh. Neutral Tint was used for the pips and pip area.

Linda then drew a very thin outline of Burnt Umber all around the pear and the broken edge on the right. Using a small brush, she put in Burnt Umber around the pips and core features, also adding small brown dots here and there.

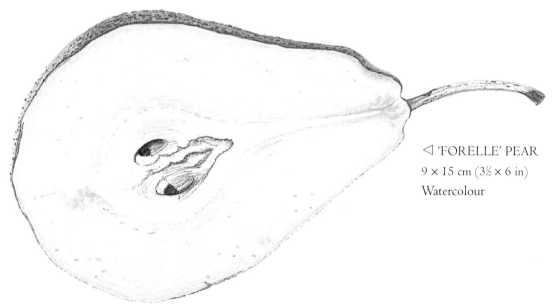

◁ 'FORELLE' PEAR
9 × 15 cm (3½ × 6 in)
Watercolour

△ **Final Stage**

After employing some Naples Yellow to give depth to the pip area, Linda went over the left-hand outline of the cut pear with Light Red and then applied Scarlet Lake to the right-hand side. The stalk was painted with Lemon Yellow, hints of Scarlet Lake and Neutral Tint, with the end made darker where it had been pulled from the tree. Linda also used Neutral Tint for the veiled area over the pips, and dappled on Scarlet Lake for spots on the small amount of visible skin. Finally, more Burnt Umber and Payne's Grey were used to define the pip area.

CHAPTER 14
PAINTING VEGETABLES

IF YOU EVER see anyone in the supermarket spending an age sorting through the squashes and onions or standing, apparently deep in thought, with a pepper in either hand weighing up the relative merits of each as regards shape and colour, they are not necessarily cranky about what they eat — they may perhaps be a botanical painter. As the range of produce on offer has become more varied, vegetables are now as tempting as fruit. Even if we are not lucky enough to grow our own, there is no shortage of good things to paint.

The following selection may persuade you to try painting vegetables for the first time. Whatever you choose, I guarantee you will be captivated by the new possibilities open to you as you explore different textures, form and colour.

▷ CARDOON
(*Cynara cardunculus*)
38 × 28 cm (15 × 11 in)
Watercolour
PAULA JOYCE FSBA

This striking plant, closely related to the globe artichoke, is depicted here in the early stage of flowering, with immature foliage. It creates a very striking and classical study which will have required great patience and skill to capture the luminous beauty of the bloom which is made up of hundreds of florets. Paula used a variety of blues, including Cobalt and French Ultramarine with a touch of Quinacridone Magenta to give a purple tint. Body colour, in this case Winsor & Newton Bleedproof White, helped to create a glowing effect.

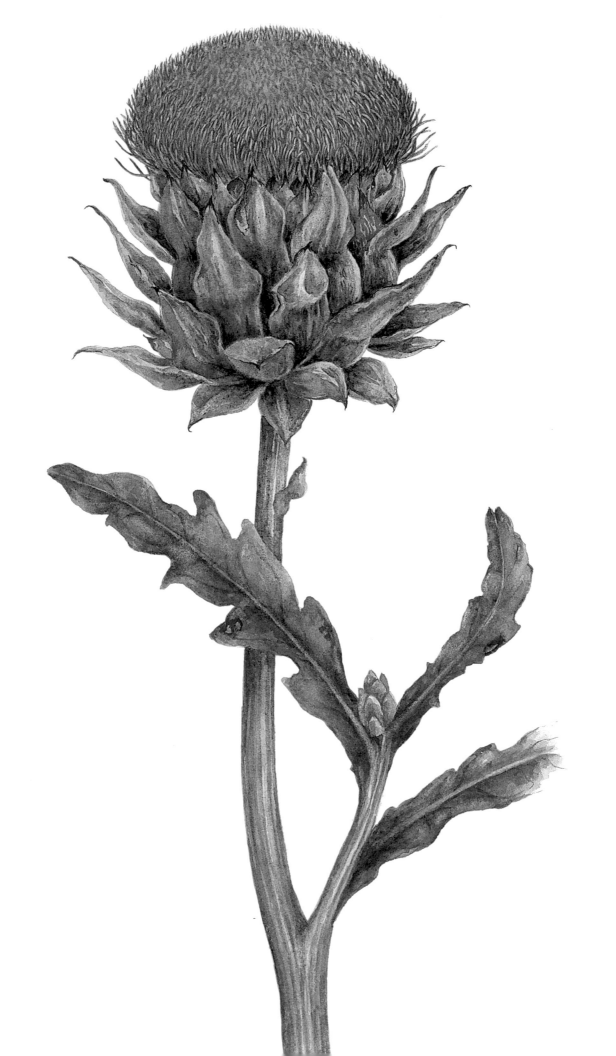

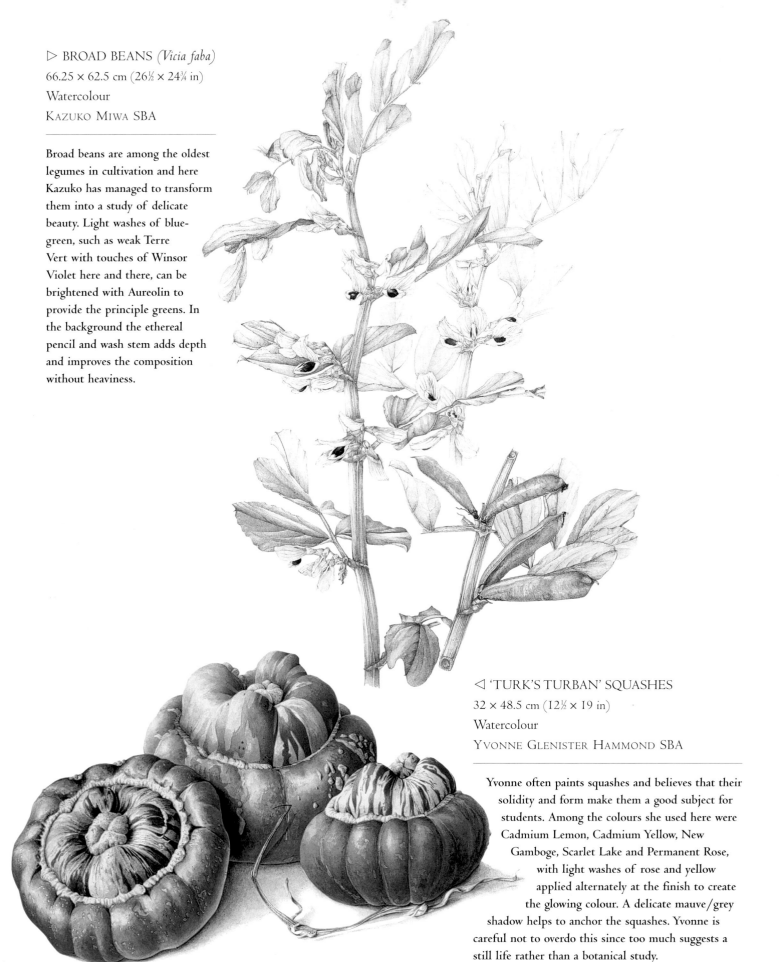

▷ BROAD BEANS (*Vicia faba*)
66.25 × 62.5 cm (26½ × 24¾ in)
Watercolour
Kazuko Miwa SBA

Broad beans are among the oldest legumes in cultivation and here Kazuko has managed to transform them into a study of delicate beauty. Light washes of blue-green, such as weak Terre Vert with touches of Winsor Violet here and there, can be brightened with Aureolin to provide the principle greens. In the background the ethereal pencil and wash stem adds depth and improves the composition without heaviness.

◁ 'TURK'S TURBAN' SQUASHES
32 × 48.5 cm (12½ × 19 in)
Watercolour
Yvonne Glenister Hammond SBA

Yvonne often paints squashes and believes that their solidity and form make them a good subject for students. Among the colours she used here were Cadmium Lemon, Cadmium Yellow, New Gamboge, Scarlet Lake and Permanent Rose, with light washes of rose and yellow applied alternately at the finish to create the glowing colour. A delicate mauve/grey shadow helps to anchor the squashes. Yvonne is careful not to overdo this since too much suggests a still life rather than a botanical study.

▷ SCOTCH BONNET PEPPER and LONG
SWEET PEPPER (*Capsicum chinense* 'SCOTCH
BONNET' and *Capsicum annuum*)
25.5 × 20.5 cm (10 × 8 in)
Watercolour
KAY REES-DAVIES SBA

Although technically fruit, these members of the
capsicum family are included here as they are
generally sold alongside salad vegetables. They
are a perfect subject for students learning how
to paint a polished surface with really shiny
highlights. Notice particularly the
details showing within the
highlights on the long
pepper and the various
disappearing edges
where pigment
has been kept to
the merest tint,
particularly to
the right of the
same pepper. Kay
used Daler-
Rowney Warm
Orange (which she
recommends for its
clarity), Bright Red,
Cadmium Red, Scarlet Lake
and a touch of Perylene Red for shading.

▷ CABBAGE
24 × 32 cm (9½ × 12½ in)
Watercolour
HARRIET FRANCIS SBA

This cabbage was
obviously chosen for
its eye-catching
mix of purple
and green.
Harriet used
green mixes of
Aureolin Yellow,
French
Ultramarine
and Terre Vert
blended with
Purple Madder,
Winsor Violet and
Permanent Alizarin.

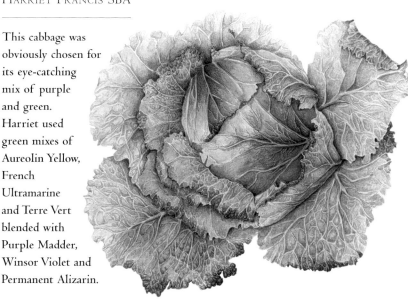

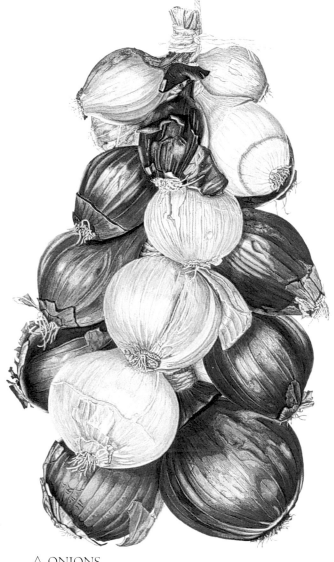

△ ONIONS
42 × 25.5 cm (16½ × 10 in)
Watercolour
KAY REES-DAVIES SBA

A humble vegetable here contributes to an eye-
catching painting, partly because the almost metallic
look of the red skins is emphasized by the papery
texture of the pale ones. There are just enough
rough patches and colour variations to prevent it
becoming uninteresting. Note, in particular, the dark
blotches at the bottom right. Kay used Caput
Mortuum Violet, Daler-Rowney Perylene Red,
Winsor & Newton Perylene Maroon + Indigo and
Perylene Maroon + Neutral Tint. She also used
Neutral Tint, Burnt Sienna and Daler-Rowney
Warm Brown where required.

BEETROOT
Beta vulgaris

Audrey Hardcastle SBA

This common vegetable is not so common when one considers the rich matt red of the globe and the contrasting shiny leaves with red and green variations in colour. Add to that the red stalks and shadows beneath the cork on the globe and it is no wonder Audrey finds it a most attractive subject for a painting.

PAINTS

WINSOR & NEWTON
Alizarin Crimson
Winsor Violet
Winsor Green
Winsor Yellow
Cadmium Yellow
Prussian Blue
Burnt Sienna
Sepia

BRUSHES

WINSOR & NEWTON
Series 7, No. 3

SURFACE

SAUNDERS
WATERFORD
300 gsm (140lb)
Not paper

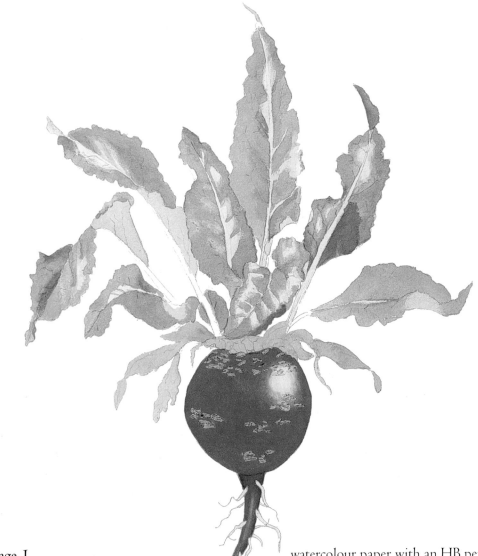

△ **Stage I**

In order to balance the picture a little artistic licence was called for, so Audrey foreshortened the stems and spread out the leaves, retaining the dead ones to add further interest in an otherwise blank area around the globe. She drew directly onto the watercolour paper with an HB pencil and used a Banford 'Magic Rub' to correct mistakes.

A Winsor & Newton Series 7, No. 3 brush was used throughout. This has the advantage of being large enough to hold plenty of paint, yet has a point fine enough to allow work on detailed areas.

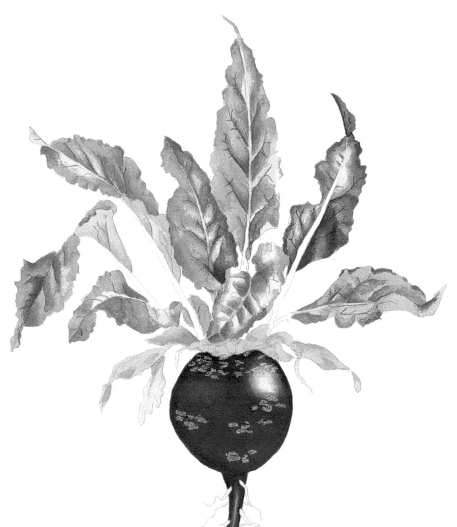

To begin the painting process, Audrey applied masking fluid to the nodules on the globe and then carefully painted a first wash of Alizarin Crimson with a hint of Winsor Violet, avoiding the shiny area. With a dry brush, she then blended the wash into the shine. A mix of Cadmium Yellow, Prussian Blue and Burnt Sienna was painted wet-into-wet onto the leaves. Very shiny areas were left white and the edges of colour were softened with a damp brush.

△ **Detail of Stage I**

△ **Stage 2**

Audrey's aim at this stage was to start modelling the plant and to give it a three-dimensional effect. Using Alizarin Crimson with a hint of Winsor Violet, she applied additional washes to the globe, adding more Violet to the side in shadow.

Taking one leaf at a time, Audrey painted in the side veins using Alizarin Crimson. Then, with the same green mix of Cadmium Yellow, Prussian Blue and Burnt Sienna, she applied washes to only small areas at a time. The washes had hard edges running along the midribs and veins but were blended out towards the shine with an almost dry brush. The darker the shadow, the more intense the colour, so in these areas less water was mixed with the pigment. Using this method, Audrey gradually painted all the leaves. No further colour was added to the green mix at this stage.

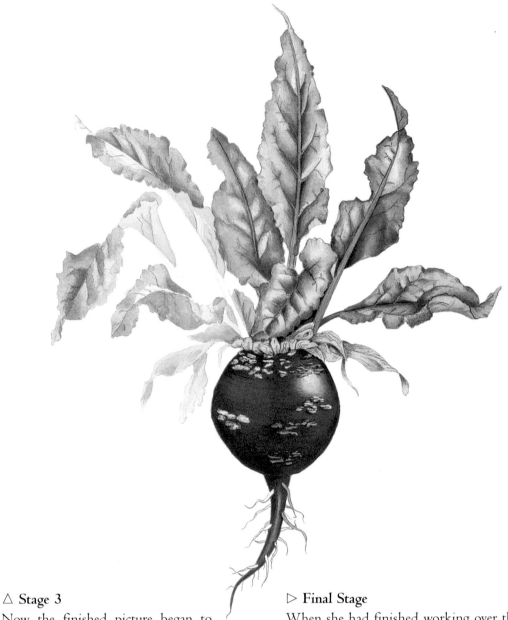

△ **Stage 3**

Now the finished picture began to emerge. Audrey removed the masking fluid and shaped the corky growths by touching in with Alizarin Crimson. The cast shadows underneath were touched in with Winsor Violet and Sepia, and a pale mix of Sepia and Burnt Sienna was dotted onto the cork.

Working over one leaf at a time, Audrey marked the stems and veins with Alizarin Crimson. The shadows were strengthened again with the green mix and a really dark finish was given to the crease next to the veins by adding Prussian Blue. By putting in the lovely red edges, Audrey made the leaves as perfect as possible. Brown leaves were defined by the use of Sepia and colour interest was created by adding greens and yellows to the original Sepia wash.

▷ **Final Stage**

When she had finished working over the globe and leaves, Audrey took time to sit back and view her work as a whole. The more tones in the painting, the more life-like and three-dimensional it will appear, so some of the stalks and veins were strengthened. When the paint was dry, Audrey applied a weak wash (nearly all water) of Winsor Green over the shady leaves and Winsor Yellow over the sunny ones. This made the picture sparkle.

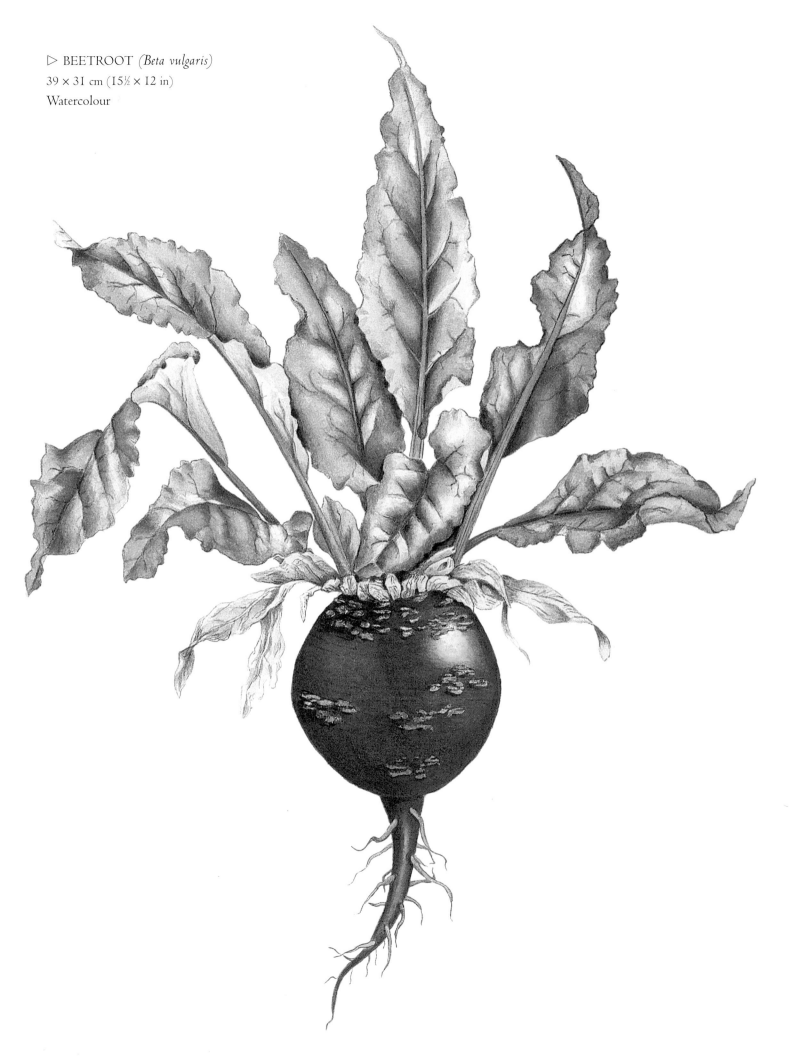

▷ BEETROOT *(Beta vulgaris)*
39 × 31 cm (15½ × 12 in)
Watercolour

CHAPTER 15

PHOTOGRAPHY AS AN AID

Working with photographs can be an unnecessarily controversial topic. Of the artists who replied to my questionnaire, three-quarters said that they sometimes used photographs but they generally and not surprisingly added the qualification that they were used only for reference and source material.

Recently, much has been made of the optical aids used by some of the world's most esteemed artists – Vermeer with his camera obscura being one of the best-known. One can be pretty sure that had he, and others, possessed a modern camera it would have been put to good use. When dealing with something as transient as a flower, which may change or fade days before a highly detailed study is complete, it is common sense to record it and its foliage.

▷ SURINAM RAINFOREST
41 × 30.5 cm (16 × 12 in)
Watercolour
Valerie Wright SBA

For this painting, Valerie used photographs all taken in the same area of forest to ensure compatibility. In reality, the rare, unnamed *Passiflora* just hung from a rather indifferent branch and the *Bromelia* in the left-hand corner were a cluster of magical growths in a nondescript clearing. The giant kapok trees, *Ceiba pentandra*, dominate the rainforest, while the canopy of slender, tall trees form the background to any rainforest composition. The sunlight highlighted some features and silhouetted others as well as binding together the various parts to make a cohesive whole.

BUILDING A LIBRARY

As any artist working commercially knows, a client will request artwork with no regard for the season. Holly glowing with berries could be needed in early summer, for Christmas cards that are to be sold in 18 months' time. Daffodils for Easter cards? Late summer is a good period for commissions for them – and as for roses, in my experience they are demanded at any time except during the height of their flowering season in late spring and early summer! While an artist's sketchbooks may or may not contain the necessary reference, photographs can usually be relied upon to save the day.

In order to place the beautiful botanical specimen in an appropriate setting, background photographs are often essential. We live in a fast world and whereas the Victorian painter may have had time to sit and sketch or even paint her background landscape, today's traveller is more likely to be taken to a stunning viewpoint and allowed 15 minutes to click the shutter. Few people can afford the luxury of independent travel or be lucky enough to accompany a scientific expedition.

Paintings derived from a selection of photographs of a certain area, such as Valerie Wright's rainforest scene on p. 119, require much thought and planning and you need to do rough sketches initially. Do not neglect to establish a foreground, middle distance and backdrop in order to create a living atmosphere. The same approach that Valerie took would equally well apply to an English woodland, a garden or a Canadian forest, and the larger your collection of photographs, the more likely you are to find the perfect subject or feature to incorporate into your painting

There is one golden rule, however. Try to use photographs which you have taken yourself in order to avoid any infringement of a photographer's copyright. It is possible to hire transparencies from photographic libraries if you are desperate, but it is expensive and although you can generally obtain the plant you want the image is unlikely to show any foliage. It is far better to buy the best camera you can afford, capable of taking detailed close-up shots, and build up your own reference library. Flower shows such as the annual one staged by the Royal Horticultural Society at Hampton Court will provide all you are likely to require to get started, particularly if you aim to work commercially. Spending the dark days of winter working from photographs to improve technique, particularly laying on washes and colour blending, will pay rich dividends.

Always bear in mind, though, that colour films have their own characteristics when it comes to reproducing colour and true rendering of blues is a particular weak point. While a good digital camera will allow you to check your photograph then and there against the reality, the risk with this newer technology is that a colour cast may affect any print you make to use as reference. Consequently, you would be well advised to make your own colour notes in paint at the same time that you take the photograph wherever this is possible.

Remember too that you are unlikely to be able to 'lift' images direct from photographs and place them into compositions as the scale is likely to vary considerably. Foreground flowers may be large and one can give the impression that they are seen with a worm's eye.

▷ FANTASY WOOD
53 × 36 cm (21 × 14 in)
Watercolour
MARTINE COLLINGS SBA

This charming painting was created by Martine to illustrate a children's story which she had written. She says the outsize primroses were done purposely to follow the plot. This is a typical example where even a photograph of tree bark could be useful, since few illustrators are likely to have time to wander in the woods looking for the perfect tree. They may, on the other hand, have just the thing in their photograph library and this will probably give them a more detailed overall view than the eye.

▷ *PHALAENOPSIS* ORCHIDS
20.5 cm (8 in) diameter
Watercolour
SARA ANNE SCHOFIELD FSBA

Sara, who is one of England's leading artists in the field, produced this plate design to the customer's requirements, although it did not go into production. The surroundings had to show a credible habitat for the orchid with supporting plants all from the same geographical area. In fact, the palms were photographed at the Royal Botanic Gardens, Kew. *Alocasia korthalsii*, like the *Phalaenopsis*, is a popular house plant and the *Aristolochia* was photographed at the Royal Horticultural Gardens, Wisley.

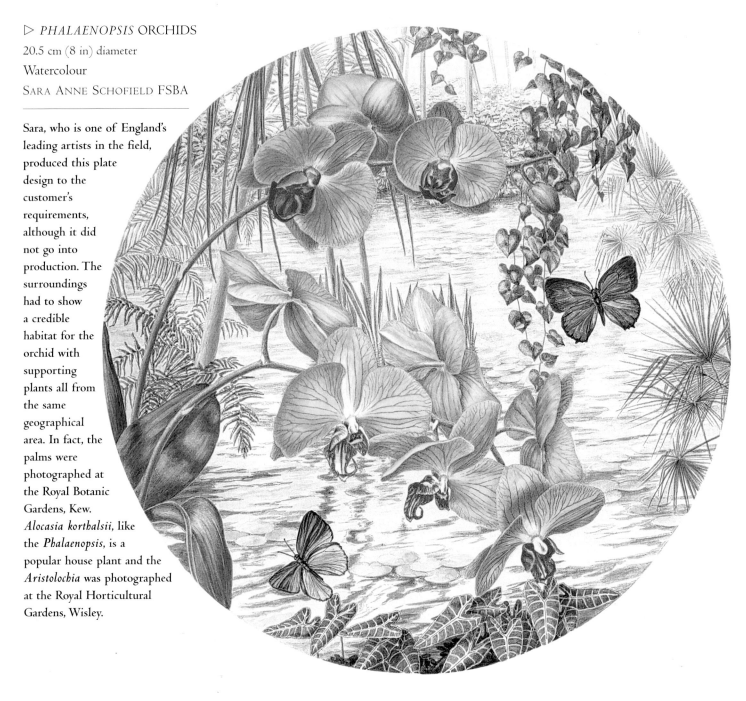

▷ CAMELLIAS AND PANSIES
63.5 × 48 cm (25 × 18¾ in)
Pastel
MAUREEN JORDAN SBA

An outdoor scene of this type takes a considerable time to complete. Maureen works on them at the same time each day, in order to keep the continuity of light and shade. However, she photographs the scene at the outset so that if a change in the weather prevents her working outside she can complete the picture, knowing that all the shadows will be cast correctly on leaves as well as on the ground.

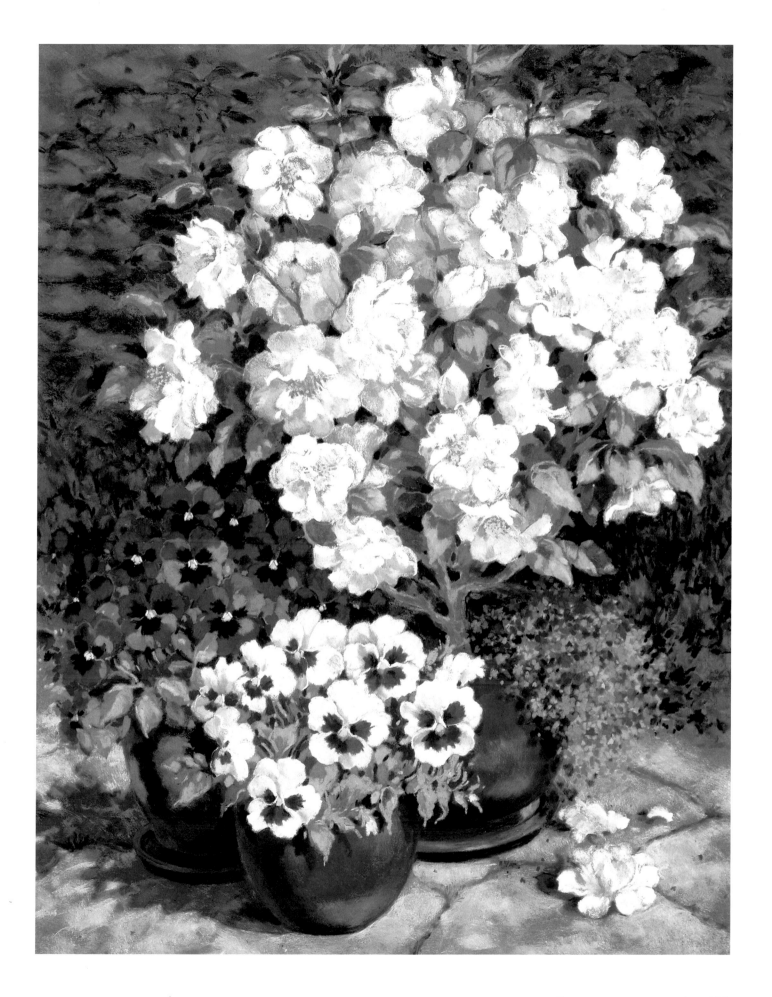

CHAPTER 16

FLOWERS IN THE GARDEN

Since its foundation, the annual open exhibition of the Society of Botanical Artists, held in London, has been entitled 'Flowers & Gardens'. This allows both members and non-members to spread their wings if they wish, and submit work that is either freer in style or inspired by a garden scene. However, all work is subject to the same stringent selection regardless of context, and freedom does not equate to botanical inaccuracy.

The following gallery of paintings showcases a variety of styles that are employed by artists working in the field of botanical painting and will provide plenty of inspiration to encourage you to explore further. Eventually, you will find your own style in which you are most comfortable working.

▷ IRISES
63 × 53 cm
(24¾ × 21 in)
Watercolour
CHRISTOPHER
RYLAND SBA

This study of irises relies on clean washes of pure colour and confident lines to portray their elegance. The leaves have received the same treatment. Try looking at a group of irises or any other flower in brilliant sunlight and see how they retain their identity even if only minimal detail is visible.

▷ FOXGLOVES

35.5 × 25.5 cm
(14 × 10 in)
Watercolour
WENDY TAIT SBA

Wendy likes to paint in
her garden, where she
had to work quickly to
capture such a splendid
clump of foxgloves. Of
necessity some fine detail
is lost, while the essence
of the plant is captured
perfectly, resulting in a
lively painting full of
colour and movement.
Botanical illustrators can
often be called upon to
produce this kind of
image for garden books
and magazines.

▷ WILD ROSES

23 × 31 cm (9 × 12¼ in)
Watercolour
WENDY TRINDER FSBA

Wendy used Bockingford 380 gsm (200 lb) paper and,
after lightly drawing in the composition, she wetted it
all over except on the very pale or white flowers.
Colours were flooded in, allowed to merge in some
areas and stay 'clean' in others. For foliage, Wendy used
yellow over light areas and blue for shadows. The
petals were painted using layers of transparent colour,
wet-on-dry, until the correct depth of colour was
obtained. Some areas of the leaves were painted in,
allowing the background to show through as veins
(except where these were darker than the leaf surface).
For the shadows, Wendy used translucent mauves in
the foreground and cooler blues or blue-greys further
back. Finally, details such as stamens and other darker
areas were added.

▷ LORDS AND LADIES

33 × 32 cm (13 × 12½ in)
Watercolour
JULIA LOKEN SBA

A woodland garden provides the setting for
these wild arum. Again, the background gives the
impression of out-of-focus plants but this time, by
keeping the foreground colours clean and light, the
arum appear to be backlit. The result is an other-
worldly image which conjures up thoughts of
magical forests where nothing is quite what it seems.

▽ IRIS BORDER

56 × 84 cm (22 × 33 in)

Watercolour

CAROLE ANDREWS SBA

Carole has a great love of old-fashioned iris and captured them here growing in her garden, with filtered sunlight reflecting off the foliage and papery blooms. Tendrils of honeysuckle add curvaceous lines to their sculptured beauty. She used Arches 300 gsm (140 lb) Not paper, following the method described for Wendy Trinder's *Wild Roses*, the exception being the use of sea salt scattered on the wet background to create an impression of other lovely blooms in the distance.

▽ HIBISCUS

25.5 × 35.5 cm (10 × 14 in)

Watercolour

CATHERINE WATERMAN SBA

Catherine was inspired by the pot of hibiscus on a patio
table with the garden shrubs providing an out-of-focus
background. She taped 415 gsm (200 lb) Bockingford
paper to a board, wetted it thoroughly and then applied
thin washes of Aureolin, Permanent Rose and Cobalt Blue
to represent the sunny, warm and cool areas. This was
allowed to dry thoroughly before a light minimal pencil
drawing placed the main flowers and leaves. Leaf shine is
principally the original Cobalt Blue wash. From then on,
Catherine wetted only the areas that she wished to work
on, dropping colours in and often mixing them directly
on the wet paper. This technique leaves petals crisply
edged and thin glazes of colour are applied on these,
allowing the paper to dry thoroughly between each
application. It takes time, so a single flower may be
painted first in bud, then half-open and in full bloom,
in order to build up the plant. Hibiscus are ideal for this
treatment because they bloom over a long period.

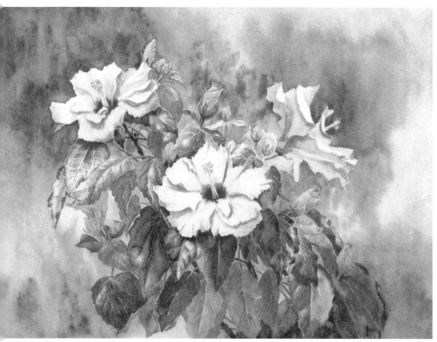

△ ROSA RUGOSA

30.5 × 21.5 cm (12 × 8½ in)

Watercolour

VALERIE WRIGHT SBA

A rose hedge caught Valerie's eye and here she has
re-created its character perfectly. Apart from the purity of
the 'Alba' roses and plump hips in all shades of ripeness,
great attention has been paid to the variation of greens in
the foliage, from the clear shades of new growth to the
glaucous tones of older leaves. Equal attention to detail has
been applied to the spaces between the foliage, which gives
a real sense of depth. This is often overlooked by students
who try to get away with flat, dark areas that result in a
two-dimensional painting.

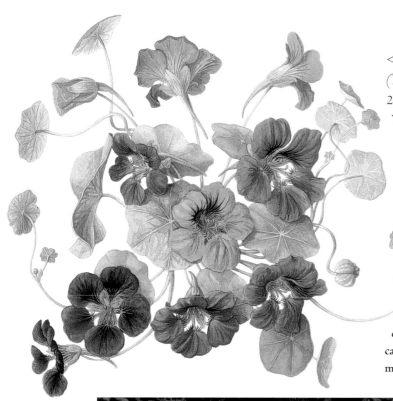

◁ NASTURTIUMS
(Tropaeolum majus)
28 × 35.5 cm (11 × 14 in)
Watercolour
VALERIE BAINES FSBA

This rich painting has one foot in each camp.
Without showing the garden background, Valerie
presents the flowers in such a way that one can
easily imagine their surroundings. The
composition epitomizes their tumbling
growth, with seed heads and tender new
shoots, while the flowers, which are quite
difficult to draw correctly, are shown from
every angle. The only thing missing is the army
of blackfly along a stem and a cabbage white
caterpillar munching on a leaf. This is, however, very
much a garden-inspired composition.

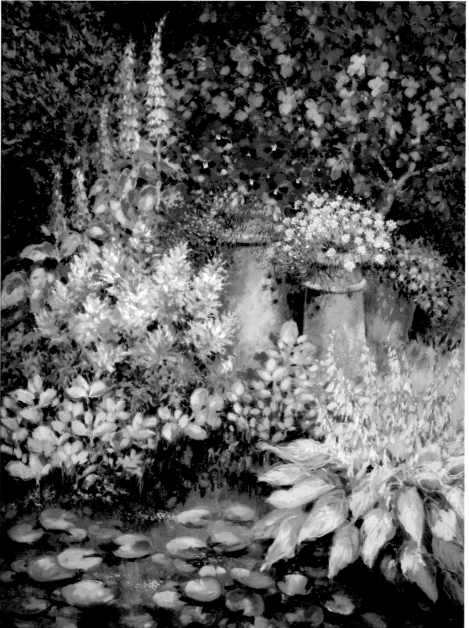

◁ FOXGLOVES BY
THE POND
65 × 48 cm
(25½ × 18¾ in)
Pastel
MAUREEN JORDAN SBA

Pastels are a perfect
medium for artists
wishing to capture the
variations of colour,
texture and tone found
in a garden. While
conveying the light and
colour of massed plants
and foliage it is still
possible to show
identifiable flowers,
from the brilliant blue
pansies to the paler
spires of the hosta with
its variegated leaves.
Foxgloves lead down to
a feathery astilbe which
casts a soft reflection
among the lily pads.
Warm terracotta
radiates light from the
centre of the picture,
which was done on
pastel card.

CHAPTER 17
BOTANICAL ILLUSTRATION

ONE OF THE questions most frequently asked is, 'What is the difference between a plant portrait and a botanical illustration?' The truth is that very often, not a lot. The botanical artist will put the same care into depicting true colour, shape and characteristics of the plant but in the case of a portrait there is a feeling of greater freedom and the chance to take a little artistic licence here and there in order to show the specimen in the best possible light. It is no different to the portrait painter who softens a jawline or reduces a nose by a fraction if he wants to flatter the sitter. Botanical illustration requires a more scientific approach with accuracy of colour, form and size being of paramount importance. It will mostly show a single species, not a mixture as one often sees in a botanical painting, both nowadays and in the past.

▷ PROTEA
33 × 28 cm (13 × 11 in)
Watercolour
LINDA FRANCIS SBA

In this award-winning study of a protea the delicately graded washes of colour and the beautifully textured leaves speak for themselves.

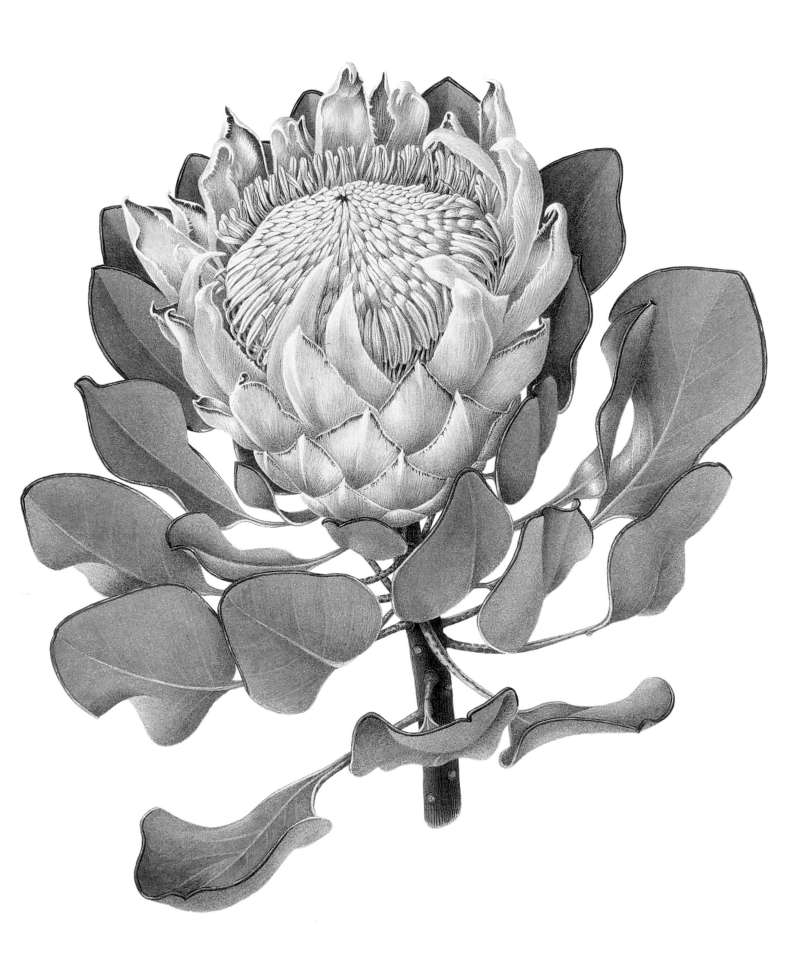

ASPECTS DEPICTED

The flower, or other part of the plant, may be dissected and it may be shown throughout its annual, or life, cycle. On the other hand, the illustration may be simply a record of its most striking features. You have to imagine someone seeing this plant for the first time and therefore show anything which might aid its identification.

The specimen need not be beautiful and the pumpkin on p. 27 drawn by Marta Chirino, an illustrator at the Royal Botanical Gardens in Madrid, is a case in point. Looking rather like a warty monster from the deep, it is of equal value to the most exotic orchid.

◁ *ZYGOPETALUM*
48 × 29 cm (18¾ × 11½ in)
Watercolour
VICKY MAPPIN SBA

The artist has succeeded in showing all aspects of this orchid, particularly the top bloom seen in profile, where the jutting 'chin' created by the fusion of the lateral sepals to the column pushes the lip forward. This can be seen below where the reverse of the flower is shown and also the relatively unmarked green colouring of both sepals and petals. The pseudo-bulb is attractively placed to complete the composition.

▷ HAZEL *(Corylus avellana)*
35.5 × 25.5 cm (14 × 10 in)
Watercolour
VICKIE MARSH SBA

This illustration spans the period from spring catkins
to maturing cobnuts, then on to the gold of autumn
foliage and ripe nuts before the bare twigs of winter
when the annual cycle begins again with newly
emerging flowers. A study of this type takes a year to
produce and you must be prepared to wait until each
part becomes available. The pencil drawings help to
add interest and to lighten the overall composition.

◁ *COTONEASTER OGISU*
42 × 30 cm (16½ × 11¾ in)
Watercolour
DOREEN JONES SBA

This meticulously executed piece is one of a set
awarded a gold medal by the RHS. It requires
dedication to work on a genus which in some species
has an immense number of tiny leaves and many
small flowers, all of which have to be portrayed as
accurately as possible. Great attention has to be paid
to the exact shade of the berries, since in many
berried shrubs there is often a variance in colour
between the different species.

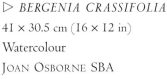

▷ *BERGENIA CRASSIFOLIA*
41 × 30.5 cm (16 × 12 in)
Watercolour
Joan Osborne SBA

Painting this plant in pieces, rather than as a whole, enabled Joan to show off the delicate flowers against the lower leaves. Colour transference from the pink flowers to the young green leaves and the red of the sepals to the mature foliage is echoed by the leaf green in the sepals and stamens. Note the way Joan has left an area of pale green on the lower leaf in order to show up the flowers and buds against it.

◁ FOXTAIL LILY
(*Eremurus robustus*)
43 × 28 cm (17 × 11 in)
Watercolour
Rosaleen Wain SBA

The intricacy of the flower spike has been captured in every detail. The cut stem indicates the height of the plant, which can reach 3 m (10 ft). It is usual in an illustration of this type for the scale of the drawing to be shown, particularly if it is for publication. The composition is given weight by the root backing both flower and seed heads, while the tiny flower parts burst like stars across the page.

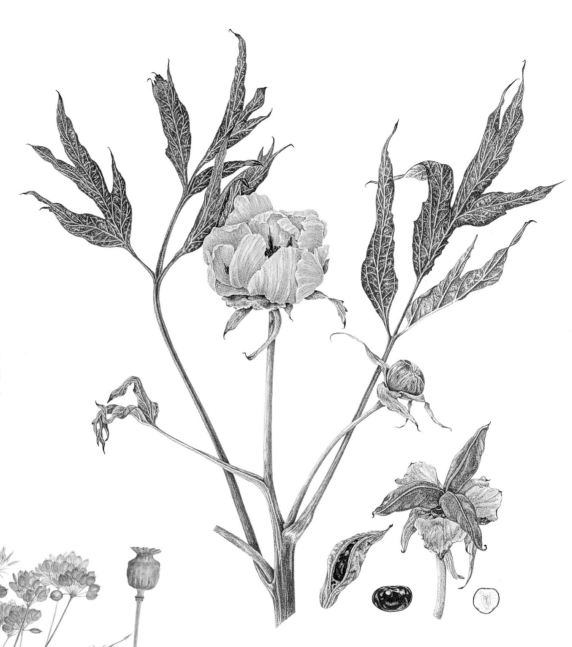

▷ *PAEONIA LUTEA*
× *DELAVYI* Group
30.5 × 28 cm
(12 × 11 in)
Watercolour
SUSAN DALTON SBA

This study of a tree
paeony shows off the
bronze foliage which is
a particularly attractive
feature of *P. lutea.*
Attention has been paid
to detail on the stems
and the positioning of
the seed heads, pod and
dissected seed is
excellent. It is not always
easy to get this right and
care needs to be taken to
ensure that it is close
enough to the main
subject and part of the
composition, without
appearing to jostle it.

◁ SEED HEADS
25.5 × 20 cm (10 × 7¾ in)
Watercolour
ROSEMARY LINDSAY SBA

It is important to remember that all parts of a plant
are of equal importance, as with these various seed
heads which make a very pleasing composition. The
linear arrangement and the contrasting form between
species is both pleasing to the eye and informative.

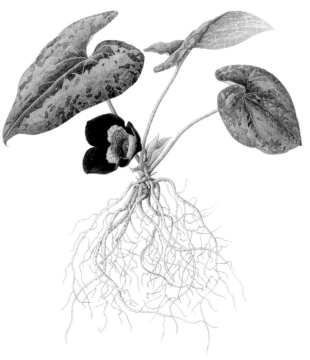

△ *ASARUM*
28 × 21.5 cm (11 × 8½ in)
Watercolour
NOBORU ISOGAI OVSBA

This study manages to show all the distinctive features of this wild ginger plant, from intricate markings on leaves, flower and stems to the delicate filigree of the root system, while remaining pleasing to the eye.

◁ OX-EYE DAISIES
and GOATSBEARD
21.5 × 11 cm
(8½ × 4¼ in)
Watercolour
HELGA HISLOP-CROUCH
FSBA

This delicate study on Kelmscott vellum is proof that no flowers are too humble to be portrayed. These were chosen for their shared habitat among grass, and resulted in a finely detailed painting.

△ *RHODODENDRON LUTEUM*
39 × 28 cm (15¼ × 11 in)
Watercolour
MARIANNA KNELLER FSBA

In this classic botanical illustration a year in the life of *R. luteum* is depicted, from dried remains of the previous year's flower through autumn-tinted foliage to the fresh green and yellow of new growth. The flower has been painted both in profile and in section and its reproductive parts are shown separately, while the leaf drawing depicts venation, portraying all that is required for identification.

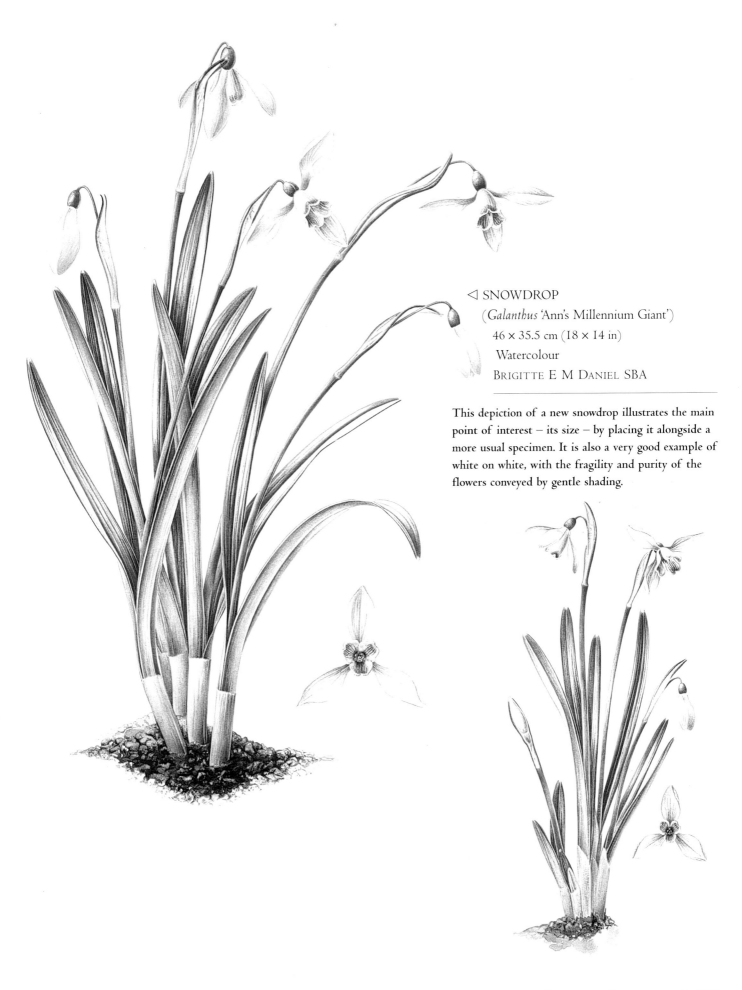

◁ SNOWDROP
(*Galanthus* 'Ann's Millennium Giant')
46 × 35.5 cm (18 × 14 in)
Watercolour
BRIGITTE E M DANIEL SBA

This depiction of a new snowdrop illustrates the main point of interest – its size – by placing it alongside a more usual specimen. It is also a very good example of white on white, with the fragility and purity of the flowers conveyed by gentle shading.

△ BIRCH RHYTHM
(Betula pubescens)
36 × 56 cm
(14¼ × 22 in)
Watercolour
CHERYL WREN SBA

A modern image,
proving that botanical
illustration has evolved
and what one does in
the twenty-first century
is not necessarily the
same as would have been
done in days gone by.
Birch bark is particularly
beautiful and these
lengths capture its
delicate patterns and
colours in a very
harmonious way.

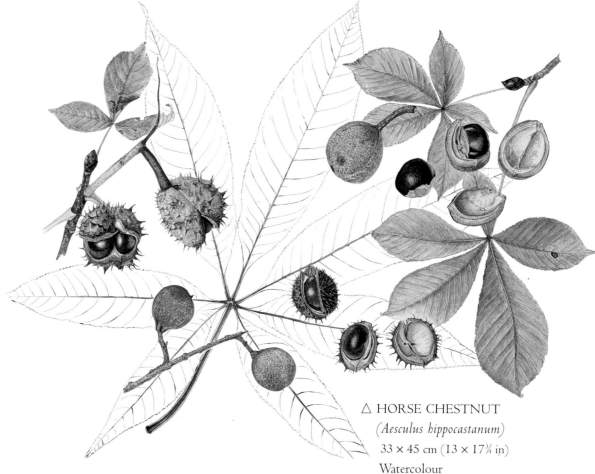

△ HORSE CHESTNUT
(Aesculus hippocastanum)
33 × 45 cm (13 × 17¾ in)
Watercolour
MASAKO SASAKI OVSBA

This is a composition which shows originality where
the pencil drawing of the enlarged leaf unites the
various elements of the fruiting tree and prevents them
from floating around on the page. Note the stippled
texture of the immature husks and the beautifully
depicted grain on the chestnut shells.

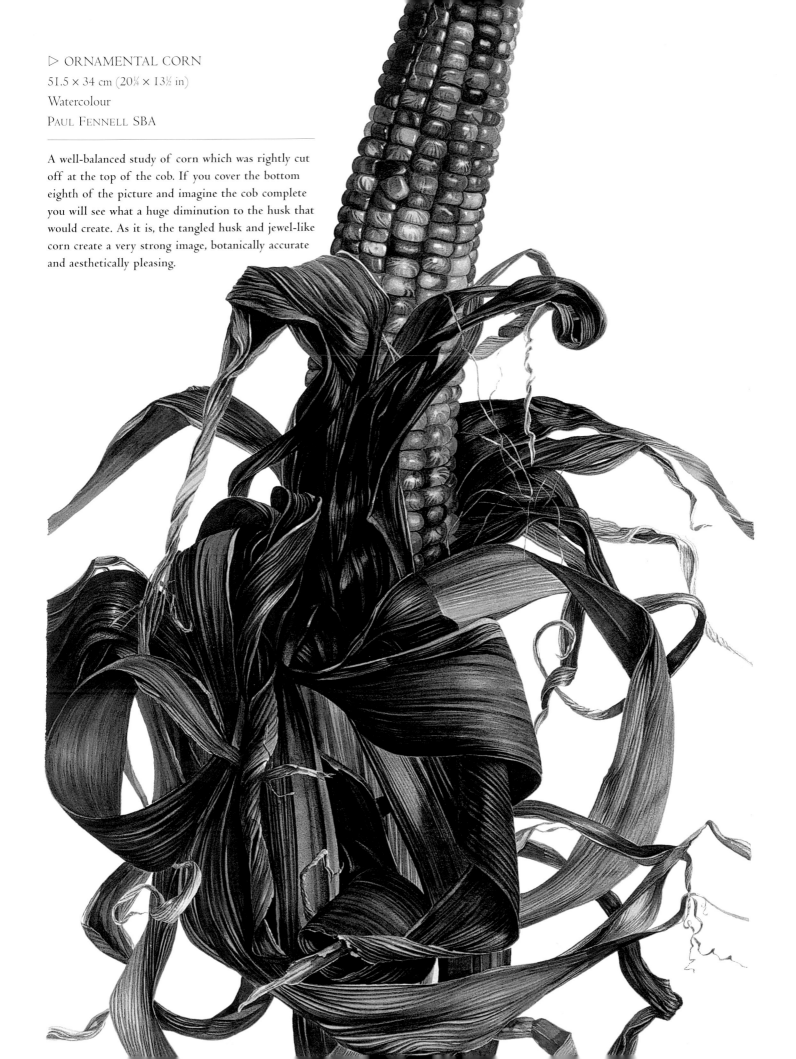

▷ ORNAMENTAL CORN
51.5 × 34 cm (20¼ × 13½ in)
Watercolour
PAUL FENNELL SBA

A well-balanced study of corn which was rightly cut
off at the top of the cob. If you cover the bottom
eighth of the picture and imagine the cob complete
you will see what a huge diminution to the husk that
would create. As it is, the tangled husk and jewel-like
corn create a very strong image, botanically accurate
and aesthetically pleasing.

CHAPTER 18
PRESENTATION AND FRAMING

I F YOU WISH your work to be taken seriously it is important to present it in the best possible manner. Your choice of frame will be influenced by whether you intend it to go in a public exhibition, to fulfil a commission or to hang on your own wall. Fashions change, so do not allow yourself to be beguiled into choosing an over-elaborate mount or moulding that may date. A classic style will add a timeless dimension to your artwork.

◁ DELPHINIUM
STUDY
41.5 × 32 cm
(16 ⅜ × 12 ½ in)
Watercolour
MARGARET HEMS

Remember that a bad painting cannot be improved by a beautiful and expensive frame, whereas a superb painting can be seriously undermined by a poor mount and shoddy moulding. The following points will help you to get it right.

• Find a framer who is prepared to take time and discuss your particular requirements. The advice of an experienced framer is valuable, so when you find such a person, stay with them and build up a reliable relationship.

• You will get what you pay for in the quality of mount board and moulding. You may be able to buy a ready-made frame to fit your work but this is unlikely to be equal to one which is custom made.

• If your work is intended for exhibition it is important to choose a substantial moulding that will not damage easily. Some highly glossed or gilded woods tend to mark and may not stand up to repeated showing if your work does not sell first time. The wear and tear caused by transporting pictures to different venues is considerable and however much care you take accidents do happen, particularly when the gallery may be handling hundreds of paintings for just one exhibition.

• If the work is a commissioned piece you will probably be able to discuss the preferred colour for the mount and type of moulding with the buyer. Sometimes the buyer will have definite ideas about matching their home decor, in which case they may prefer to buy the work unframed in order to get just what they want.

• Normally it is best to choose a neutral-coloured mount, such as ivory, which always looks good and shows off most botanical subjects to advantage. Single wide mounts are currently fashionable but classic double mounts rarely go out of fashion. Oval or round mounts tend to be far less popular. Remember that while your taste may be for dark green or some other strong colour this will almost surely restrict the appeal for prospective buyers.

• The mount board should always be of acid-free conservation quality, as should also the backing card which is placed behind the picture to keep it away from the hardboard backing. If the buyer hangs the painting in bright sunlight or on a damp wall that is their decision; you will have played your part in trying to preserve your work for posterity.

• If you are using a framer for the first time, the following points will help you to assess the quality of his work:

• The aperture or window cuts in the mount should be clean with no overcut at any of the right angles. These should exactly match the angles of the frame. For miniature work, even a tiny overcut will appear huge.

• The mitred corners of the frame should be close and clean, with no sign of gaping.

• The painting should be firmly attached at the top of the mount so that there is no danger of it slipping when hung. You, of course, will not see this being done, but a casual word to the framer when placing the order, mentioning the trouble caused if a slip occurs when the picture is on exhibition, or worse just after it has been sold, will not go amiss.

• The glass should be spotlessly clean inside and out.

• The entire frame and glass should be a close fit, with the backing securely sealed. This is especially important in areas which are plagued during summer with thrips and other insects.

• If you are exhibiting the picture, ask for D rings on the back as these are easily covered with sticky tape, thereby preventing damage to other artists' frames.

• Picture glass thickness of two millimetres is most commonly used but there has been a great improvement in the non-reflective glass available. The best no longer gives a greenish tinge to the work beneath and is virtually undetectable. It will restrict ultraviolet light passing through and so will protect the painting from sun damage. It is expensive, although it could be said that the amount it adds to the cost of framing is worth while in the knowledge that your work will remain in pristine condition for possibly centuries to come.

CHAPTER 19

EXHIBITING AND SELLING

As your painting skills improve you will probably begin to wonder what direction your work should take. If you attend classes or go on one of the residential courses offered by various adult education centres in the UK, your tutor should be able to advise and encourage you. On the other hand you may not have those options or you may be self-taught, in which case some words of advice here might be useful. It is possible that you will always paint purely for pleasure, in which case you will be satisfied for your work to hang on your own walls and in the homes of family and friends. That is fine; there are many reasons why people paint and not everyone needs to earn money from their art, nor are they competitive or ambitious. For some, it is relaxation and many find it fine therapy during illness, bereavement or at other difficult times which everyone has to face at some time in their lives. For that reason alone it is a skill worth pursuing, adding something to the bank of resourcefulness we all need to have within us.

You may like to join a local art club and this will probably give you the chance to show in their exhibitions. If you sell a painting it will give a boost to your confidence, since there is nothing like the thought that someone has parted with money in exchange for one of your creations. Would-be professional artists should also join a local group as you will meet like-minded people and it is a chance to get your work seen, at least locally.

However, if you are at all serious in your artistic ambitions you will want to give your paintings greater exposure and perhaps put them up for independent critical examination. In this respect the most widely recognized body for many years has been the Royal Horticultural Society, whose shows in London during the winter months provide a welcome and central platform for many aspirational artists. Unfortunately, the shows are fewer in number now as the RHS diversifies throughout England, but it is still worthwhile applying to them for space to show your work. There is no charge for this nor commission on sales and many of today's well-known botanical artists started in this way, making useful contacts and obtaining commissions for their work. Above all, the medals awarded, ranging from the Grenville Bronze through Silver and Silver-Gilt to the much coveted Gold, have long been recognized as a peak achievement. Artists come from all over the world in the hope of gaining these awards. For further information write to the Secretary to the Picture Committee, The Royal Horticultural Society, 80 Vincent Square, London SW1P 2PE.

In recent years the Society of Botanical Artists Annual Open 'Flowers & Gardens' Exhibition at the Westminster Gallery in London has become an increasingly popular venue, attracting exhibitors from many countries throughout Europe, the USA and Japan. An average of 750 works is shown, all of which are carefully selected from well over a thousand works submitted by members and non-members.

As well as occasional exhibitions for members only, held at locations ranging from Durham to the Isle of Anglesey, specialized themed shows are also put on. In recent years these have included Medicinal Plants, Plants of Japanese Origin and Plants from South Africa and the Cape.

Awards given at the Open Exhibition include the Founder President's Honour for the artist who creates the loveliest picture in the Exhibition; the Joyce Cuming Presentation Award for the best truly botanical painting; the St Cuthbert's Mill Award for an outstanding watercolour painting; and the Abbey House Gardens Award, a cash prize given for the best depiction of plants in their natural environment. Of great importance are the Certificates of Botanical Merit, judged by an outside independent adjudicator who is eminent in the field of botany or horticulture.

As a registered charity, with the aim of keeping alive the beauty of botanical painting and bringing it to the public in our exhibitions, we feel it is of increasing importance to uphold the tradition in modern times. Our second aim is to educate and with that in mind the Society will be marking its 20th anniversary by starting a Two-Year Diploma Correspondence Course in January 2005. This book will provide the foundation on which the course will be based. For details of the course, exhibiting at the Open Exhibition or becoming a member of the Society, contact the Executive Secretary SBA, I Knapp Cottages, Wyke, Gillingham, Dorset SP8 4NQ or email pam@soc-botanical-artists.org. Other examples of members' work may be seen on our website, www.soc.botanical-artists.org. Charity Registration Number 1047162

BIBLIOGRAPHY

Blunt, Wilfred and William T. Stearn, *The Art of Botanical Illustration,* The Antique Collectors' Club, 1994

de Bray, Lys, *The Art of Botanical Illustration,* Christopher Helm, 1989

Gildow, Janie and Barbara Benedetti Newton, *Colored Pencil Solution Book,* North Light Books, 2000

Guest, Coral G, *Painting Flowers in Watercolour: A Naturalistic Approach,* A & C Black, 2001

Martin, Judy, *The Encyclopaedia of Coloured Pencil Techniques,* Headline, 1995

Sherlock, Siriol, *Botanical Illustration: Painting with Watercolours,* B. T. Batsford, 2004

Sidaway, Ian, *Colour Mixing Bible,* David & Charles, 2004

West, Keith, *How to Draw Plants; Techniques of Botanical Illustration,* A & C Black, 2004

Wunderlich, Eleanor B., *Botanical Illustration Watercolour Technique,* Cassell Illustrated, 1991

CREDITS

Illustrations on pp. 9, 10 and top right on p. 11 courtesy of the National Museums and Galleries of Wales.

INDEX

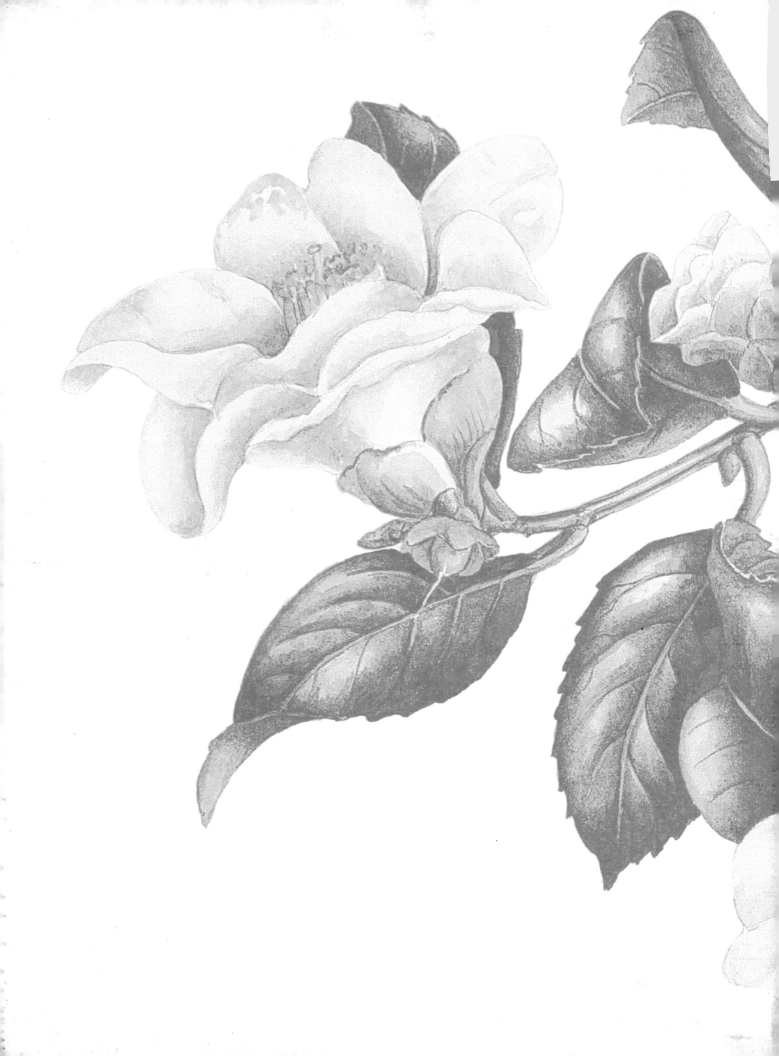